GREEK ART

WALTER-HERWIG SCHUCHHARDT

WEIDENFELD AND NICOLSON
5 Winsley Street London W 1

Translated by Sabine MacCormack

First published in Great Britain by Weidenfeld and Nicolson
5 Winsley Street, London W 1 (© 1972)
SBN 0297 00389 5
Printed in Germany

CONTENTS

INTRODUCTION

The classical world of Greece and Rome displays a remarkable homogeneity by comparison with Oriental cultures on the one hand and Western and Byzantine Christendom on the other. The unity of Western civilization in antiquity was for the most part much more significant than its division into Greek and Roman components. Nevertheless, the Greek and Roman civilizations differed profoundly in the relationship that each established between the individual and the state and between the state and the world at large, as well as in the scope of political claims for power and dominion. Although the Romans developed their communal life, their constitution, their statecraft, and their claims for imperial dominion independently of Greece, they readily and devotedly accepted the intellectual and artistic heritage of Greece and recognized Greek achievements in art and literature as exemplary. Greek art owes recognition of its uniqueness to Roman civilization, which interpreted and propagated it to the outside world, but it demonstrated its independence in recurrent periods of self-examination and renewal.

Roman culture is in many respects the first great example of the procreative power of the Greek spirit. The *Imperium Romanum* not only brought about the worldwide propagation of Greco-Roman culture, but also forged it into an entity that was to endure for 2,000 years. This is true especially for classical art, and applies to classical architecture in a wider and more comprehensive sense. The architectural styles invented by the Greeks were taken over by the Romans, so that the transition from Hellenistic to Roman architecture was an unbroken, developmental process.

The civilizations of the ancient Middle East had also learned from each other—the Akkadians from the Sumerians, the Babylonians from both, and the Assyrians from the Babylonians. Much of this ancient culture which, from the first millennium B.C., spread from the Middle East to the Mediterranean countries, had become an anonymous legacy.

This legacy reached the Greeks when, about 700 B.C., they emerged from the strict seclusion of their origins, assuming geographical and intellectual links with the East. For centuries before this, the Greeks had developed their creativity and principles of thought from their own resources with lucidity and intelligence.

The conflict with the East began with the very significant process of colonization carried out by the Greeks for over 150 years, from the late 8th century to the 6th century B.C. The enormous tribal expansion embraced the shores of the Mediterranean, of the Propontis (now the Sea of Marmara) and of the Black Sea. For the first time, the Greeks were brought into direct contact with foreign countries and nations, a process which, owing to their intellectually enterprising nature, was of crucial importance for the further development of Greek culture.

The beginning of the 7th century not only produced a new epoch of Greek culture in a geographical area that now extended over the whole Mediterranean and its shores, but at the same time brought to an end the first great period of Greek art, which, owing to the style of its ornament, is called Geometric. This period, which lasted from 1100 to 700 B.C., was followed, in the 7th century, by the early Archaic period, and, in the 6th, by the mature and late Archaic periods. The Classical age of the 5th century and the late Classical age of the 4th were followed by three centuries of Hellenistic art—from the death of Alexander the Great in 323 B.C. until the principate of Augustus, and the beginning of the Roman Empire, in 27 B.C.

Geometric art, after long and undisturbed development, reached its final phase and dissolution with a certain petrification and desiccation of its forms. Our knowledge of this process is restricted exclusively to pottery, and especially to the pottery of Attica, whose principal city culturally as well as politically was Athens, for here alone a sufficiently large number of specimens survives (*Ills. 1–4, 8*). At the end of the Geometric age the powerful figurative and ornamental motifs of the East began to appear, marking the end of the calm, self-reliant early period, defined by rigid forms, and beginning a new age, which was open to external influence and rich in imagery.

The 7th century had a special character and a special significance for the development of Greek art. It was a period of transition, during which Greek artists moved away from the strict seclusion and austerity of the early period. Whereas the Geometric style had been unpretentiously restricted to minor arts, handicrafts, and modest buildings, the art of the 7th century is characterized by a style of dramatic liveliness which probably also found expression in paintings on wood and clay and by monumental sculptures in stone and clay, the origins of which can be traced back to the middle of the century. Judging by their size, stance, and posture, these figures were evidently inspired by Egyptian models.

During the 7th century the various regions of Greece first acquired their own artistic identity, for the various tribes and cities developed individual styles: that of the Greek settlements of Ionia, on the shores of Asia Minor, has been called the Ionic; that of Attica and Athens, the Attic style; that of the Peloponnese, the Doric style, which can be sub-divided into the Corinthian, Argive, and Spartan area styles. In architecture, too, a decisive step was taken; here, as in sculpture, technical and artistic achievements balance each other. In the course of the 7th century the transition from buildings of wood to buildings of stone was made. Now, for the first time, a substantial course of orthostats—slabs standing up-right—was constructed above the customary modest foundations of rubble or slabs. The first stone pillars, generally worked out of a single block of stone, were also erected. This transition to building in stone apparently encouraged a rethinking of the principles of architectural organization, for during this period began the slow development of the canon, or set of rules, that later came to define the classic forms of the Doric and Ionic styles. All these achievements were made with a restless power, often with revolutionary violence. The passionate forces that effected them are to be seen at work most clearly in vase painting. But we also gain a glimpse of the struggle with matter entailed in the creation of those first monumental statues and architectural members and ornaments of stone.

In the 7th century the foundations were laid for all forms of Greek art. These foundations were of course especially and immediately valid for the 6th century and for the further development of Archaic art. The 8th and the 7th centuries differed profoundly in all aspects of art; the 7th and the 6th centuries, on the other hand, were very closely linked. Every great and decisive achievement that was made after the middle of the 7th century was brought to a flowering and perfection by the generations immediately following. With the 6th century, statues and temples, sanctuaries and funerary monuments were created in singular variety in large numbers in all countries inhabited by Greeks. Workshops for the minor arts and pottery appeared in unprecedented numbers, and were productive as never before. Greek artistic endeavor was never again as wide in its scope, as colorful and varied, as in the 6th century. For at that time, the Greek colonies, the cities of southern Italy and Sicily, and the settlements on the shore of North Africa, in the Nile Delta, and on the Black Sea took a full part in Greek artistic activity. Their work was not as rich and original as that of Athens, Argos, Corinth, the islands, and Ionia. But the contributions of these colonial cities and their workshops enriched the vigorous creativity in which the Greek nations were united during the 6th century. The development and ultimate exhaustion of this many-sided Archaic art can be traced very clearly.

The transition from Archaic to early Classical art took place during one generation, between 510 and 480 B.C. This change can be seen not only in vase painting but also in the

development of sculpture. Only one transitional temple, on the island of Aegina, survives to provide comparison with Classical buildings, like the Temple of Zeus at Olympia. Nonetheless, the transition from the 6th to the 5th century may also be regarded as a decisive turning point in the history of Greek architecture. It should be pointed out, however, that this chronological turning point has a conditional, theoretical significance only; furthermore, it is primarily valid for the great progressive centers of art, such as Athens, Argos, and Corinth, since the remoter districts cultivated a late Archaic style well into the 5th century.

The two generations that followed the great transitional period of the early 5th century may be termed early Classical and high Classical. Thus, the Temple of Zeus at Olympia (*130*), since it was built between 470 and 456 B.C., would be attributed to the early Classical age, and the Parthenon (*119, 132*), built between 448 and 432, to the high Classical age. Whatever the terminology, these two most significant temples of the century form decisive points of climax, and are very important sources for our knowledge and understanding of Greek architecture and relief sculpture. The two temples also sheltered the most famous of all freestanding images of gods by the most famous sculptor of such images in antiquity, the Olympian Zeus of Phidias and his Athena Parthenos (*73, 74, 134*).

The whole period of Classical art lasted from the first quarter of the 5th century until the beginning of the last quarter of the 4th century. After the death of Alexander the Great, in 323 B.C., a change took place that ultimately turned the course of painting, sculpture, and architecture in the direction of the Hellenistic age. But the last quarter of the 4th century was in many ways closely related to the late Classical age. Indeed, when they are compared with the Archaic 7th and 6th centuries on the one hand, and the Hellenistic 3d century on the other, the Classical 5th and 4th centuries form a close unity. Yet they are also clearly distinct one from the other, so that it is possible to speak of a first and a second Classical age. Using modern terms freely, one might even distinguish a "Romantic" 4th century from a "Classic" 5th.

In the early Classical age great individual artists emerge with clarity for the first time, even though we often know only their names: Myron, Kalamis, Hageladas, and Onatas the sculptors, as well as the great Polygnotos, who transformed painting into a new art. Of course we also know the names of a few artists of the Archaic period; these have been handed down in classical literature or are known through the inscriptions placed on the bases of their works by way of signature. In addition, some Archaic sculptures can be attributed to a particular anonymous master on the ground of style; certain characteristics of his artistic personality distinguish him from other craftsmen of his time. Thus, in both cases, we know a part, perhaps the core, of the work of a particular artist, but not his personality in a historical or biographical sense.

But with the 5th century artists appear, whose personality speaks to us both through the specific style of their works and through a biographical tradition. In this way, a new factor is introduced into the history of the arts: the personality of the artist, whose unmistakable and unique genius is revealed in his works and was recognized in his own time. Thus, for example, we speak of the age of Phidias and the century of Praxiteles. Certainly, artists' signatures are to be found in the art of the East and Egypt, and they bear witness to the consciousness of self and to the rank and significance of particular masters. But in the face of the great number of anonymous artists and the huge mass of anonymous works, they are merely exceptions. Only in Greece, from the Archaic period onward, are the names of artists commonly inscribed not only on works of sculpture but also on early pieces of pottery. Moreover, classical literature not only contains stories about artists but a real historical survey, including attempts at chronological, geographical, and even stylistic classifications. However, such historical endeavors were made in a later period, the early Hellenistic age of the 3d century B.C.

Tracing the connections between the surviving monuments and the remains of a literary history of Greek artists has remained one of the most important activities of archeological research since the time of Johann Winckelmann. Especially in the realm of sculpture, it is possible to isolate categories and groups of monuments and to study them according to their special characteristics and their development. An example is the funerary relief, which played an important role in the Archaic period, declined in importance in the earlier part of the 5th century, but in the last third showed a rich and manifold development. This category of sculpture radiated particularly from Athens, becoming a kind of Attic monopoly during the 4th century. These funerary reliefs were articles of export and are to be found in almost all countries inhabited by Greeks. Similarly, on the mainland, the islands, and in the Ionian east, votive reliefs had already evolved in Archaic times; in the 5th, and particularly in the 4th century, they were produced in quantity. In addition to these reliefs, votive offerings in bronze and clay were made, which have been found predominantly near shrines. Among them are true masterpieces, which make explicit the preeminent role of sculpture in the framework of Greek art.

At all times, Greek sculpture was closely linked with architecture, which, especially in the 6th and 5th centuries, was elaborately decorated with sculptural ornament. However, reliefs and sculptures in the round, when applied to a particular building, were strictly adapted to the style, or "order," of the building as a whole. The Doric order included sculptural decoration on the metopes and pediments *(107, 119, 132)*. Buildings of the Ionic order had a continuous frieze in place of the band of decorated metopes and grooved triglyphs, which was often decorated with narrative representations in relief *(108, 133)*; this

relief was generally flatter than that on the square Doric metopes. Only in the case of the Parthenon was a band of continuous relief on the walls of the cella (the famous Parthenon frieze, which represents the Panathenaic procession) combined with sculptured metopes on the entablature and pedimental compositions on the east and west fronts.

Even in the Classical period, only temples were furnished with such rich sculptural decoration. Utilitarian buildings, such as town halls and other public edifices, were not furnished with sculptural decoration, even though they were constructed in precious marble—the only exception being *akroteria* (decorations at the corners of a pediment on a horizontal base) in the form of statues or ornamental sculptures, which were attached over the two corners and the apex of the pediment (*107*).

The names of famous architects of the Classical period are known and can be linked with important buildings—for example, Iktinos and Kallikrates with the Parthenon and Mnesikles with the Propylaea. As regards painting, however, although many names survive, there are no originals with which we might link them. In sculpture, too, hardly any works by famous artists are known in the original. However, a number of masterpieces have come down to us in the form of copies, mainly Roman ones. By contrast, the monumental paintings of the 5th and 4th centuries, which were generally executed on large slabs of painted earthenware or wood, have survived only in extracted form in vase paintings of the time or in adaptations of the Hellenistic period.

In vase paintings of the early Classical period there are, in some rare cases, representations that clearly make reference to very large and famous paintings, for instance to the Battle of the Amazons, by the painter Mikon, on the "Painted Porch," the Stoa Poikile, in the *agora*, or marketplace, of Athens. In this painting, judging by the vase copies, figures and groups were represented in pronounced foreshortening, an early bold use of perspective. After the mid-5th century, this magical device became the common method of representation on flat surfaces, replacing the rigid, two-dimensional method in which figures and objects were simply placed side by side that had been practiced to the exclusion of any other in Egyptian, ancient Middle Eastern, and Archaic Greek painting. In the early Classical period, the first approach to an illusionistic style was made, a style that was to undergo a triumphant development during the Hellenistic and much of the Roman period, and which was rediscovered, or discovered afresh, in Western European art about a thousand years later.

We cannot trace the origins of this new, revolutionary means of representation in the major wall paintings of the 6th and early 5th centuries, since extant examples are lacking; yet, here again, vase painting provides material for the study of this problem. The highly skillful vase painters of Attica developed a new technique about 530 B.C. Until that date,

figures and ornaments had been drawn on the natural red-brown earthenware background in black glaze (vessels painted in this fashion are appropriately called black-figure). Now painters began to cover the whole background—that is, the whole exterior of the vessel— with the black shiny glaze, carefully leaving the figures untouched; these appeared in the red-brown of the earthenware beneath. This reversal had the great advantage of enabling the painter to elaborate the area of the red-figure silhouettes with fine brushstrokes, whereas the older, compact black silhouettes could only be structured by means of laborious and clumsy engraved lines. Here was a completely new method for the representation of the movements of the human body. From these beginnings, Classical vase painters of the 5th century soon attained a masterly command of perspective, and by the middle of the century the use of perspective was taken for granted by every Attic vase painter, even though it was handled with widely varying skill. This artistic technique was also part of the repertoire of every sculptor of reliefs. Indeed, foreshortening and perspective were explored simultaneously in vase painting and relief sculpture during the first half of the century, finding superb exploitation in the figures of the Parthenon frieze of the high Classical age.

With the development of red-figure vase painting in Athens, Attic pottery became of great importance as an article of export. Attic vessels of high quality are to be found in great numbers in the graves of rich Etruscans, who in the 6th and 5th centuries maintained a lively commerce with Athens. The products of Attic potters are found in the whole Mediterranean area, in the East, and on the shores of the Black Sea, as well as in Massilia, in the Gallic hinterland, and in Spain. Attic vessels are occasionally met with even north of the Alps. The output of workshops elsewhere in Greece soon became narrowly provincial.

During the last quarter of the 5th century, Attic vase painting reached a glorious climax in a luxuriant late style, as represented, for example, by the artist Meidias and his school. Vase painting continued to be practiced in Athens in the 4th century and was widespread and important. But the form of the vases, as well as their ornaments and imagery, became opulent and exuberant. The art of maintaining in the image an equilibrium between its function as decoration of a vessel and as an autonomous and independent expression was lost. By the end of the 4th century, vase painting had lost its position as a major medium of expression, and for the remainder of the Hellenistic age we miss one of the richest and most colorful aspects of Greek art. We also miss the reflection of major works of painting in this highly durable art. For we know that painting of the 4th century followed a splendid course of development, maintaining fame and importance until the end of antiquity. Similarly, though for a different reason, it is impossible to trace a coherent development in the architecture of this century. The character of the great sacred sites of Greece, such as Olympia, Delphi, and the Acropolis of Athens had been determined at an earlier time. No

buildings of equal splendor and import were created in the 4th century, although older buildings were frequently replaced or restored—for instance, the Temple of Artemis at Ephesos. In these projects, the plan of the earlier building was closely followed; the architecture of the 4th century in general has certain conservative and antiquarian characteristics. This is not at all true of utilitarian buildings, such as the arsenal of Philon, a huge storehouse at Piraeus, the port of Athens, which was erected to house the equipment of the navy. Although not a stone of this building remains, we do have a careful description of it in the form of an inscription, from which an exact reconstruction can be made.

Having now made a series of negative statements about the 4th century, namely, that the significance of vase painting decreased, that its major painting remains practically unknown, and that the development of architecture stagnated, one must admit that sculpture moved into the foreground. Here the productive genius of Greece remained unexhausted, and developments continued with unaltered and lively energy. As in the 5th century, great artists provided the decisive impetus. Among them were Lysippos of Sikyon, who, born in the first decade of the 4th century, appears to have continued his activity until the last decade; Praxiteles, whose glorious marbles filled the ancient world (95); and Leochares, who was the court sculptor of Alexander and, like Lysippos, created highly famed portraits of the great king. During the century various kinds of relief sculpture were further developed—votive reliefs and, particularly in Athens, funerary reliefs, of which beautiful and often very moving examples are to be found in all countries inhabited by the Greeks. However, as regards funerary reliefs in particular, the final point of their development and production fell in the 4th century. Between 317 and 306 B.C. the Athenian state enacted a law that was intended to restrict the form and size of funerary monuments. As a result of this prohibition, Attic funerary art was a good as destroyed. After the end of the 4th century, only tombs consisting of modest little columns or tablelike stone blocks were erected.

A kind of termination was reached at the end of the 4th century in all fields of Greek art and culture, though it is especially noticeable in sculpture. Alexander the Great had created a new world by his conquest of the East, the Hellenistic world. This term is a modern one, coined by the historian Johann Gustav Droysen, who in 1833 published a pioneer history of the Hellenistic Age. The term denotes precisely the historical process that took place as a result of Alexander's conquests and after his death, that is to say, the Hellenization of the area that we call the Middle East. This process worked all the more rapidly and effectively, since the East had reached the sterile end of a long succession of empires and cultures and was ready to absorb the attainments of Greek art and culture. The Hellenistic age was one of large dimensions, in both time and space. Confusion on the political scene, which lasted from the wars of the Diadochi after Alexander's death until the conflict between the

Hellenistic states and Rome, was paralleled by a confusion in the arts resulting from a proliferation of works of art, in a variety of styles from all parts of the Hellenistic world—from Greece and the Aegean area and, in even greater numbers, from Asia Minor and the Hellenized East. Two generalizations may be made, however. The high Hellenistic period was characterized by extravagant monumentality and pathos; that of later times tended toward a certain classicizing rigidity.

The new age brought forth a kind of architecture intended to satisfy heightened, often baroque requirements. Perhaps the most magnificent example of planning and execution on a monumental scale before Roman times is the upper city of Pergamon in Asia Minor. The overpowering vigor of the design and its execution transformed the natural contours of the hill of Pergamon into a series of terraces, on which markets, sanctuaries, palaces, and fortifications were laid out. On one of these stood the famous Altar of Zeus (*102, 103, 105, 106, 146*). The terrace above it supported the sanctuary of Athena; on one of its sides, behind a two-storied portico, was housed the famous library of Pergamon.

Extensive porticos were particularly favored in Hellenistic times. Athens, by then vener-. able and laden with tradition, was graced with several: Eumenes II of Pergamon (197–159 B.C.) donated a portico, 163 meters long, for the Temple of Asklepios on the south slope of the Acropolis, and Attalos II of Pergamon (159–138 B.C.) gave a two-storied portico for the agora of Athens, which has been re-erected and serves as a museum for the finds made on the site. Another Hellenistic portico, the "Middle Stoa," stood at right angles to the Stoa of Attalos, and—almost 150 meters long—delimited the agora on its south end.

Excavations of Pergamon and other sites have produced numerous original works of Hellenistic sculpture. Other famous monuments of this time are known through Roman copies. This comparatively rich legacy makes it possible to sketch the history of this art in Hellenistic times. Following the severity of the 3d-century style, a new development led to the early achievements of the art of Pergamon, as represented by the famous Ludovisi Gaul and the Dying Gaul. At the beginning of the 2d century B.C. an increasing delicacy on the one hand and a classicizing rigidity on the other are to be noted, so that, in the course of the 1st century, Hellenistic sculpture reached a natural end and transition into Roman imperial art.

VASE PAINTING

The history of Greek art begins in the four centuries between 1100 and 700 B.C. A period of preparation, of incubation free from outside influence, the age was of great significance for later developments. During this earliest period of Greek art, vase painting is the only consistent guideline to the development of artistic concepts. Other forms of artistic activity existed, but most of the products are lost for ever. Weaving and embroidery were undoubtedly practiced, but their character can only be guessed at or deduced from developments in pottery. Clearly, similar or even identical forms of textile and ceramic ornaments existed; however, whether the origin and invention of forms is to be looked for in the ornaments of pottery, which are known to us, or the patterns of textiles, which are not, cannot be resolved. The art of carving in wood, bone, and ivory found expression in the production of furniture and implements as well as in statuettes. Finally, at least from the 9th century, the art of casting bronze was practiced, and numerous Geometric statuettes of men and animals survive (38). Nevertheless, it is from the ceramics that most of our knowledge derives. The transition from the art of the late Mycenean Bronze Age, whose creators were Greek in speech but otherwise culturally part of the Aegean-Minoan tradition, to the first modest traces of Greek civilization—early Proto-Geometric pottery—took place during the course of the 11th century B.C. This transition and the subsequent flowering of the Geometric style can be traced particularly clearly in Athens, for the ancient cemetery of Kerameikos outside the Dipylon Gate has yielded a large stock of pottery of the 2d and early 1st millenniums B.C. Thanks to the careful investigation of the finds made on this site, a reliable chronology of these critical centuries has been established.

The first crude attempts to work within the Mycenaean repertoire of curvilinear and naturalistic motifs were followed, in the 10th century, by more proficiently decorated work of a severe, spare type. These Proto-Geometric vessels are characterized by clearly defined

bands of sparse, simple geometrical decoration. Full Geometric pottery of the 9th and 8th centuries displays the same banded decoration, but the bands are narrower and the decoration more varied; as the period progressed, the motifs began to include rigid little figures of men and animals in scenes of increasing complexity within the geometric bands. It was in Attica that this style was especially highly developed, and its products are still recognized as being of the greatest artistic quality, in respect to general appearance and individual ornament (1).

Of the two vases shown (2, 3) from the great age of the Geometric style, the 9th century, the first dates from the beginning, the second from the middle of the century. In both examples, the body of the vessel as well as the neck are largely covered with black glaze. The earlier vessel has a simple but bold ornamental midband, which well suits its sturdy shape. This band divides the pot into two parts—a larger lower part, which rises in a steep curve, and a shoulder area, which turns toward the neck in a shallower curve. Because of the black sheen of the thick glaze, which is almost unbroken by ornament, and the fine profile of the lip, this vase may be a successful imitation of a metal vessel. The later vase is much more elaborately decorated. Its shape, from the foot to the firm curve of the body and the high arched neck, also reflects the precision and elegance of a metal vessel, and the orderly ornamental design recalls the severity of a pattern in wrought iron. The motifs and bands emphasize the structure of the vase, so that shape and decoration balance each other.

By the 8th century B.C., decoration often spread across the whole body of a vessel, as the beautiful Geometric amphora in Munich shows (8). The severely proportioned body and somewhat stiff neck are encased in a taut system of decorative bands. Side by side with purely abstract zones of meanders, checkers, zigzags, and lozenges, figurative representations now appear: rows of geese, reclining ibex, and grazing deer. Because they are arranged in regular rows, these figurative representations still blend into the decorative system as a whole.

The Geometric vase from Kerameikos (1), which was the sole monument on a grave in the cemetery, is a vessel of unusual splendor and size. A dramatic figurative scene is set into the delicate fabric of ornament. In accordance with the vessel's function as a funerary monument, the lamentations for the departed are represented. A splendid work of Attic ceramic art, this amphora, made shortly before the middle of the 8th century, represents a climax of the full Geometric style and, at the same time, illustrates the transition to the late Geometric figurative style of the second half of the century. Another grave monument in the Kerameikos Cemetery, a huge *krater* (4)—a broad, wide-mouthed vessel in which wine was mixed with water—demonstrates the tendency to increase narrative representation during the late Geometric period and shows how potters adapted their repertoire of shapes

1 GEOMETRIC VASE, from the Kerameikos Cemetery, outside Athens. Mid-8th century B.C. Height 155 cm., maximum diameter 74 cm. National Museum, Athens, No. 804. This exceptionally large vase is entirely covered with geometric ornament painted in glaze. The precisely placed ornamental bands become wider toward the center of the body of the vessel. Between the handles is a particularly broad band in which a scene of mourning is depicted. Its importance is emphasized by a framework of horizontal and more emphatic vertical bands. In the middle of the composition is a bier, on which lies the departed—a black, extended figure. Above him, the shroud, a fine network of lines, extends as far as the upper margin of the picture. Beneath the bier, or, more correctly, in front of it, two persons kneel, and on the left two others sit on chairs; they, and the standing mourners—seven men on the left, and six, with a boy, on the right—raise their arms to their heads. This dramatic scene can also be imagined, in a larger format, as a flat picture on wood or clay, or even as a wall mural. The earlier Geometric style of pure ornament, enlivened only by bands of animals, is here being supplanted by the beginnings of a figurative style.

2 EARLY GEOMETRIC VASE. Beginning of the 9th century B.C. Height 44 cm. Kerameikos Museum, Athens, No. 576. The body of the vessel has a sturdy, ball-like shape, and a stout, boldly curved neck. At the level of the handles, a broad unglazed band is filled with Geometric motifs; the concentric circles are a reflection of earlier Mycenaen art.

3 EARLY GEOMETRIC VASE. Mid-9th century B.C. Height 69.5 cm. Kerameikos Museum, Athens, No. 2146. Restored from numerous fragments, but almost complete. The body of the vessel is an elongated egg shape, from which the neck rises in a neat, elegant curve. The decoration of the lower part consists of alternate stripes of black glaze and unglazed clay. The shoulder of the vase has a rich collar of delicate ornament. The neck is divided into halves by a meander motif on the unglazed background. The decorative band in the center shows discs surrounded by concentric circles, which are set into, and emphasized by, an elaborate framework of ornamental bands. This area of decoration between the handles may be compared to the frieze of the Doric temple, which consists of alternating plain and banded areas. (See 107.)

4 LATE GEOMETRIC KRATER, from the Kerameikos Cemetery, outside Athens. Detail. After 750 B.C. Total height 123 cm. National Museum, Athens, No. 990. The dramatic and elaborate representation of a funerary procession with chariots and a multitude of figures clearly indicates that the rigid pattern of traditional Geometric ornament is being discarded. (See 1.) The band of figures between the handles has been made wider in the center in order to allow ample space for the representation of the bier, the dead man on it, and the shroud. The rows of mourners are arranged in two tiers. Ornaments are still scattered among men, animals, and objects.

5 AMPHORA. c. 670–60 B.C. Height 142 cm. Eleusis Museum. Restored from fragments. On the sides of the steeply curved vessel a field of huge pictures is spread. Two Gorgons, terrible demons of night, hasten across the center, their fantastic heads, framed by serpents, facing the onlooker. From the right, the goddess of wisdom, Athena, comes to meet them. She protects the hero Perseus, who is in the act of beheading Medusa, the third of the terrible sisters; the hero and the dying Gorgon are represented on the other side of the vessel. On the neck of the amphora the blinding of the giant Polyphemos by Odysseus and his companions. Between the two narrative panels is a band of fighting animals—lion and boar. Almost all figures and ornaments are painted in black glaze, except the body of Odysseus, which is white. This monumental vessel is one of the most splendid extant examples of so-called Proto-Attic painting of the 7th century B.C., which resolutely moves away from the strict Geometric style in the direction of dramatic narrative.

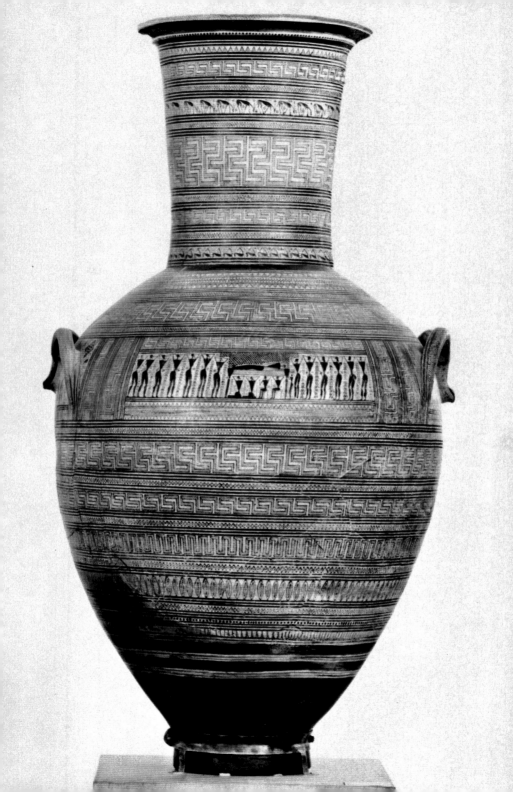

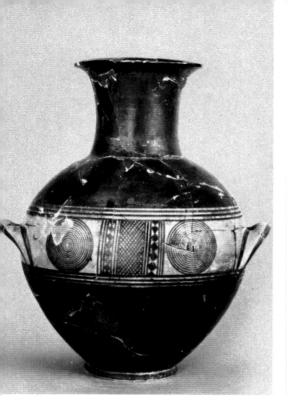

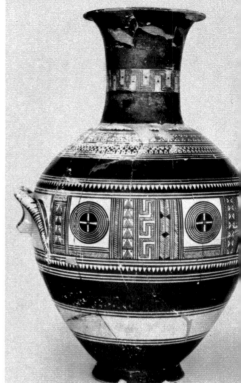

△ 2 ▽ 4 △ 3 ▷

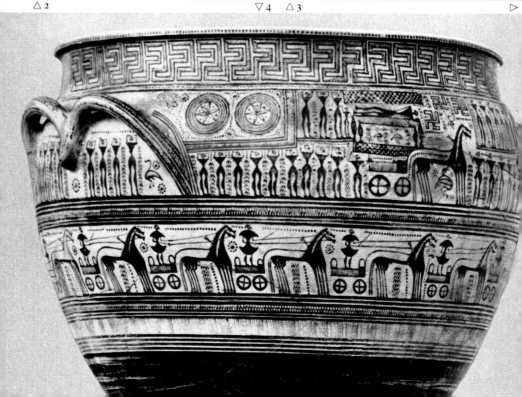

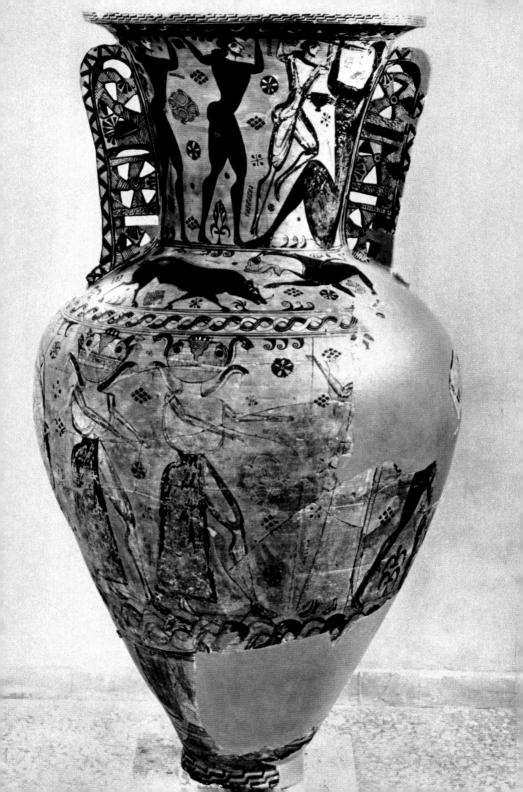

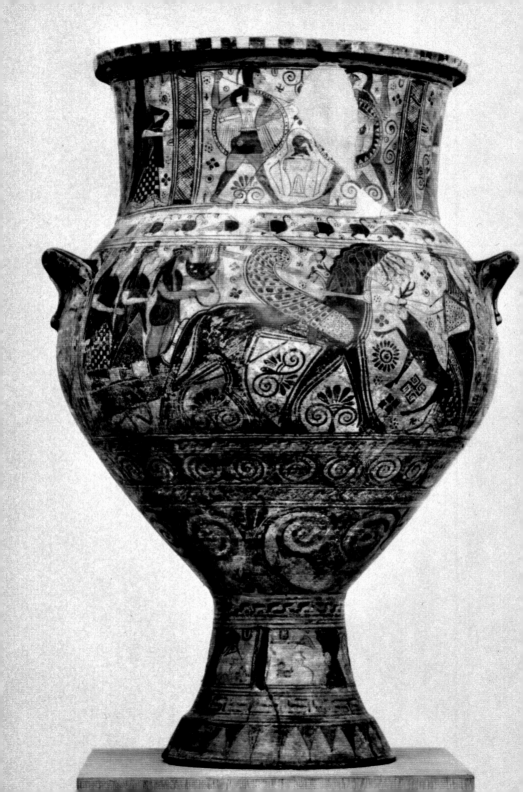

6 VASE, from Melos. Mid-7th century. Height 95 cm. National Museum, Athens, No. 3961. The vessel has been restored from large fragments. The body opens up above the foot in a bold curve. On the central part of the neck, a contest between two armed warriors is depicted. At their feet is a suit of armor, helmet, and shield, probably the prize for the victor of the contest. On either side stands a woman. The central band shows Apollo, playing the *kithara*, a lyrelike musical instrument, in a chariot with two women; the four chariot horses move to the right toward the goddess Artemis, who holds a tame stag. On the other side of the vessel, the neck is covered with spirals arranged around a lotus flower, and on the central band two facing horses bracket a female head rendered in profile. This side was thus clearly the back of the vessel. All kinds of ornaments are scattered in the empty spaces. The vase was made in a workshop on the island of Melos or Paros, both of which were influenced by Attic vase painting and by the art of the East.

7 VASE, from Naxos. Shortly before the middle of the 7th century B.C. Height 82 cm. National Museum, Athens, No. 11708. Restored from large fragments; almost complete. This vessel, with its clear structure, and its severe, sparse ornament of horizontal stripes, is a late product of the Geometric style. The pictorial areas contained in the firm framework of lines show representations of animals, creatures of fable, and lions, which, in form and content, are derived from Oriental art and belong to the new, imaginative pictorial style of the 7th century. Nonetheless, these representations are designed strictly ornamentally, even symmetrically, and are firmly incorporated into the decoration of the whole; in this way, the vase achieves real unity.

8 GEOMETRIC AMPHORA, probably from the Kerameikos Cemetery, outside Athens. 1st quarter of the 8th century B.C. Height 51 cm. Antikensammlung, Munich, No. 6080. The vessel is entirely covered with ornaments. Above the foot are simple, black bands of glaze; above these is a frieze with geese, followed by a rich sequence of Geometric ornamental bands. The two strips of meander ornament, separated by a very carefully painted band of checkers spanning the vessel at the point of its greatest circumference, are predominant in the decoration. On the shoulder between the handles is a stylized row of reclining ibexes, with their heads turned back. On the neck of the vessel is a large pattern of meanders, and above these a band of grazing deer. The animals have no decisive role of their own, but are simply welded into the Geometric system of decoration.

accordingly. Beneath the vessel's lip, in broad, almost ceremonious narrative, the funerary procession from home to cemetery is shown. The bier on which the dead man lies rests on a four-wheeled hearse, drawn by two horses. Above him the long narrow shroud is represented carefully checkered and apparently floating. The rows of mourners are in black silhouette, the men with short swords at the hip. The band below shows a procession of warriors in their chariots; the knightly life of the whole age finds a splendid expression in this impressive scene.

In Greek vase painting of the 7th century, pure geometric design became subordinate to the figurative style that gradually emerged in the late Geometric period. Just as the Geometric style was developed most logically and fully in Attica, its gradual alteration and final transformation into the great Archaic figurative style was nowhere as clearly evident as in Attic pottery. The process lasted for two full generations, from the middle of the 8th to the end of the 7th century, when a definite figurative style was attained.

An amphora recently found in Eleusis, which has been reconstructed from numerous fragments (5), was fashioned during the middle of this period of transformation and birth. Both the size of the vessel and the aims explicit in its monumental figurative decoration demonstrate a trend toward composition on a large scale. The pictorial zones have expanded and overwhelmed the now modest geometric bands. The artist reveals a fine dramatic sense of pathos and narration in his depiction of the blinding of the one-eyed giant Polyphemos by Odysseus and his companions. How this scene must have captured the imagination of the men of that early and turbulent period! If the great amphora from Eleusis was made roughly in the decade 670–660 B.C., the smaller but still sizable vase from Melos, now in the National Museum in Athens, should be dated slightly later, in the middle of the century (6). The solemnity of the theme—the appearance of the sun god Apollo and his encounter with Artemis, goddess of the moon—perhaps explains the severity of the style; possibly, of course, the manner was simply natural to the artist. In any event, the pacing horses, the tapestrylike spread of figures and ornaments, and the stiff ceremonial of the depicted event are characterized by a calmness and rigor, sharply distinguished from the turbulence of the amphora from Eleusis, whose drama and violence seem to presage the great age of Greek theater. The solemn encounter of the gods on the Melian vase, on the other hand, brings to mind early Greek poetry.

During the Geometric period, the Aegean islands and Ionian cities had their own pottery workshops; but, by comparison with Athens, their development of the style was insignificant, their forms unimaginative. In the 7th century, however, rich and original pottery began to be made in all parts of Greece; indeed, never again were ceramic workshops so widely distributed in the Greek world, master craftsmen so numerous, and styles so colorful and

varied as in this century. One of the most delightful, and one of the earliest examples is the famous griffin jug from Aegina, now in the British Museum (*11*). The head of a griffin molded in imitation of metal models (see 39) is set on a high stiff neck, which in turn appears to be welded to the separately formed, spherical body of the vessel. This body is decorated with a strong, almost hard network of lines that isolates and emphasizes the animal forms shown within it. The jug bears witness to a thoroughly self-reliant style that developed in an island workshop, perhaps on Paros, in the early 7th century. The pictorial decoration on a vase from Naxos (*7*) has a much drier and severer effect; it strongly recalls Geometric decoration, although the vessel should probably be dated around the mid-7th century. An *oinochoe*, or wine jug, with trefoil mouth, found in Cumae, the Greek Kyme, an Ionian colony north of Naples, is decorated boldly and on a large scale (*10*). Judging by its style and manner of ornamentation, the vessel comes from Corinth. It is an example of the Proto-Corinthian style, and was made about 700 B.C. A later jug in the subsequent full Corinthian style, on which the animals and creatures of fable are arranged in a heraldic and rigid manner (*9*), belongs to the end of the 7th or the very early 6th century. It was exported to Rhodes and was found in one of the tombs excavated near the ancient city of Kameiros.

With the 6th century, more restful themes and a firmer style, which had been introduced during the last years of the 7th century, became established. The huge scale of early Archaic figural compositions was abandoned, or at least reduced. More concise and simpler forms took the place of profuse supplementary ornament and the sweeping lines of complex ornamental tangles. During this period a multiplicity of schools and workshops, of styles and personal approaches flourished. But Attica, and Athens particularly, assumed an even more decisive role in the production of pottery; it is therefore fitting that the creations of Attic workshops should be cited as examples of the richness and quality of Archaic Greek vase painting of this century.

The Attic style is as fragile and delicate as it is compact, lucid, and restrained. The chief technique used by Attic vase painters of this period (which came into general though not exclusive use at the end of the 7th century) is called black-figure, because lustrous black-glazed figures are silhouetted against the red clay surface of the vessels. Details were incised on the silhouettes—features, clothing, and ornaments—and touches of white and red were painted in to denote complexion and hair. The style is excellently exemplified by a bowl in the Louvre depicting the myth of Perseus and the Gorgons (*12*). The form of this vessel and its complex stand are a superb example of structure and design. The representation of the adventure of the Gorgons in the upper band of the vessel is the most beautiful part of the ornamentation of this ceramic masterpiece. Seventy years earlier this story had been illustrated in the exuberant, emotional language of the early 7th century (*5*). The exaggerated

size and the manner of presentation of the scene on the Eleusis amphora serve to emphasize the fine and delicate rendering of the same mythical drama on the Louvre vessel. How great is the contrast between this finely delineated, precisely and intellectually formulated presentation and the undisciplined and wild imagery of the earlier vessel!

We reach a climax of Attic vase painting in Archaic times with a cup (*13, 14*) by a black-figure artist who has been called the Xenokles Painter (names have been arbitrarily assigned to a number of clear-cut artistic personalities such as the Xenokles Painter on the basis of the subject or provenance of their most important work, a dedication they used, or a known association with a specific potter). Because this artist was not one of the greatest of the Archaic masters the achievements and skill of the epoch are well illustrated in his work. On the inside of the *kylix*, or drinking cup, is represented the struggle between the hero Herakles and the sea god Triton; they are encircled by the daughters of the Sea. The exterior of the cup is decorated with a chariot and two crouching sphinxes; the simple yet distinguished form of the cup renders this exterior decoration particularly effective.

The artist Oltos painted a running figure of Dionysos, god of wine, in the inside of another kylix with brushstrokes that are just as assured (*15*). The god hurries along, holding a huge drinking horn in his left hand, gathering his cloak with his right, and turning back his bearded head, wreathed with ivy; it is a splendid image, set, like a seal, into the center of a cup that was dedicated to the service of Dionysos.

The pictures gracing a lidded amphora from the workshop of the potter Amasis (*16*) belong to the period of the Dionysos kylix. In beautiful harmony and interdependence, vessel and decoration honor the god of wine and his gift. The manner in which the compact figures of the satyrs pressing out the grapes are adapted to the delicate silhouette style of the painter shows the accomplishment of this artist and of the highly developed black-figure style.

Exekias was one of the last Attic vase painters to explore the black-figure style. He was active during the third and early fourth quarter of the 6th century. Even though he loved detail—the pleated seams and the rich patterns and ornaments of garments—and even though he outlined his pictures sharply, not only faces, but also figures and objects, he was

9 EARLY CORINTHIAN JUG. c. 600 B.C. Height 29 cm. British Museum, London, No. A 1352. The elegant jug with its generous curve and handle with two discs attached near its upper end is an accurate imitation of a bronze vessel. Creatures of fable, painted with much imagination, face each other in two separate bands. The background is enlivened by scattered ornaments of stylized flowers. The neck of the jug is covered with black glaze.

10 PROTO-CORINTHIAN OINOCHOE WITH TREFOIL MOUTH, found at Cumae, Italy. c. 700 B.C. Height 33.4 cm. Museo Nazionale, Naples. The firm rounded body of the one-handled *oinochoe*, or wine jug, is covered by curling twisted bands, which give the impression of being abstract ornament and naturalistic motif at the same time. Except on the neck, every trace of Geometric restraint has been abandoned. The bands move around the curvature of the vessel freely and sweepingly, deliberately exploiting a new freedom of design.

11 GRIFFIN JUG, from Aegina. End of the 8th to beginning of the 7th century B.C. Height 41.6 cm. British Museum, London, No. A 547. 78.8/20.385. The date of this vessel, which is unique of its kind and presumably made in an island workshop, is disputed, but falls within the period between 725 and 675 B.C. Above the almost spherical body of the vessel is set a firm neck that ends in a griffin head with a wide-open beak. The lower part of the jug has plain ornaments with triangles framed by lines that end in curls, or volutes. Above is a pattern of plaits and a meander. On the shoulders are fields with lively animal scenes and, on the neck, decorative patterns. The vivid shape of this vessel reveals the predilection of the Archaic period for dramatic art.

12 DINOS, by the Gorgon Painter. Detail. c. 600 B.C. Height with stand 93 cm.; without stand 44 cm.; maximum diameter 30 cm. Louvre, Paris, No. E 874. This globular bowl, called a *dinos*, imitates metal vessels. The delicate style of the black-figure decoration is closely related to the work of the famous vase painter Sophilos; this piece was probably made in his workshop. The main pictorial ara shows the adventure of Perseus and the Gorgon. On the left is the chariot in which Athena arrived on the scene, with Hermes as her escort. Medusa, headless, is sinking down at the goddess's feet in a graceful ritualized attitude, and on her right, one of the terrible Gorgons runs away. The elegance of pose, the spirit, the rhythm of movement, and the sharp gestures, as well as the metallic precision of line, are characteristic of Attic vase painting.

13, 14 KYLIX, by the Xenokles Painter. c. 550 B.C. Height 17 cm., diameter 32 cm. Museo Nazionale, Tarquinia, Italy, No. RC 4194. On the inside of the cup is shown the wrestling match between Herakles and the sea god Triton. Herakles wished to force the god to reveal the secret way to the garden of the Hesperides. Along the rim sea goddesses, the Nereids, dance. A chariot, delicately painted, decorates the rim of the bowl with the utmost precision. The vessel is faultlessly and clearly structured; the convex curve of the lower part of the cup, balanced by the slightly concave curve of the edge, rises gracefully above the narrow foot and stem; the handles are confidently positioned in free space. Form and decoration are joined in lovely unity.

15 KYLIX, painted by Oltos. Mid-6th century B.C. Height 14.5 cm., diameter 33.5 cm. Antikensammlung, Munich, No. 2581. On the inside of the cup, Dionysos is represented running, with a drinking horn in his hand. The artist has found a spirited solution to the problem of filling a round space.

16 AMPHORA WITH LID, from the workshop of Amasis. c. 530 B.C. Height 34.7 cm. Martin-von-Wagner-Museum, Würzburg, No. 265. Satyrs, strong muscular fellows, are pressing grapes. One of them tramples on the fruit in a basket; from a flat inclined surface the juice flows into a large clay vessel (*pithos*) buried in the ground. On the left, a satyr pours wine from a jug (*hydria*) into another clay vessel half buried in the ground. The frieze above shows Dionysos sitting on a stool, surrounded by dancing maenads and styrs. The form of this globular amphora conveys something of Dionysiac contentment, and the satyrs are a wonderful embodiment of Dionysiac action. Their vitality is conveyed with great precision and conciseness. The brilliance and liveliness of the Archaic style are superbly illustrated by this black-figure vase.

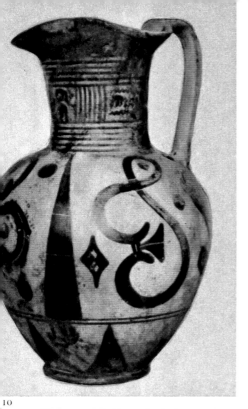

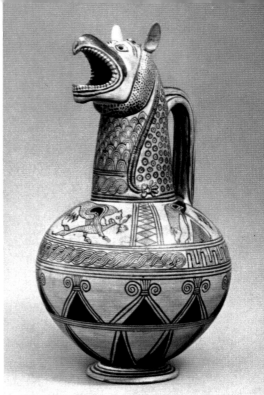

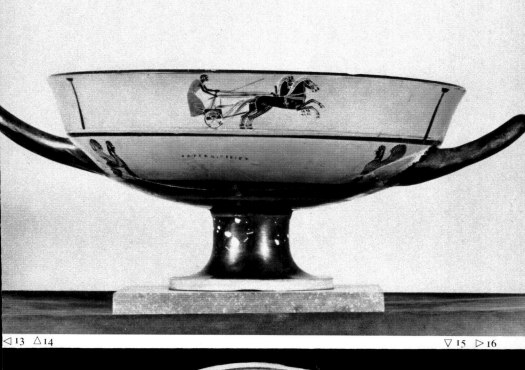

◁13 △14 ▽15 ▷16

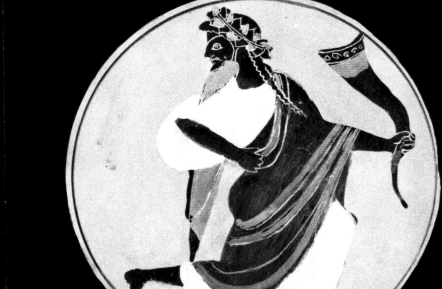

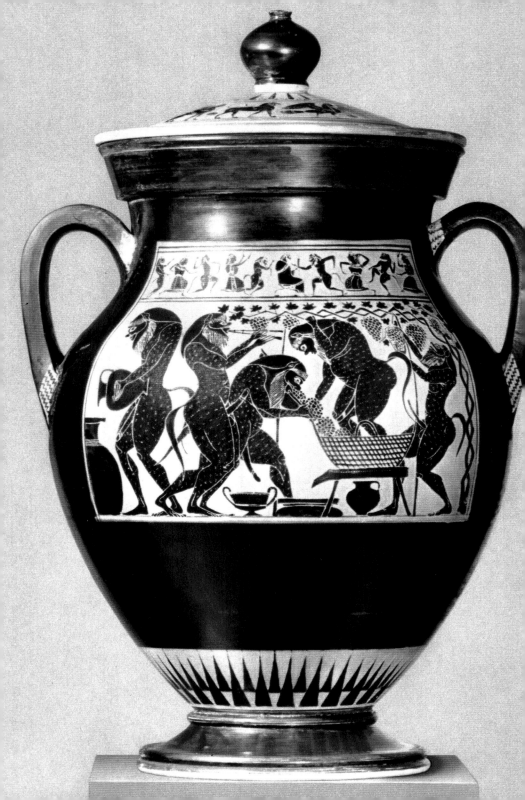

at the same time a painter of large forms and large figures. We not only have numerous vase paintings by him, small and large, delicate and expansive, but also several paintings on sizable clay plaques (47 × 37 cm.), on which are represented, in an elevated, serious style, mourning for the dead, funeral assemblies and processions. One of his most famous paintings is on an amphora in the Vatican (22). It represents Achilles and Ajax playing draughts. It is not known whether the great Archaic painter represented this famous scene for the first time or whether he simply defined it decisively. After the second half of the 6th century it was often shown on vases and perhaps even represented in sculpture. Exekias was able to give the scene a unique distinction and a quiet intensity that perfectly invokes the heroes, who, completely absorbed in their game, failed to hear the trumpet call and had to be called to combat against Troy by the goddess Athena. Exekias was a masterly portrayer of states of mind. His eminence as a draftsman is proved by his assured delineation and his love for detail. His greatness is displayed perhaps even more clearly by the generously conceived figures he created in the difficult, restrictive silhouette style.

Exekias was both potter and painter (we know this because he signed his work in two instances "Exekias decorated and made me"). A neck amphora in London is signed by him as potter only, but the painted figural representation and ornament reveal his characteristic conception and touch unmistakably. On the body of this broad, yet delicate vessel (23), Exekias painted the combat between Achilles, the hero of the Trojan War, and Penthesilea, queen of the Amazons, between fine spirals. The tale of battle, love, and death is caught at the climax; again, Exekias has chosen to represent a moment of arrested activity at the heart of conflict, thereby heightening its drama and pathos. The difference between the almost mannerized battle scene, on the one hand, and the simplicity of the board game, on the other, speaks for the versatility of this great master; it also illustrates the differentiation of manner that took place in the black-figure style at the end of the Archaic period.

About the time when Exekias was decorating the London amphora in his late style, a transformation of the art of painting was initiated in Athens as the figure style was introduced. On vases of this type, the figures are reserved within a background of black glaze, and the inner contours are painted on the red clay in black lines. The technique permitted a greater range of expressiveness in feature and gesture and a more accurate rendering of pose and anatomical detail. The change from one style to the other was brought about in the leading workshops of Athens during a very short period, in the last third of the 6th century. By 500 B.C., the new style with all its advantages and possibilities had achieved triumphal acceptance. In Athens, the old black-figure method was almost entirely discarded, except in retrogressive or conservative workshops. The vase painters of the new red-figure style gained a worldwide reputation for the city; their products defeated all rivals. Corinth

and Sikyon, Sparta, the island schools, and the Ionian East ceased production or drastically reduced their output. Gradually, the products of Attic workshops spread to the remotest countries of the civilized world. The Athenian monopoly was maintained for two centuries, until, in the course of the 4th century, production began to decline. One important variant of the black- and red-figure styles was the white-ground, which was employed from the 6th century onward. In this technique, a white background wash was laid down, and over it the figural or ornamental decoration was applied by incision or in lines of black glaze or, later, a variety of impermanent color washes.

Two Attic cups illustrated here (17, 18) from the early period of the red-figure style were painted by the vase painter Oltos, who was active in the last quarter of the 6th century; we have already seen an example of his work in black-figure (15). He was one of the pioneers of the new style and handled it with assurance and spirit. Both cups were made between 520 and 510 B.C. in the mature style of the master. By this time he had experimented with the new technique for over ten years and had come to handle it with complete mastery. On the kylix in Copenhagen (17) the ornaments are set into a glassy black background. The profile view of the kylix from the Vatican collections (18) illustrates the clear and foreful components of its structure. Above a disc-shaped foot a vertical shaft supports the curved, shallow body of the cup, from which handles jut out, rising a little above the upper rim of the cup. In this case, the potter as well as the painter signed the vessel. Such double signatures occur especially frequently in this early period of the red-figure style.

Euphronios and Euthymides, two of the most important Attic vase painters, helped to bring about the success and wide influence of the red-figure style. Subsequently, a pupil of Euthymides decisively influenced the new style and brought about its full development. He is still known as the Kleophrades Painter, although his proper name, Epiktetos, has been ascertained. A man of unusual talent and power of expression, the Kleophrades Painter had an individualistic temperament and, moreover, was very productive. Although he is certainly still linked to the early stage of red-figure vase painting and its repertoire of forms, his figures have impressive stature, bearing, and gestures that clearly differentiate his art from the delicate, ornate, often underdeveloped figures of his teacher Euthymides. Even though the Kleophrades Painter at first limited himself to the customarily defined pictorial area, he occasionally allowed his figures to overlap the framework, which is often dissected in a daring sweep (20). On later vessels by this artist there are figures that are freely conceived and placed in magnificent isolation; they stand on a groundline and spread over the whole vessel, even its shoulder and neck (26). The heavy bodies of the Kleophrades Painter's athletes and their broad, often clumsy gestures, differ—even those of the early 5th century—from the more concise representations of his contemporaries in Athens. It has therefore

been thought, with some justification, that he was of Peloponnesian origin. The activity of the Kleophrades Painter can be traced during at least three decades, from 510 to 480 B.C.; he painted almost all types of vases produced by Greek workshops.

The splendid Munich amphora by the Kleophrades Painter (*19, 20*), which belongs to his early period, treats on one side an old, much represented theme, the "farewell of the warrior" (*20*). Individual forms are still derived from late Archaic art, for instance, the richly pleated garments, the delicate, conventional manner in which the woman holds her cloak, the capricious spread of her fingers. Nonetheless, in their subtle contours and poise, in their action and gestures, the figures are filled with a new energy, a new presence. The gesture of the warrior who offers the bowl is broad and fluid; the woman bends forward with ease and shows her full absorption in the action of pouring. Even the dog shares in the new, seriousness of mood, the new richness of form. The solemn posture of the figures, the heavy, almost angular shape of the profiles, the generous flowing movements of the arms reflect the new and individual style of the Kleophrades Painter, which lifts him out of the late Archaic milieu and also differentiates him from his contemporaries of the transitional period. The other side of this amphora (*19*) shows the figures of two athletes and their trainer. The complicated pose of the young man on the right, who appears to be binding leather thongs on his wrist for a boxing match, balances the cleverly conceived if clumsily rendered back view of the athlete on the left. With a telling gesture of what is perhaps admonition the trainer turns to the young man on the left. None of the figures overlap each other, although the elbows of the two figures on the right almost touch. They stand in the ornamental framework of the picture like separate statues, like actors on a stage. Their gestures and movements are imbued with restraint and dignity. Each figure appears to be self-contained; yet a broad, common rhythm joins the three figures into a group.

The somewhat later amphora by the Kleophrades Painter depicting Achilles and Briseis possesses greater sharpness of design (*26*), although the pictures on the two pots are nonetheless stylistically related. It is difficult to say to what extent the new and restrained expressiveness of the Severe Style of the transitional period or the individuality of this master determined the character of his pictures. In the work of the Kleophrades Painter it appears that the mood is particularly closely related to the period of activity. Certainly, the figures of his mature works speak in a most moving way of the greatness and seriousness of the generation that lived in the years between the battles of Marathon and Salamis.

One of the most beautiful pictures of the mature red-figure style is the painting inside a kylix that bears on its foot the signature of the potter Sosias (*24*). The composition of this group showing Achilles and his friend and companion Patroklos is especially admirable, and the deep feeling that is expressed in the rendering of the scene, and its fine precision,

17 KYLIX, painted by Oltos. Detail. c. 520–10 B.C. Diameter 30.5 cm. National Museum, Copenhagen, No. 13407. Underneath the body of the cup and beside the handles are palmettes enclosed in tendrils of vine. The combination of deliberation and freedom in their arrangement calls to mind a musical composition. Scenes in the red-figure style appear in the center of the cup and on its wide raised rim. On the rim, a bearded satyr moves toward the right, and a centaur toward the left.

18 KYLIX, painted by Oltos. c. 520 B.C. Diameter 31.8 cm. Vatican, Rome, vase collection, No. 16516. This Attic cup belongs to the period of transition from black- to red-figure painting and combines both techniques. Inside is shown a running Dionysos, similar to the figure in the cup in Munich (15) in the black-figure style. On the outside, the cup is painted in red-figure. Both Oltos, the painter, and Kachrylion, the potter, signed their names on the vessel. On the sides, next to the handle, are full, almost fleshy palmette ornaments; next in sequence comes a great pair of eyes (intended to ward off evil) which take up the greater part of the bowl of the cup; in the center is the small, delicate figure of an armored foot-lancer, a hoplite. Crouching down, he moves stealthily away to the left, his shield with the device of a bird on his arm. The small, light-colored figure is enlivened by a few contours.

19, 20 AMPHORA WITH LID, by the Kleophrades Painter. End of the 6th to the beginning of the 5th century B.C. Height with lid 76 cm.; height without lid 65.3 cm. Antikensammlung, Munich, No. 2305. This vessel has an exceptionally beautiful form. Above the heavy stepped foot the egg-shaped body unfolds; the transition from the body of the amphora to its broad, strong neck is made without any interruption. Above, the rim, forming a sharp horizontal edge, protrudes like a shelf, and its slanted surface is covered with a frieze that shows mounted hunters and their prey in very delicate black-figure silhouette. The slightly rounded lid is crowned by a knob in the form of a pomegranate. The central picture on one side shows a trainer, with two athletes (19); on the other side a warrior's departure from home is depicted (20). The heavy form of the amphora is balanced by the broad, well-separated figures, the deliberate, rhythmically repetitive seams of the garments, and the generous profiles.

21 WHITE-GROUND CUP, by the Brygos Painter. c. 490 B.C. Height 14.4 cm., diameter 28.5 cm. Antikensammlung, Munich, No. 2645. The wild movement of the maenad is enclosed by the circular rim of the cup. The shaft of her staff, or *thyrsos*, held diagonally in her right hand, divides the circle into approximately equal halves. The pointed ends of the cloak and the folds of the garment beneath, rendered by close parallel brushstrokes, almost push the figure away from the edge, reinforce its movement, and give clear rhythm to the lower half of the composition. In the upper half, the head, surrounded by flying hair in which a snake is coiled, strikes the determining rhythmic note.

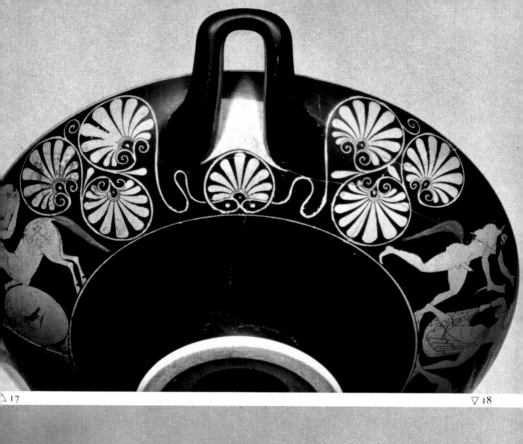

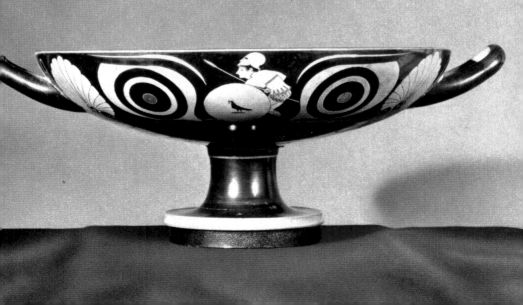

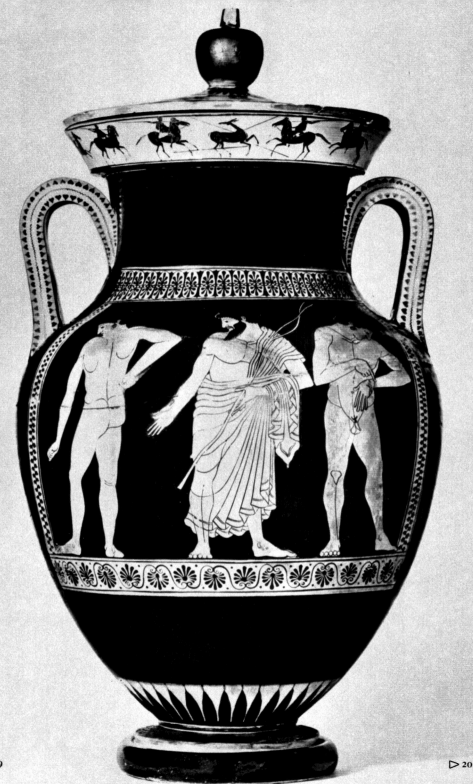

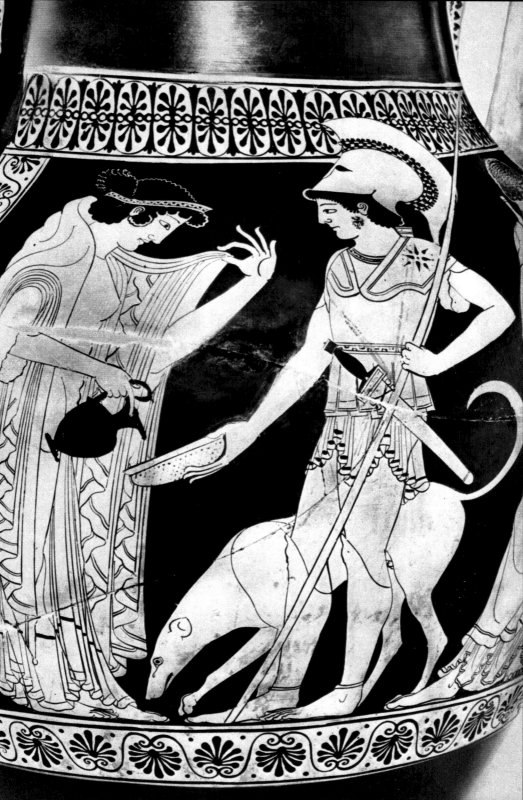

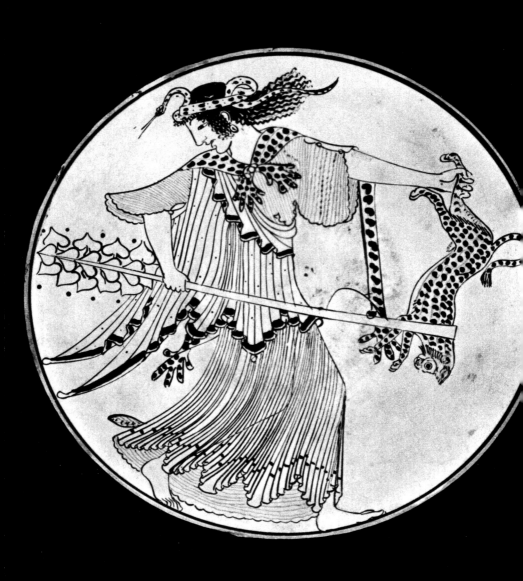

are quite extraordinary. Such a bold and masterly arrangement is rarely to be found, even in works of the late 6th century, a period that was so richly endowed with artists of talent. The profoundly human tone in which better pain and living care are allowed to speak—in spite of some awkwardness in the expression—augur those great dramatic statements about human suffering uttered a generation later in Classical art of the 5th century.

In the studio of a potter named Brygos worked an important artist, whose style and mannerisms can be found on more than 150 vessels, mainly cups. If Epiktetos, the Kleophrades Painter, had a powerful temperament that was matched by an equally powerful expressive gift, the Brygos Painter, a representative of the Classical period of red-figure painting, never lost his power of expression, despite the moderation and discipline of his style. A somewhat younger contemporary of the Kleophrades Painter, he worked in the first two decades of the 5th century. A white-ground cup in Munich (*21*) gives a good impression of his art and character. The theme is one of ecstasy and passion. Caught up in a god-inspired frenzy, a votary of Dionysos passes by in a wild turmoil of movement. In her left hand the maenad grasps a young panther by its hind leg. Her right hand holds a *thyrsos*, a reed with ivy at the top, the shaft directed toward the right, as if for a thrust. Instead of a fillet, a snake is wound round her hair; its head is extended far over her forehead, and its tail coils toward the back amid a mass of hair. Despite her barbaric wildness and passion, the maenad is dressed richly, almost conventionally, in a costume similar to that worn by the delicate sculptured *kore* from the Acropolis (see *56*). A long garment called a *chiton*, with knotted sleeves, falls to her feet; in front, the hem of the garment is draped in a regular zigzag pattern, while the back ripples gently. A short cloak is tied over her right shoulder and falls diagonally. Two ends, strictly stylized, fly backward under the force of her movement. Below her neck the maenad also wears a knotted panther-skin which hangs down behind. Two paws lie on her breast, two more hang down at the sides. The tip of the tail appears at the bottom left corner, behind her flying garment. The frenzied movement is beautifully contained within the round shape of the cup. It was painted at the height of the career of the Brygos Painter, about 490 B.C.

We are indebted to the same distinguished and productive painter and potter for another vessel with an arresting form. It is a *psykter*, a jar used for cooling wine (*25*). The picture shows the poetess Sappho and poet Alkaios, who were both from Lesbos and lived during the late 7th century. They have been linked in a story that tells of the passionate love of Alkaios and the severe response of the poetess: "If you desired what was good and noble, and your tongue had not spoken evil, shame would not fill your eyes, but you would be speaking about what is right." Seeing the poet absorbed in his song and in his love, and the woman turning toward him, one can almost hear their legendary dialogue. For perhaps

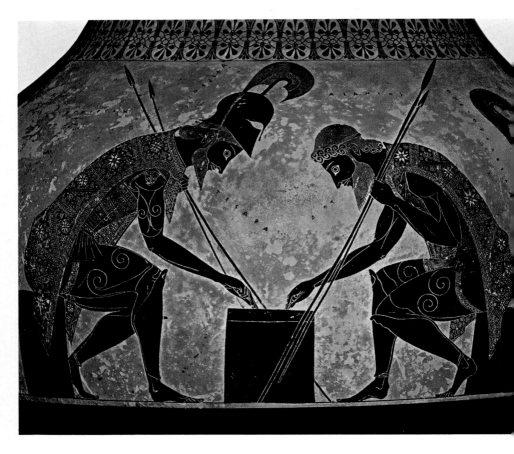

22 AMPHORA, by Exekias. Found at Vulci. Detail. c. 540–30 B.C. Height 67 cm. Vatican, Rome, vase collection, No. 16757. The vessel has been reconstructed from large fragments, and there are no major restorations. Exekias, one of the greatest masters of late Archaic art, has signed this vessel both as potter and painter. The scene is outlined with precise strokes. The Greek commanders Achilles and Ajax are shown playing draughts in the camp before Troy. Seen in pure profile, sitting on stools at the very front of the picture, the two heroes, dressed in richly ornamented cloaks, are entirely absorbed in the game, set up on a small square table. In this mature work of the black-figure style, Exekias with a minimum of means expresses the deep interest of the two heroes in their game, in which Achilles was the winner and Ajax the loser.

23 AMPHORA, by Exekias. Found at Vulci. c. 525 B.C. Height 41.3 cm. British Museum, London, No. B 210. The vase was reconstructed from large fragments, without major restorations. On the neck is a double band of palmettes and lotus flowers. On the lower half of the vessel, three rows of ornaments are disposed above each other—a circle of rays, a key meander, and stylized buds. On the rounded part of the vessel is the combat between Achilles and Penthesilea, queen of the Amazons. The style is severe and uncompromising, the contours sharp. The black body of Achilles and the white one of Penthesilea are clearly contrasted, yet, at the same time, skillfully intertwined. On the other side of this mature Archaic vessel is shown Dionysos, whose son Oinopion pours out wine for him.

42

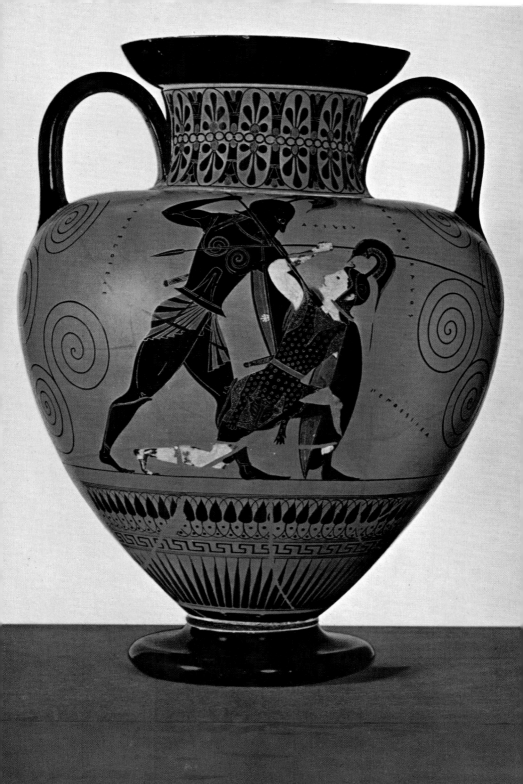

24 KYLIX, by the Sosias Painter. Detail. c. 500 B.C. Diameter 32 cm. Staatliche Museen, Berlin, No. F 2278. The picture inside the cup shows the heroes Achilles and Patroklos. Even though they appear in full armor—both wearing corselets, Achilles has a heavy helmet on his head, and Patroklos is seated on a round shield—the scene represented is very human, even tender. Achilles puts a bandage on the wounded arm of his friend. While Achilles is absorbed in his task, Patroklos, tormented by pain, sharply turns his head to one side, and grits his teeth, which are indicated in white. The left shoulder pad of his armor has been undone and rises up behind his shoulder. All the resources of the new red-figure technique are freely and expertly used. The highly elaborate lines inside the contours of the figures, a late Archaic characteristic still in use, give the picture the effect of an engraving.

25 PSYKETER, by the Brygos Painter. c. 480 B.C. Height 53 cm. Antikensammlung, Munich, No. 2416. This vessel, in the form of a woven basket, or *kalathos*, served as a wine cooler. The vase painter turned its high bucketlike shape to splendid advantage. On the wall of the cylinder is shown an encounter between the poets Sappho and Alkaios. The two tall figures are beautifully displayed on the vertical side of the vessel. The simple profile view of the man in balanced by the complex movement of the woman. Interrupting her walk, she turns about, so that the upper part of her body is seen frontally, but head and face appear in a bold three-quarter profile. This elegant composition is characterized by deep feeling and restrained emotion.

26 AMPHORA, by the Kleophrades Painter. c. 480 B.C. Height 44 cm. Private collection, Riehen, Switzerland. The heart-shaped oval form of the vessel, with its sharply turned neck (which is, however, not offset from the body) and steep attached handles, resembles the Panathenaic amphoras, which were given as prizes at the Panathenaic games. On the two opposite sides of the vessel are juxtaposed two figures—Achilles, who is shown here, and his beloved Briseis. The viewer would have connected the two separate figures by turning the vessel. The drama of the story of these two individuals, as here represented, has no tragic overtones.

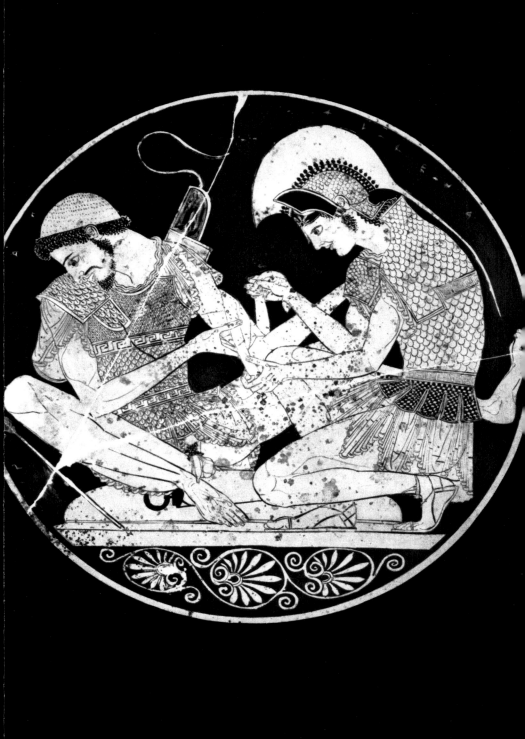

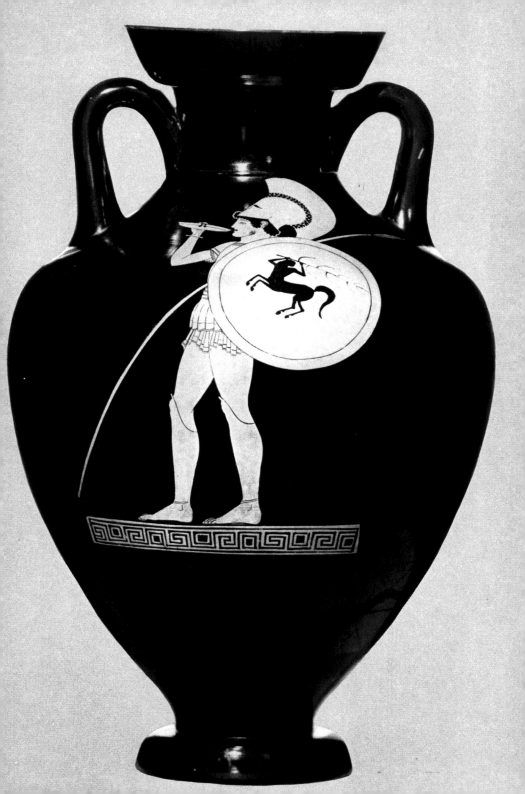

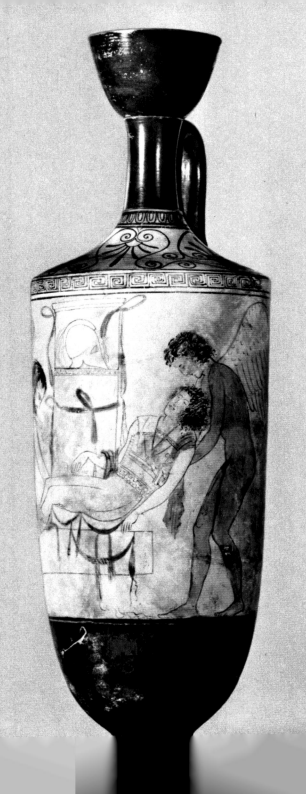

the first time a scene filled with spiritual and psychological tension has been successfully attempted, the like of which is not to be found in earlier Greek art or in the art of the East.

From this time, and throughout the course of the 5th century, we encounter again and again the evocation of moods and states of mind. This holds true in particular for the paintings on vessels used in the cult of the dead. For such representations a particular form of vase and decoration was chosen: the tall one-handled, narrow-necked oil jug called a *lekythos*, painted in white-ground technique. In the course of time, such funerary lekythoi become larger and their decoration more elaborate.

The muse painted by the Achilles Painter on a white-ground lekythos is absorbed in a deep reverie as she plays her lyre (*29*). The vermilion color of her cloak balances the soft yellow of the chiton underneath. Below the seat, lightly sketched in, is written the word "Helikon," to indicate that she is one of the inhabitants of the mountain of the muses. Listening to the strains of her own song, she is the embodiment of the otherworldly, intellectual existence found in the Greek afterlife in Elysium, and so brings comfort to the bereved.

With this scene of the life of the soul on the mountain of the muses, we have reached the flowering of high Classical white-ground vase painting, in the period when the Parthenon was built. (Toward the end of the century, lekythoi in particular, but other types of vases as

27 WHITE-GROUND LEKYTHOS, by the Thanatos Painter. c.440 B.C. Height 48.9 cm. British Museum, London, No. D. 58. In the center of the picture is a plaque decorated with red ribbons, on which a helmet is drawn. The god of sleep, on the left, and death, on the right, carry a fallen young warrior. His face is shown in three-quarter view. The composition displays the restraint and control of form and content that are characteristic of mature Classical work.

28 WHITE-GROUND LEKYTHOS, by the Phiale Painter. Detail. Found at Oropos, northeast of Athens. c.440 B.C. Height 36 cm. Antikensammlung, Munich, No. 2797. The vessel is decorated in the mature Classical style and was destined for use as a funeral monument. A free,

rapid drawing shows Hermes as guide of souls, seated on a rock. In front of him stands a young woman whom he will conduct into Hades.

29 WHITE-GROUND LEKYTHOS, by the Achilles Painter. Detail. c.440 B.C. Height 36.7 cm. Antikensammlung, Munich, Collection H. von Schoen, No. 80. Opposite the seated muse, on the other side of the vessel, is a standing woman, probably also a muse. The profound solitude and remoteness of Mount Helikon illustrated on this funerary vessel mirrors an Elysian beyond. It is an example of the high Classical maturity of white-ground vase painting.

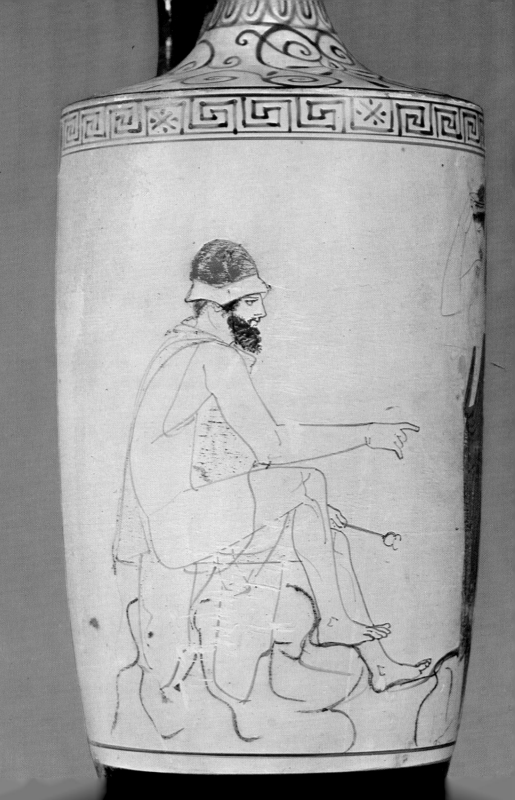

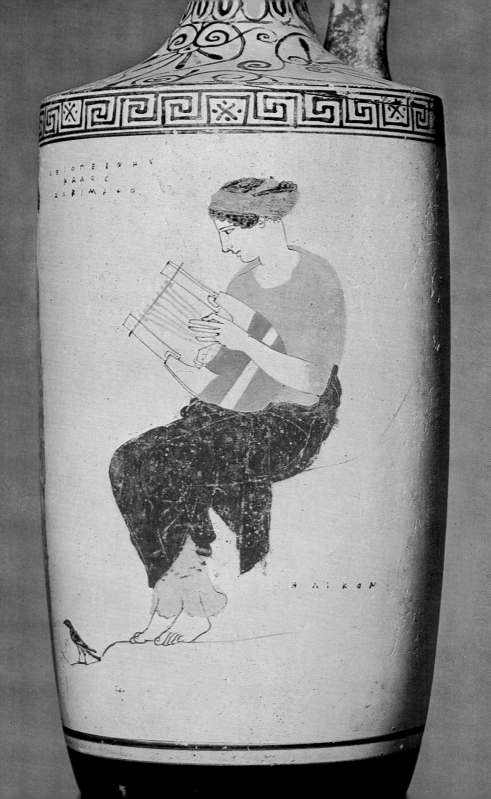

30 CALYX KRATER, by Polygnotos, the vase painter. Found at Spina. c. 420 B.C. Height 54.8 cm.; diameter at the rim 53 cm. Museo Nazionale di Spina, Ferrara, No. T. 300. The height and width of this beautiful krater are almost equal; its proportions are bold and strong. The shape of the body and the handles attached to the lower part of the vessel make the term *calyx* a particularly appropriate designation for this krater type. The representation of the Battle between the Gods and Giants is vivacious and complex and can be viewed from many angles. Expressive and rich late 5th-century style.

31, 32 AMPHORA WITH TWISTED HANDLES, painted in the manner of Meidias. c. 410 B.C. Height 54 cm. Museo Civico, Arezzo, No. 1460. The form of the vessel is compact, even severe. Above the heavy stepped foot is a narrow disc with a concave profile, from which the steep sides of the vase rise. The shoulder is sharply turned, almost horizontal. The twisted handles are stiffly bent in toward the neck. The rim is carefully decorated, and its sharp profile imitates metal forms. Driven by a team of four horses, which the sea god Poseidon had presented to him, the hero Pelops skims over the sea (indicated by a dolphin on the right, in front of the horses). Above a branch of the little tree behind him are two doves mating. Pelops appears to look back at his pursuers, but his bride, Hippodameia, looks majestically forward into the distance. Highly decorated, lively late 5th-century style.

33 FRAGMENT OF A VOLUTE KRATER, found at Spina. End of the 5th century B.C. Measurements of the surviving fragment: height 33 cm.; width 22 cm. Museo Nazionale di Spina, Ferrara, No. T. 404. Several large fragments of this stately krater survive, and they bear the remains of a picture with large figures. A royal personage seated at the left presumably represents King Pelias of Iolkos; a female figure who stands before him and with outstreched arm places a wreath on the brow of a young man is probably Athena. An inscription on the krater identifies the young man as Polydeukes, who overcame the Bithynian king Amykos in boxing. The figure is executed in a broad forceful style, the lines of the profile are sensitive, and the glance open. This fragment seems to reflect a painting of large format. The style is indebted to the mature Classical tradition.

52

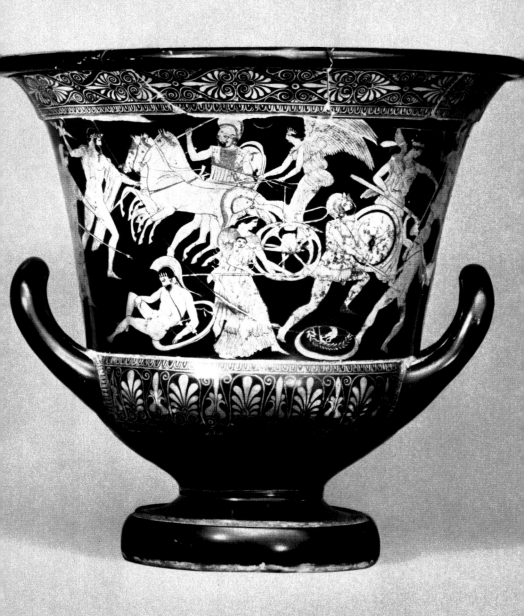

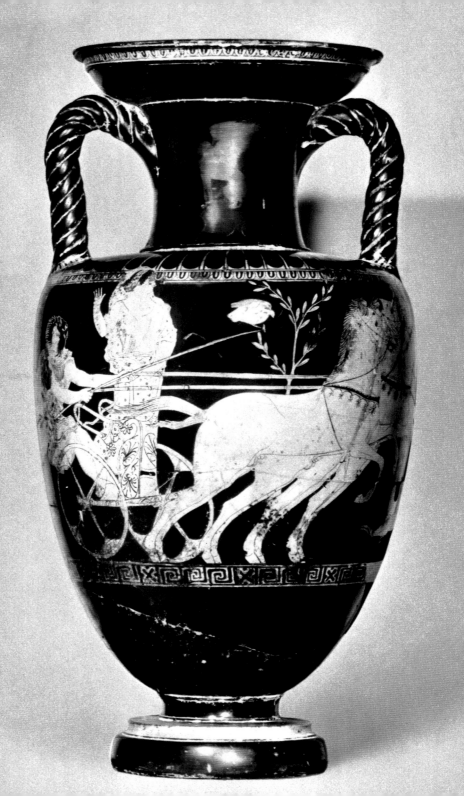

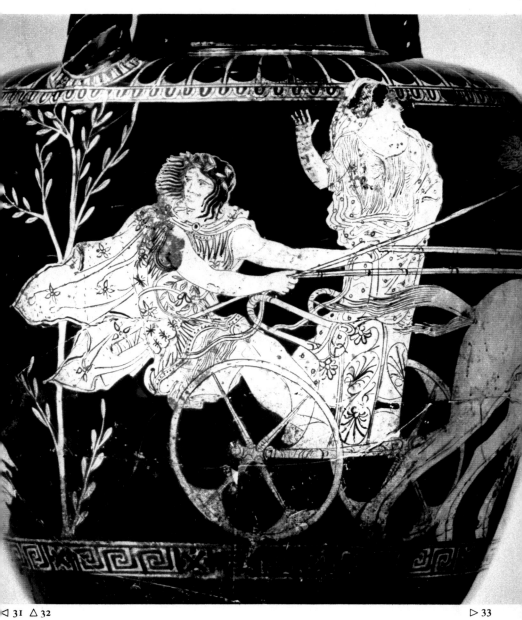

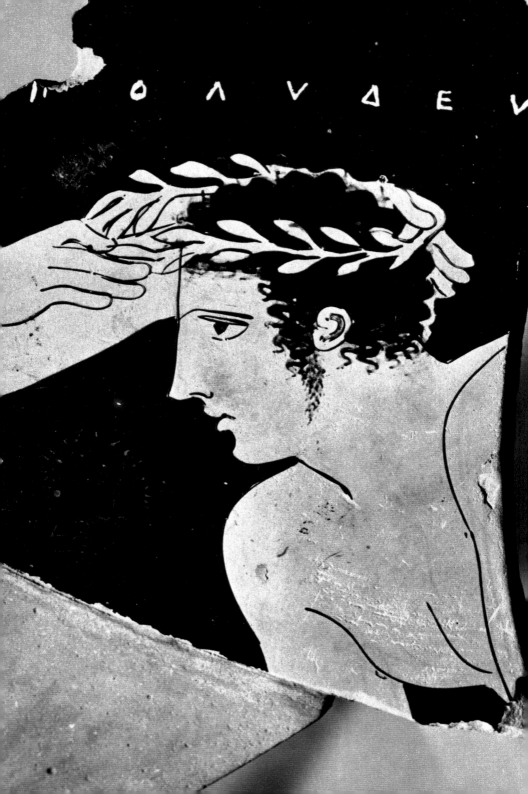

well, underwent development in the direction of ever richer and ever more refined forms.) On white-ground funerary lekythoi the world of the dead and its rites, indeed the whole world of the beyond, speaks in a sublime language. Real and visionary figures, the living and the dead, meet each other at the grave as at a frontier post. The cruel demons and sphinxes were discarded or transformed into beautiful, exquisite figures.

On a white-ground lekythos by the Thanatos Painter, which also dates from the years around 440 B.C., Sleep and Death, Hypnos and Thanatos, are shown in their silent occupations (27). They carry a young warrior, still wearing his armor from the battlefield, and they will gently lay him down at the side of his grave. The tomb is depicted in detail, for it will bear witness to the heroic death of its occupant. Above a high step rises a stone plaque, on which, above a horizontal strip of ornament, appears a large Corinthian helmet in delicate outline. The helmet, lost in battle, is commemorated forever on the tomb of the young man whose curly head now rests on the breast of Hypnos.

A picture by the Phiale Painter, showing Hermes, the guide of souls to the underworld, seated on a rock, was painted at the same time and in the same manner (28). His lowered left hand, resting on his knee, holds a herald's staff. His right hand is raised and the lower arm is held above the slightly lifted right leg as he gives directions to a young woman, who presses a diadem down on her hair. She prepares for her voyage into Hades, on which Hermes will accompany her as a silent guide. The figure of the seated god is shown in pure profile; the limbs, however, are carefully disposed in a beautiful flowing language of contours. Because of weathering, the delicate pastel coloring has almost vanished; there remains only the fine network of reddish-yellow lines that outline and construct the body. Hair and beard are painted dark brown; the top part of the cap is rendered in a reddish tint, probably to indicate that it is made of fur. The rock is outlined in bold black; these lines are clearly differentiated from other reddish lines, representing a garment that has been spread out over the rock. Two of its wide ends, the tips marked by little crosses, hang down next to each other. The garment probably is a large cloak. Apart from the two figures—the woman preparing for her last journey and the god, who, calmly waiting, encourages and instructs—the artist has depicted, behind the woman, her grave monument, rising above some steps. It has rightly been remarked that in this scene there is really no unity of place or time. The god is sitting on the banks of the river Acheron in the underworld; the woman adorning herself is at home; and the tomb is in the cemetery outside the city gates. But the imagination easily links the three aspects of the scene together. The god speaks to the woman calmly and urgently; she adjusts her hair as she once did in life. Such delicacy of allusion, subtlety, and succinctness are characteristic of the art of the short period known as the high Classical age.

By about 430 B.C., the fine sense of order, simplicity of contour, and clear positioning of figures in space began to weaken, but, particularly at the end of the century, this tendency was often disguised by an exuberant heightening of expression, which seems very much out of keeping with the terrible events of these years in which the Peloponnesian Wars came to an end. Its horrors notwithstanding, this period produced great artists, who were able to create an accomplished and complicated style, perhaps in an attempt to escape from the suffering around them. Among such artists was the painter of a radiant representation of a wedding journey on an amphora with twisted handles in Arezzo (*31, 32*). The main band is filled by four racing chariot horses and by two figures in the chariot. Their names are inscribed: Pelops and Hippodameia. The young hero, leaning far back, hangs on the reins, while his bride stands upright indicating either surprise or alarm with her raised right hand. The garments are abundantly ornamented with embroidered patterns, the chariot is decorated with palmettes and rosettes. Pelops wears a wreath of laurel or olive twigs. His head is turned back—for he is looking in the direction of their pursuers—and his hair flutters violently, as does his cloak, which billows even farther back into space behind. The effect of speed is rendered with great mastery. An artist connected with the great vase painter Meidias created this stirring scene around 410 B.C.

About the same time, though a little earlier, Polygnotos (not the famous painter of large murals who was active in Athens in the middle of the century, but a skillful vase painter of the same name) represented the great battle between gods and giants on a vessel of a type called a *calyx krater* (*30*). This powerful theme occupied Greek poets and representative artists for centuries. Phidias represented it in relief on the east metopes of the Parthenon and in a painting on the inside of the shield of Athena Parthenos. This last composition, a circular painting about 4 meters in diameter, which must have been completed by the time of the erection of the statue of Athena Parthenos in 438, influenced the representation of the theme until the end of the 5th century.

A wonderful volute krater in Tarentum (*23–36*) brings us to the end of the century and leads us away from Greece and Athens, the most productive center of red-figure vase painting. It belongs to the group of vases made by Greek colonists in southern Italy. These craftsmen were either vase painters from Greece who ran workshops in the colonies or residents who founded workshops in order to paint in the Attic manner. The Tarentine vase painter of the illustrated volute krater had a masterly command of the methods of the rich late 5th-century style and could certainly rival contemporary Athenian craftsmen. The rendering of certain details—necklaces, pendants, belts, and shoes—in a diluted color, and the consequent achievement of a delicate sculptured effect, should be noted as it was of great importance for the development of technique in the future.

58

A fragment of a volute krater from Spina shows a young man bending his head to receive an olive wreath from a female figure, which is partly preserved on a connecting fragment (33). The style is still in the tradition of the great vase painters of the mature Classical age; the artist was perhaps a member of the school of a vase painter such as Polygnotos. The fine flowing movement of the hands, of the woman who sets the wreath on the head of the young man, lightly pressing it down with her fingers, resemble gestures on the Attic funerary reliefs of the late 5th century. The slightly open mouth of the young man, and his significant and expressive gaze, announce the new achievements in the portrayal of states of mind and moods made in monumental painting of this period.

Finally, a beautiful, completely preserved bronze volute krater (37) will serve to illustrate the type of work that served as a model for ceramic vessels. The bronze krater comes from southern Italy. It was probably first used at banquets and later followed its owner, some great lord, into his tomb. This splendid vessel was made in the early 5th century. A comparison between it and its ceramic counterparts makes clear with what mastery Attic potters imitated metal models, while at the same time taking advantage of painted decoration offered by the clay medium.

In the 4th century, numerous workshops still practiced the red-figure style, developing its potential and spreading it farther and farther afield. They were to be found in Athens, and —especially in the second half of the century—in the numerous Greek cities of southern Italy and Sicily. In this area especially, but also in northern Italy, Greek pottery found a wide market; the vessels that have come down to us here almost always come from tombs and were probably made solely for funerary use. In the late 4th century, important painters were still to be found decorating pottery; they were masters of the brush and created elaborate compositions in a stately and luscious style. However, the sophisticated demands of the period gradually exhausted the possibilities of this branch of art, and the great achievements in the field of panel and mural painting led to the decline and disappearance of vase painting. With the end of the 4th century B.C., this art, rich in tradition, fell into disuse both in Athens, the city of its most glorious development, and in the many places in southern Italy and Sicily in which it had flourished.

34-36 VOLUTE KRATER. Late 5th century B.C. Height 72 cm. Museo Nazionale, Tarentum, No. 4358. This is one of the most significant products of South Italian vase painting, which had developed under the influence of Athenian vase painting. The main side of this handsome krater with volute-ended handles shows Dionysos, enthroned on a rock (36). In his right hand, he holds a five-pronged scepter, which is visible behind his head. The head of the young beardless god is adorned with a broad fillet, which is decorated with a pattern of palmettes and lotus flowers. The high-laced boots, with long tongues emerging from the top, are carefully drawn. The capricious style, which tends toward mannerism, in the rendering of the garmments, for example, is also the instrument of a highly realistic, arresting kind of representation. An example of its most successful application is the maenad who with cheeks extended plays a double flute (34). She wears a scarf wound round her head, a necklace with various kinds of pendants, long earrings, and, on each arm, a gold bracelet in the form of a twisted snake. The figure of Dionysos, seated in a relaxed pose and watching the procedings, remains in the high Classical tradition; the other figures, however—the two maenads on the left, Artemis, who holds out a torch over Dionysos, and the satyr beside her, display both the mannered extremism and the elegance of late-5th century vase painting.

37 VOLUTE KRATER. Early 5th century B.C. Bronze. Height 64 cm. Antikensammlung, Munich. This well-preserved vessel for mixing wine and water is a superb example of Classical metalwork. It was probably made in an Etruscan workshop but closely follows Ionian models. The body of the vessel and the foot, which curves outward, are chased; foot and shoulder are decorated with bands of elongated leaves. The decorations of the rim, however, and of the elaborately designed handles are cast. The steeply rising volute handles are set on supports in the form of Gorgons, which rest firmly on the body of the vessel. The Gorgons have snake legs and are covered with scales. The firm outlines of the sides of the vessel strike the onlooker as a premonition of high Classical art; the representation of the Gorgons, on the other hand, is an echo of the Archaic period.

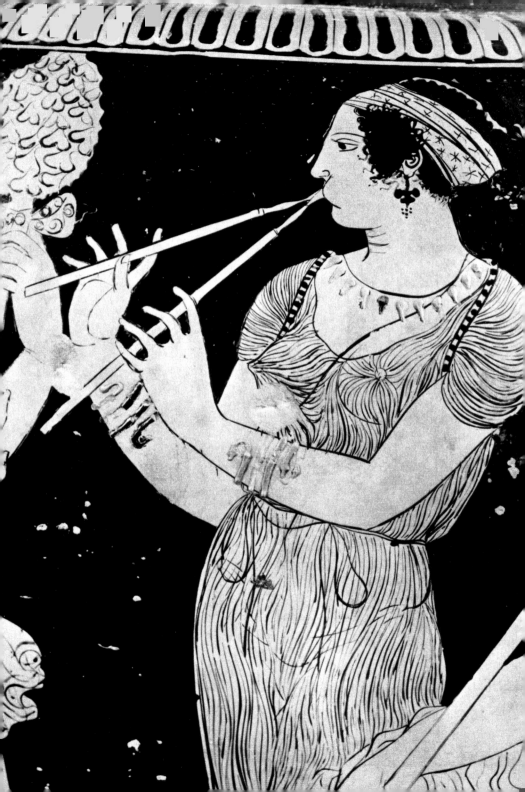

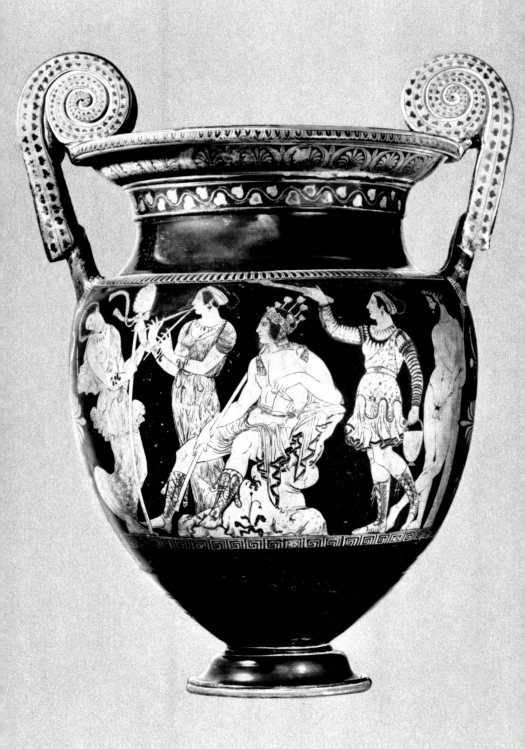

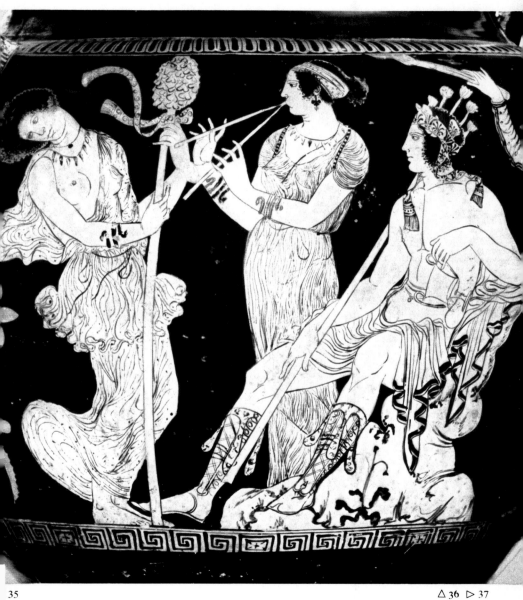

SCULPTURE

The origins of monumental Greek sculpture lie in the middle of the 7th century B.C., although no exact date or corroboration in the form of historical or literary sources can be given. Prior to about 650 B.C., sculptural images were constructed in Greece, but these were generally made of wood and were small in size. Subsequently, stimulus from the East —particularly Egypt and Mesopotamia—prompted the Greeks to attempt the production of large figures in stone and to develop a sculptural style of their own.

Inspiration from the East notwithstanding, life-size Greek sculpture was not, even initially, the product of blind imitation, for although the earliest statues of standing nude youths, the so-called *kouroi*, do clearly resemble Eastern, and especially Egyptian types, they are no less clearly independent, and thoroughly Greek creations in several important respects. These did not even represent something entirely new in Greek art, for, in the various arts of the Geometric period, we can detect the growth of artistic concepts and techniques that contributed to the abrupt appearance of sculpture of large dimensions. The gradual development and application of the latter can initially be traced in the Geometric pottery of the 10th to the 8th centuries, but in the later Geometric period, in the 9th and 8th centuries, they can also be observed in objects that, despite their small size, reveal the Greeks' capacity for producing sculptural form. This capacity, though restrained by the formulas of Geometric taste and expression, and tied to the modest dimensions of the minor arts, could and did in a very short time complete the step into monumental art.

The numerous small Geometric sculptures of bronze and clay that have become known, thanks to excavations of sanctuaries and tombs, very often represent animals. A small representation of a cow or a ram was a more lasting votive offering to a divinity than an actual living victim. Horses had a deeper religious importance, which can be traced directly to the worship of Poseidon and Athena and may be supposed to have existed in connection

with other divinities; and horses make frequent appearance as votive sculptures. Despite its small size, the little Geometric bronze horse in Berlin, which probably comes from Olympia, is a real work of art (*38*). The almost abstract quality of its contours, the powerful contrast between flat areas, such as the neck and the lower part of the thighs, and roundly modeled areas, such as the upper thighs and the tubular head, and the sharp, beautifully calculated accents of the knees, genitals, and nose, all serve to make the little horse a most expressive work of art. It dates from the last phase of the Geometric age, the second half of the 8th century, and impressively demonstrates the sculptural ability of artists of this period.

The bronze head of a griffin from Olympia (*39*) brings us into the period of the birth of monumental Greek sculpture, the middle of the 7th century. Every line, every contour, every curvature of this superb work bears witness to the imagination and skill of its creator. However, this eminently sculptural piece is not an independent work in its own right. Together with other heads of its kind, it formed part of the decoration of a large bronze cauldron, protruding from the sides with outstretched neck. Probably six such heads rose from the upper part of the vessel, which was curved inward. Especially in profile view, the head shows that a craftsman was capable of creating a real work of art. If this single surviving representation of a griffin produces so profound an effect of demonic power, how much greater must have been the impression made by a ring of such magical animal heads! The griffin head from Olympia was cast when important schools of art were developing in different parts of Greece.

The bronze statuette of a man carrying a ram on his shoulders, also in Berlin, is a work of free sculpture in its own right (*40, 41*). The figure stands before us in full and firm plasticity. The particular style of the statuette confirms that it comes from Crete, which was at that time held by Dorian Greeks from the mainland, and is revealed in the compact forms, the sturdy proportions, and the bold interrelation between man and animal. The muscular, athletic frame of the man, with his heavy, chiseled head pressed forward by the weight of the animal, expresses convincingly the strenuous action of carrying a sacrificial victim to the altar. Three quarters of a century later, the same type of composition was attempted and better resolved by the Attic sculptor who made the famous Calf-Bearer (*44*). The theme is rendered much more spontaneously and freely, and with greater artistic control. Nevertheless, despite its crudeness, the figure from Crete exemplifies an initial breakthrough to a work that is sculpturally conceived; the lively forcefulness of its shape and details are admirable. Although the figure of the man with the ram is small, the ability of the sculptor who formed it is clearly demonstrated in the work.

The highly innovative attempt to render the human figure in a monumental format was made in many different parts of the Greek world after the second half of the 7th century.

Youths (*kouroi*) were represented nude, standing with one foot forward, arms at the sides (very much like Egyptian monumental statues of dignitaries). Female figures (*korai*) were similarly posed but consistently draped. Seated figures of both sexes were also popular. One of the best-preserved examples of the early statues of young men is a kouros in the Metropolitan Museum of Art in New York (*42, 43*). Nearly 2 meters (6½ feet) tall, this kouros is by no means the largest among this new group of statues, some of which were 3, 4, even 9 meters high. Such colossal proportions, which predominated in the early period and which in the course of the 6th century were replaced by life-size or slightly over life-size proportions, were probably inspired by Eastern models, particularly the huge figures of Egyptian art, but also were the expression of a creative power, which, suddenly unconfined, discharged itself in exuberant excess.

Beyond its size, the Archaic kouros owed a number of its specific characteristics to Oriental and Egyptian models. Among these are strict frontality, the advancing left foot, and the firm adherence of the hands to the upper part of the thigh. However, the nudity of these early statues of young men was foreign to the East, as was the boldness with which the Greek sculptors allowed the figures to stand freely, without a support in the back or a prop of any kind. Finally, these Greek statues were rendered with a novel idealization; portrait statues were important in Egypt, but Greek sculpture of the Archaic period does not seem to reflect the features and characteristics of individuals. Thus, despite many links with older cultures and art forms, even these earliest representations bear witness to the freedom of the Greek mind.

With the stone Calf-Bearer, which once stood as a votive offering on the Acropolis of Athens, we enter the 6th century (*44*). The theme of the group is an old one, here rendered by an Attic artist in a calm and noble manner. The image represents a country nobleman who has ascended the Acropolis in order to offer a little calf to the goddess Athena. This simple action is immortalized in the image with great seriousness and solemnity. The upright, easy posture of the man seems hardly to be affected by the burden that he carries on his shoulders. Indeed, the artist has succeeded in joining the two beings—the tall, straight figure of the man, and the horizontal rounded figure of the calf, into a higher artistic form, a true group. The effect of unity is initially achieved by the crosslike junction formed by the arms of the man and the legs of the animal. Even though the actual focal point, where feet and hands met, has broken off, what survives to reflect the whole disposition of limbs makes eminently clear how firmly man and animal are intertwined. The composition is perfected by the two heads. The head of the animal is turned forward in a position parallel and closely juxtaposed to the head of the man, prompting an unusual, moving comparison between the two beings. With this composition, which is convincing both artistically and

38 GEOMETRIC HORSE, probably found at Olympia. Second half of the 8th century B.C. Height 16 cm. Bronze. Staatliche Museen, Berlin, Antikenabteilung, No. 31317. Judging by its sharp, vivid style, the little work should probably be attributed to a Corinthian master. Although such Geometric bronzes are the earliest documents of Greek sculptural art, they nonetheless represent the late phase of the Geometric period, as is indicated by the well-balanced, abstract curvatures of limbs and body.

39 GRIFFIN HEAD, from a bronze cauldron. Mid-7th century B.C. Bronze. Height, including the vertical knob on the head, 27.8 cm. Olympia Museum, No. B 145. The sharp edges and ridges that delimit the curves of the head are outlined and joined with surprising sharpness and boldness. Notice the tongue, which rises toward the upper curvature of the beak, and the four steep curves above the eye by which the brow is built up, terrace-fashion. On the peak of the brow is a knob, representing a mystic fruit, a legacy of Oriental representations of griffins. The work is hollow-cast. An eyeball, made of bone, and a pupil, probably of colored stone, were once set into the piece. Made of thin metal, the head was attached to the chased neck of a cauldron with rivets. Even though this work was a subordinate piece of decoration, it should stylistically be grouped with the expressive sculptures of the early Archaic period.

40, 41 MAN CARRYING A RAM. Mid-7th century B.C. Bronze. Height 18.5 cm. Staatliche Museen, Berlin, Antikenabteilung, No. 4777. The early Archaic statuette comes from Crete, which was at that time inhabited by Dorian Greeks. Dorian sculptural style is clearly displayed in the angular cubic structure of the figure and the somewhat clumsy, even crude rendering of the trunk and limbs. On the other hand, traces of the ancient Minoan art and culture that flourished in Crete in the 2d millennium B.C. have been remarked in this figure (manifested, e.g., in the loincloth, the manner in which the belt confines the figure above the hips, and the position of the arms). Minoan tradition was blended in this statuette with Dorian Greek characteristics.

42, 43 KOUROS, found in Attica. c.620–10 B.C. Island marble. Height without plinth 193 cm.; height of plinth 6 cm. Metropolitan Museum of Art, New York, No. 32.11.1. This severe Archaic statue is one of the best-preserved examples of the colossal figures that initiate the history of monumental Greek sculpture. The clear structure of the body and face are still determined by rigid Geometric proportions. The face has a high, vertical, triangular form; the large eyes dominate the upper portion. The hair is carefully and decoratively arranged to resemble beautiful strings of beads. There are traces of red color on the hair, the headband, the band round the neck, and the nostrils. Further works by this sculptor have not, so far, been traced.

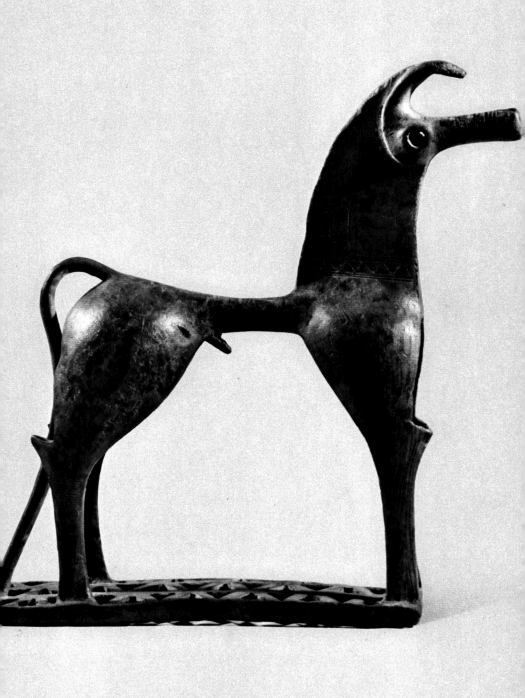

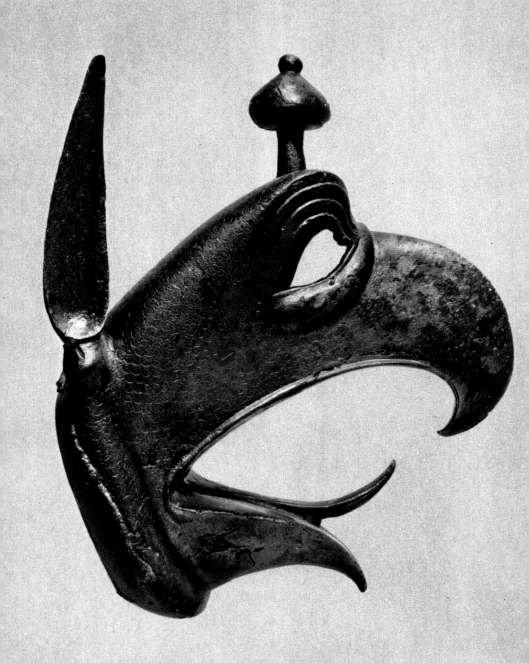

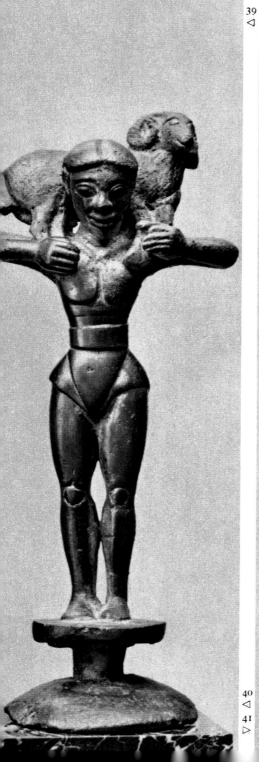

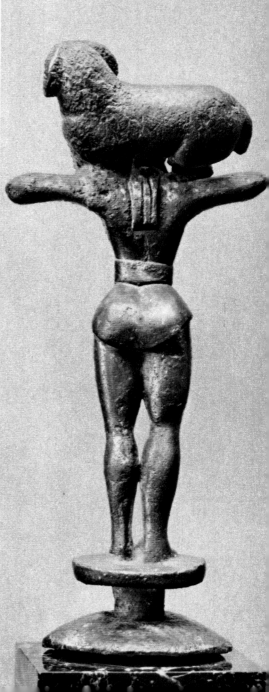

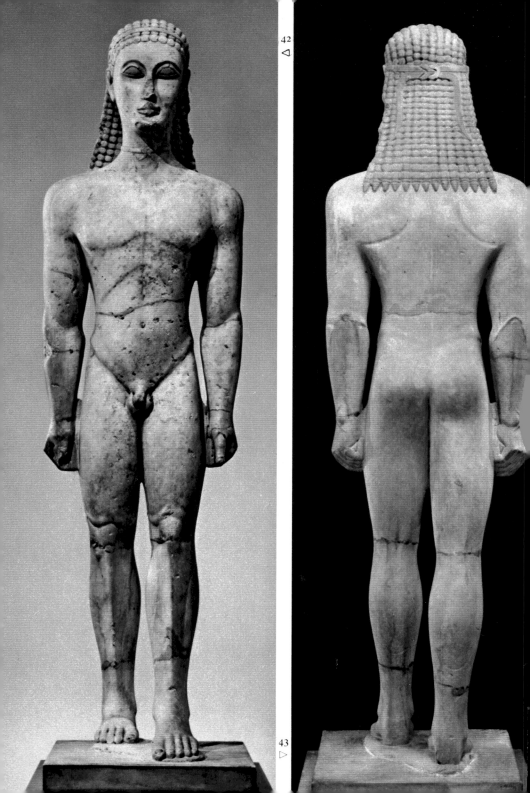

42
◁

43
▷

spiritually, the artist produced a votive offering that must have been among the most beautiful and most precious on the early Archaic Acropolis.

In the same third decade of the 6th century, another Attic sculptor made the statue of a richly clothed standing maiden (49). It was found, carefully buried, by the side of a road lined with tombs, in Mesageia, the central part of Attica, south of Hymettos. It appears that her whole long undergarment was painted in red. Her cloak was perhaps differentiated from it in yellow ocher. It is draped over both shoulders in the manner of a stole, so that its folds hang evenly in the back. Two ends fall down in front; the carefully delineated border shows that the cloak is draped in four layers. On its head the austere Archaic figure wears a high, crownlike cap, the *polos*. It probably denotes the figure as a goddess, even though it was, occasionally, worn by mortal women (see 63). The pomegranate that the figure holds out, firmly clasped in her right hand, does not help to resolve the question whether a goddess or a departed woman is represented. However, the majestic appearance, the solemn, almost ritual positioning of the arms, the radiant look in the widely opened eyes, strike us as divine. One could well see in this royal figure an early representation of Aphrodite, the goddess of life and fertility.

Three reclining lions and the head of a ram, all made in the 6th century, bear witness to the variety in Archaic representations of animals. The earliest work is an early Archaic lion from Corfu (45), probably made around 600 B.C. The long spare body is still closely related to works of the 7th century. The forequarters, however, and especially the head, are rendered in a manner that dissociates the work from the old symbolic idiom; here, a new and immediate method of presentation creates an unusual impact. A reclining lion from Loutraki, in the area of the Corinthian Gulf, is conceived more rigidly, with a stricter adherence to sculptural formula (47). Its character as a heraldic animal is convincingly expressed. Perhaps this lion was originally one of a pair, which would have reinforced the heraldic impression. Completely different in its turn is a lion from Miletos, now in Berlin (46). Magnificently, almost naturalistically portrayed, yet retaining something of the abstract impressiveness of its Archaic ancestors, it lies on its plinth, broad and sleepy. Again, this conception was probably inspired by Oriental, possibly Egyptian models; again, however, it is conceived completely afresh—the nature of the animal has been realistically grasped, and the details of its majestic appearance have been studied. The rendering of the coat—with its folds and changes in texture—and of the soft, yet powerful paws, shows the Ionian Greek perception for nature and breathing life. The mane, on the other hand, arranged in bold, patterned strands, and the face, which is almost a mask, demonstrate the forcefulness of Archaic sculpture. The sharp observation of the nature of a predatory animal, which is reflected in all the details, indicates that the Ionian artist had had the opportunity of studying lions in captivity.

An important late Archaic image that formed part of the Hall of Initiation, the Teleste-rion, at Eleusis, and is preserved in the museum there, represents a ram's head (48). The head served as a waterspout, and was attached to the roof at the end of a long side, near the corner of the triangular gable, or pediment. The animal head is still attached to part of the marble edge of the roof; the bold Archaic profile rises up to magnificent horns. It appears as though the head is merely an incidental addition to the gutter, although it was worked out of the same block. Seen on its own, however, it is a masterpiece. As in the case of the lion from Miletos (46), the connection between the whole sculptural form, which was visualized as a unity, and the lively and sensitive rendering of the details (which may also betray an Ionian hand) is admirable. The Archaic Telesterion was built in the time of the tyrant Pisistratos; the head should thus be dated in the decade 530–20 B.C.

Let us now return to the beginning of the 6th century, in order to become acquainted with a special kind of Archaic sculpture, Archaic Attic sculpture in poros. Poros is a soft but smoothly textured limestone, of a dark brown, light brown, or yellowish color. One ad-vantage of this material is that it can be easily worked with a knife. However, it is not weather-resistant. Sixth-century Attic sculptures in the triangular pediments at the short ends of temple roofs were often carved of this stone, for under the raking, jutting cornice (*geison*) they were relatively well protected. Because of its unattractive surface, poros was completely decorated with paint. Even today, the remains of Archaic Attic pedimental sculptures of this material display a variety of colors, which marble sculptures did not have. The soft material permitted the creation of particularly rich and varied sculptural forms, and these poros sculptures must have been distinguished by liveliness and a striking realism of form and color.

The remains of a pediment from an Archaic temple on the Athenian Acropolis are an excellent example of such colorful and vivid pedimental sculptures (50). The three erect torsos, with their alert heads and animated, piercing eyes, represent the mythical three-bodied Typhon. If we consider that, in addition, the torsos were equipped with wings, and that the bodies terminate in long, tightly coiling serpent tails, this fabulous creature must be recognized as a splendid embodiment of what is hinted at by its attributes—that is to say, of the three elements, fire, water, and air. Thanks to the softness of the poros, the modeling is energetic, even baroque, and the original blaze of colors must have contributed to its effectiveness. The mythical scene to which this three-bodied being belonged filled the right wing of the pediment; it was balanced on the left by a representation of the contest between Herakles and the seagod Triton.

Apart from this pedimental composition, so rich in form and content, in shapes and colors, there were several smaller poros pediments on the Athenian Acropolis that presented

mythical events with a similar technique and zest. They belonged to the smaller temples and treasuries, and gave the Archaic Acropolis an extremely varied appearance.

Like sculpture in poros, sculpture in terra-cotta, especially in the case of works of larger format, derived much of its effect from vigorous coloring. A female terra-cotta head, found in Kalydon in Aetolia, in central Greece (58), is an almost life-size example. It does not form part of a standing female figure, but of a sphinx, whose crouching animal body survives in fragments. Such crouching sphinxes were often used as akroteria. The power of these fabulous beings, which was intended to ward off evil from the temple, is still evoked by the head of the Archaic sphinx from Kalydon. By comparison with the three-bodied Typhon (50), with its rich, swelling forms, this female head is severer and harder. Since other architectural terra-cottas were found with the sphinx, such as fragments of metopes and antefixes, which bear letters in the Corinthian alphabet, the sphinx probably also comes from a Corinthian workshop. It belongs to the early 6th century, the period between 600 and 580 B.C. Only a decade later, about 570, a mature Archaic marble sphinx was made in Attica, to serve as the finial of a tall funerary monument in the public cemetery of Athens outside the Dipylon Gate (59). Comparison between the heads of the two sphinxes points up the Corinthian character of the sphinx from Kalydon and the Attic character of the other. The terra-cotta head has a hard definition of form; the other, softer, more subtle shapes. The features of the terra-cotta sphinx are modeled with sharp edges, and a more ancient tradition of carving still lives on in the soft clay. The modeling of the Attic head is gentler, more sensitive, and at the same time more tightly integrated. The Athenian sphinx seems less demonic, and almost human, even amiable. Its milder expression, strikingly different from the animistic power of the head of the sphinx from Kalydon, creates a new and sunnier world. With this sphinx from the Kerameikos Cemetery and other works of the second generation of the 6th century, a definite humanization and rationalism, the rule of Apollo rather than Dionysos, pervades the art of sculpture.

In the 6th century, the nude male statue of huge dimensions appeared less and less frequently; however, life-size and less than life-size figures are also unusual; the famous Apollo of Tenea, only 1.53 meters in height, is one of the few examples. The average size for the kouroi of this century is a little over life-size. The Kroisos Kouros, 1.94 meters high, and one of the best preserved of these figures, may serve as an example (57). This mature Archaic kouros now stands in the National Museum in Athens, on a base to which, however, it may not belong. A funerary epigram on the front of the base mentions the name of the departed—Kroisos.

The initial impression this statue produces is one of almost exaggerated plasticity, with full forms blending into one another, and a vigorous conception of detail. The conjunction

44 CALF-BEARER. c. 570 B.C. Marble from Hymettos. Height 165 cm. Acropolis Museum, Athens, No. 624. The plinth and the right foot of the figure survive separately. According to a fragment of the original inscription, the man represented was called Bombos, Kombos, or Rhombos. His hair falls in three plaits or strands behind each ear. The upper part of his head has a rough surface, which would have helped color to adhere. The edge of his beard running along the cheeks is trimmed in an elegant curve. The eyes were inserted separately. This early Archaic masterpiece unites man and animal in true harmony.

45 RECLINING LION, from Corfu. c. 600 B.C. Dimensions of the base 121 × 41 cm.; maximum height 45 cm. Greenish-yellow limestone. Corfu Museum. This early Archaic sculpture still belongs stylistically to the late 7th century and is thus roughly a century older than the reclining lion from Miletos (46). The heavy, compact formation of the body and limbs suggests an origin in a workshop in Corinth, which was the mother city of the colonists of Kerkyra (Corfu).

46 RECLINING LION, from Miletos. End of the 6th century B.C. Length of the plinth 171 cm.; width of the plinth 66 cm.; length 173 cm. Island marble. Staatliche Museen, Berlin. The folds of the skin on the haunches were expertly observed and rendered. The paw, doubled back against the soft bulk of the body, is modeled with delicacy and animation. The strands of the heavy mane are carefully stylized, yet soft and tactile; they surround the head like a collar. A combination of joy in the observation of nature and pleasure in the representation of precise details, both characteristic of Ionian Greeks, has contributed to the creation of an Archaic masterpiece.

47 RECLINING LION, from Loutraki. Mid-6th century B.C. Height 53 cm.; length 100 cm. This Archaic statue is made of poros (freshwater limestone). Ny Carlsberg Glyptotek, Copenhagen, No. 5. Statue and plinth are carved out of one block. On the tongue are remains of red paint. The thighs and shoulders are boldly modeled; the body is more conventional and shaped according to formula. The work, judging by its style, material, and provenance, is Corinthian.

48 RAM'S HEAD, from Eleusis. 530–20 B.C. Length 35 cm. Eleusis Museum. This late Archaic head and the section of the edge of the roof to which it was attached are of island marble. They formed part of the Telesterion, a temple at Eleusis. The head of the animal is modeled in a few firm, yet subtle curves, and the eye is delicately set into the face, which has the suppleness of soft leather. A rounded ridge, as finely modeled as the rims of the eyes, swings down toward the nose. The face is framed and delimited by a triple wreath of small round curls, behind which appear large curved horns. These are subdivided by finely curved ridges, which are sculpted with great sensitivity. This head presumably is the work of an Ionian. Some traces of pigment survive—red on the eyes and blue in the hair.

49 STANDING MAIDEN, found at Keratea near Lavrion, Attica. c. 570 B.C. Probably marble from Hymettos. Height with plinth 193 cm.; width of shoulders 55 cm.; height of plinth 10 cm. Staatliche Museen, Berlin. This severe Archaic statue was found not far from the kouros now in the Metropolitan Museum (42, 43). It was wrapped in sheets of lead and carefully buried. Hence it suffered scarcely any weathering or damage. Perhaps the statue was removed at the time of the Persian invasion, before the Battle of Salamis (480 B.C.), and not recovered later. As a result of the good state of preservation, numerous traces of color exist: yellow, red (produced from iron ocher), and strongly oxidized blue. The towering pillarlike form of the figure is continued in the high, narrow head, which rises above a long neck and is crowned by the *polos*, headdress of a divinity. This verticality of the structure is counterbalanced by the widely protruding shoulders, the broad gestures, and the position of the feet. A new tendency toward greater roundness of forms can be detected.

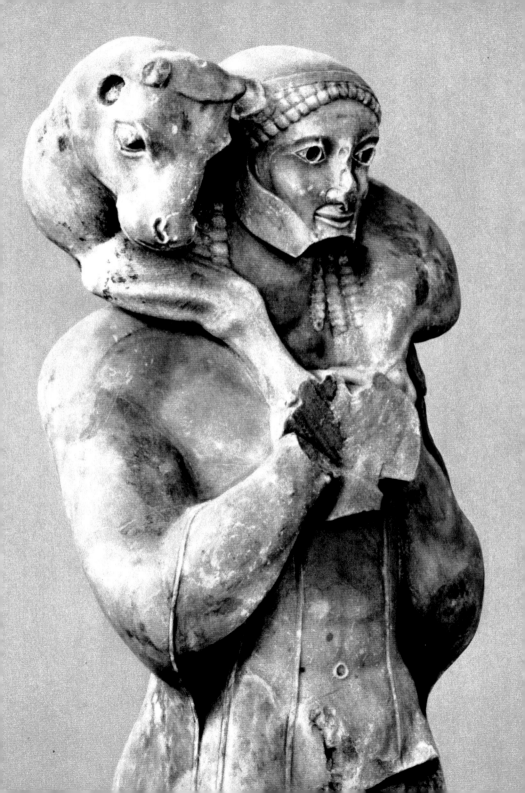

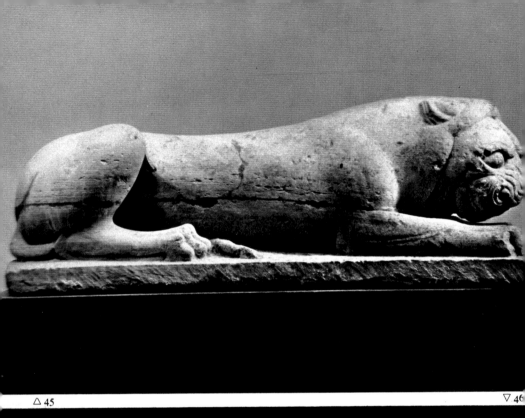

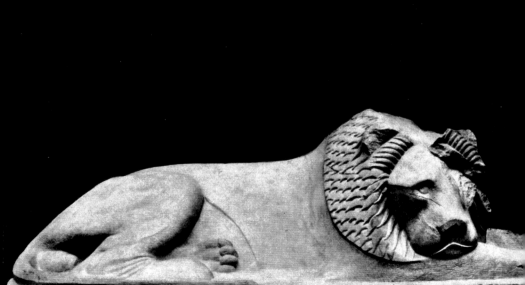

of flourishing strength of appearance with rich differentiation of individual details makes the Kroisos Kouros an especially beautiful and significant example of mature Archaic art of the decade 530–20 B.C. The taut beauty of this masterpiece is especially clear in the details; one should, for example, observe and compare the inner outline of the arms and of the corresponding outer outlines of the torso and upper thigh. The arrangement of these outlines is dramatic and artful, for, against a light background, they create an independent and graceful two-dimensional ornament.

The Rayet Head (*51, 52*), a head of a youth, belongs in the same decade. It is now in the Ny Carlsberg Glyptotek in Copenhagen, the first classical acquisition purchased by the founder of the Glyptotek, Carl Jakobsen—in Paris in 1879, from the French archeologist Olivier Rayet. It remains one of the most beautiful and important pieces of this great collection of antiquities. It is 25 cm. high, and thus, like the Kroisos Kouros, is about life-size. Its conception, however, is thoroughly monumental. Traces of coloring—for example, dark red on the hair, eyes, and lips—survive. The smooth surface of the face still conveys an impression of the original *ganosis*, a polish of melted wax. This mature Archaic head of an athlete has strong, firmly molded and individualistic forms, which denote the hand of a particularly well-developed artistic personality; in this also it resembles the Kroisos Kouros. The eyes are wide open, the cheeks are modeled tautly, and the chin has a solid roundness. Nonetheless, the overall effect is not heavy or massive. The precise articulation of the individual forms gives the face an energetic liveliness and an expression of radiant confidence.

The splendid mature Archaic kore—called the Kore of Antenor owing to an inscription on the base to which it probably belongs—also dates to the twenties of the 6th century, probably the years around 520 B.C. (*55*). The powerful torso and the broad, almost luxurious expanse of the garments are in accord with the height of this statue, which is well over life-size. If we imagine the rich, variegated coloring that once covered it, we will gain a conception of its original splendor. The clothing is characteristic of a new type of kore figure, brought to Athens from eastern Ionia shortly before the middle of the 6th century; it remained an accepted type until the end of the Archaic period in the early 5th century. The variety of materials and complex draperies, and of hems with colored edges, and the charm of an asymmetrical arrangement of clothing soon helped the new fashion to predominate over older and more sober forms. The Ionian cloak was especially effective. It was tied on one shoulder, usually the right one—the knots were carefully and lovingly represented—and it fell diagonally between the breasts and below the left arm. This diagonal drapery, in crossing the upper part of the body, accentuates it. The lower parts of the cloak have a complete new distribution of material. Below the knotted sleeve and the raised arm—in the case of the Antenor Kore the right one—the hem of the cloak hangs down splendidly and

impressively in front of the body, displaying a zigzag of folds and edges. The folds of the hem decrease in length at the center, so that between the breasts, the cloak is reduced to a hand's width. On the left side of the kore, and around her left hip, the hem descends again, but only as far as the waist, while on her right side the broad folds almost reach her knee. The undergarment, the chiton, is pulled tightly around the girl's legs and hips, for her left hand, lifted gracefully, raises the material and draws it sideways. A system of diagonal folds, running upward, subdivides the garment on the right, whereas on the left the fine material falls down in vertical folds. These folds, which are absolutely straight, precisely delineated, and parallel to each other, have the satisfying effect of repeating in a more delicate fashion the broad vertical folds of the cloak lapped over the right hand.

The same type of kore is represented in a somewhat later statuette from the Athenian Acropolis, on which there remain traces of elaborate coloring (56). This figure is only a fifth of the height of the Kore of Antenor. But it is not only the smaller format that creates an impression of delicacy and meticulous execution, for the relationship between body and clothing has also changed significantly. The powerful Antenor Kore, with its square shoulders, widely spaced breasts, and ample chest, seems to carry the weight of cloth and draperies effortlessly; the body of the little late Archaic statuette, on the other hand, is narrow and slender, almost frail. The gently curved contours of bosom, hips, and waist make it almost an ornamental form. The splendid garments in which this fragile figure is attired seem all the heavier, and the decoration on the wide borders and scattered colored patterns are emphasized. The relationship between body and head is also different. The Antenor Kore has a strongly formed, proudly erect neck and head, but by comparison with the size of the body they appear small. The face of the late Archaic figure, on the other hand, with its mass of hair and the diadem, looks almost too large and too heavy for the narrow shoulders and delicate body. Her delicacy, grace, and proportions speak for a provenance in the Ionian islands.

We may conclude our survey of the development of Archaic korai in the 6th century with two heads from the Acropolis of Athens, both dating from the end of the century or perhaps as late as 500 B.C. (63, 64). Even though, in respect of place of origin and date, the two heads belong together, they differ greatly in form and expression. Both have headgear, one (64) a diadem with a slightly curved profile, the other (63) a high and heavy headdress, which bears more resemblance to the crown of a goddess, the *polos* (see 49), than to the headdress of an ordinary mortal. But since this head from the Acropolis certainly formed part of the figure of a kore, not of a goddess or a departed woman, the heavy pomp of her headdress should be regarded as an unusual elaboration. The high crown rests on a shallow arch of hair, which is divided in two layers; the upper layer forms a zigzag band representing stylized

strands of hair. This band lies above a narrow strip of wavy hair, which delimits the upper part of the forehead. Thus, above the severe forehead, there is an almost ornamental partition that supports the heavy crown. The countenance—especially the forehead—has a strangely smooth and cool delineation. The curves of the brows, with their sharp edges, the precisely rounded form of the eyelids, the decisive formation of the nose, and the firm and clear-cut lines of the lips balance the curves of the rest of the face, which gives the impression of being made of china.

By comparison with this cool certainty of form, the other late Archaic head of a kore from the Acropolis (64) has a fascinating indefiniteness in its shapes, and a strangely veiled expression. The delicate face is modeled in a soft and rounded fashion. The lids rest heavily on the narrow, elongated eyes. The arches of the brows do not set off the forehead from the hollows of the eyes with so chiseled a line; rather, softly rounded, they form a subtle transition from the forehead to the shallow hollows in which the eyes are embedded. The high cheekbones, the protruding chin, and the beautifully curved, full mouth, set in a slight recess, give a stronger, more definite expression to the lower part of the face. Here, too, the face is clearly differentiated from the ornamental cap of hair and the high polos. An almost classicizing severity and coolness, on the one hand, and a romantic delicacy and animation, on the other, give a fine example of the range of possibilities open to the sculptors of the late Archaic period.

A beautiful late Archaic sculpture of a young man who is about to lift a female figure onto his shoulders (53, 54) is part of a larger group, a pedimental composition on the Temple of Apollo at Eretria in Euboea. It is Theseus, who fought against the Amazons and overcame and carried off their queen, Antiope. The Amazon may be recognized by her leather jerkin, which covers the whole upper part of her body; she has a rich, complicated coiffure crowned by a diadem. The head of Theseus is covered by a cleverly sculpted wreath of tight curls. His countenance is particularly forceful; the rounded eyes, the protruding mouth lend it a fresh, even dramatic expression. It may be supposed that the whole pedimental composition was produced in an Ionian island workshop that had close links with Athenian artists, perhaps one on Paros.

Another set of pedimental sculptures survives from the late Archaic Temple of Aphaia at Aegina (see 107). These sculptures were recovered in the early 19th century in front of the Doric temple, which is situated on the northeastern tip of Aegina, on a wooded height above the sea. Soon after they were found, they were bought by Ludwig, crown prince of Bavaria, and were restored. In 1830 they were displayed in the Glyptothek in Munich, which was built to house the royal collection of antiquities, especially those from Aegina. The same theme, the conflict between Greeks and Trojans, is represented in both pediments; on the

50 TRIPLE-BODIED DEMON (Typhon). Group from a corner of the eastern pediment of an Archaic temple on the Athenian Acropolis. c.570 B.C. Painted poros. Height 77 cm.; length, including the serpent bodies (as extant) 325 cm.; height of the relief of the human parts of the three bodies 41 cm. Acropolis Museum, Athens. The three bodies and the background are cut from one block. The upper parts are of human form, with arms and heads. From these upper bodies, three serpent tails, intertwined with each other, extend to the right into the corner of the triangular pediment. Each of the three bearded creatures holds an object. The one with the friendly extroverted glance on the right holds a bird in his left hand. Above the wing appears the center of his right hand, which he holds over the bird in a careful protective gesture. The middle figure carries in his left hand a bunched undulating object, and the figure on the left has a similar object, which is, however, still more wavy. Ernst Buschor has interpreted these three symbols—presumably correctly—as fire (left), water (center), and iar (right). They identify the three-bodied demon as a spirit that could turn itself into the different elements. This vivacious Archaic group is stylistically related to the Calf-Bearer (44).

51, 52 RAYET HEAD. c.530–20 B.C. Height 25 cm. Parian marble. Ny Carlsberg Glyptotek, Copenhagen, No. 11. The eyes of this individualistic head are abnormally widely opened and strongly emphasized by the broad curving lids; the pronounced waves of the young man's cap of hair are further subdivided by close, curved rows of locks. This head, like that of the Kroisos Kouros (57), is characterized by radiant vitality; in addition, it displays a special seriousness of expression, which is a particular characteristic of the sculptor of this mature Archaic work. There are traces of dark red color in the hair and eyes and on the lips.

53, 54 THESEUS CARRYING OFF ANTIOPE, from Eretria. c.510 B.C. Parian marble. Height 110 cm. Chalkis Museum. The group comes from the west pediment of the Temple of Apollo Daphnephoros at Eretria (Euboea). In this pediment was represented the battle between Amazons and Athenians. The group shows Theseus lifting Antiope, queen of the Amazons, whom he has carried off, into his chariot. Remains of kneeling Amazons wielding bows also survive. Apart from a small cloak which hangs round his shoulders, Theseus is nude. Antiope wears a short chiton and a leather jerkin. The two bodies are convincingly united into a group, in spite of all the difficulties that the spirited theme entailed for an Archaic sculptor. Both figures are sculpted out of one block; individual parts, such as the arm of Theseus, were attached separately. Over the ring of small round curls, Theseus wore a bronze wreath. This elaborate late Archaic pedimental composition was presumably created in a workshop of the Ionian islands.

55 KORE OF ANTENOR. c.520 B.C. Island marble. Height with plinth 255 cm. Acropolis Museum, Athens, No. 681. The fullness of her frame, and her lavishly draped garments and ornaments make the kore a splendid example of mature Archaic art at the height of the rule of Pisistratos. A base with an inscription, and a setting for a plinth very probably belong to this figure. If so, this kore was dedicated by the potter Nearchos and made by the sculptor Antenor, son of Eumares. This Antenor must have been a well-known Attic sculptor of the second half of the 6th century B.C. Stylistically, the female figures of the east pediment of the Temple of Apollo at Delphi are closely related to this figure of a maiden from the Acropolis. (This particular pediment and the whole east façade of the temple were executed in marble at the expense of the Athenian princely family of the Alkmaeonidae; the rest of the building was of limestone.)

△ 50 ▽ 51 ▽ 52 ▷ 53 ▷ 54

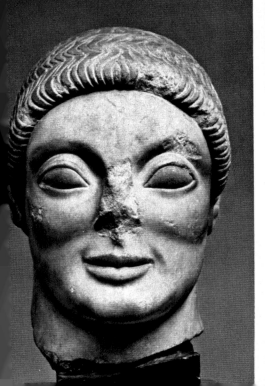

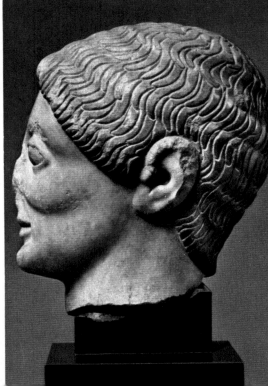

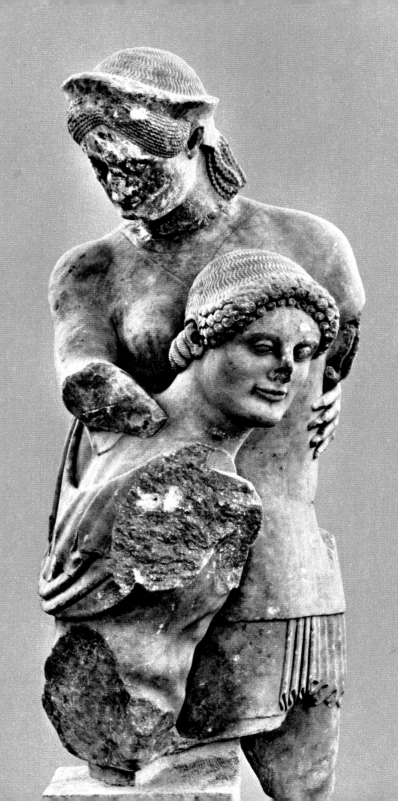

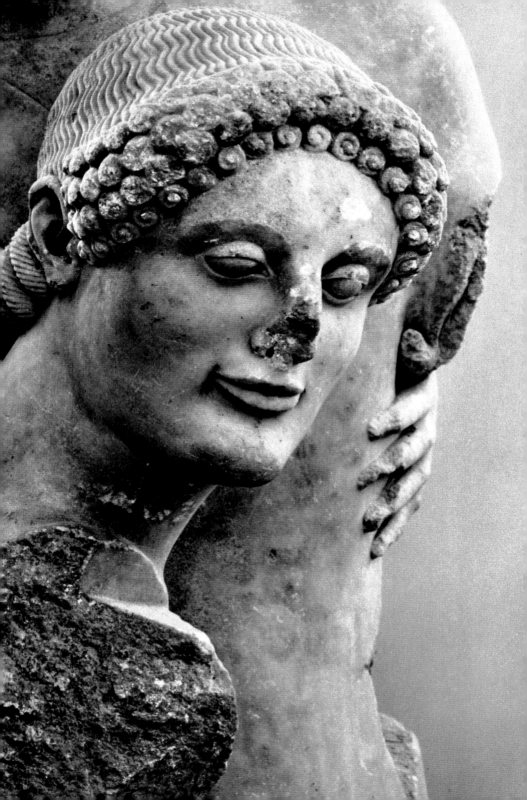

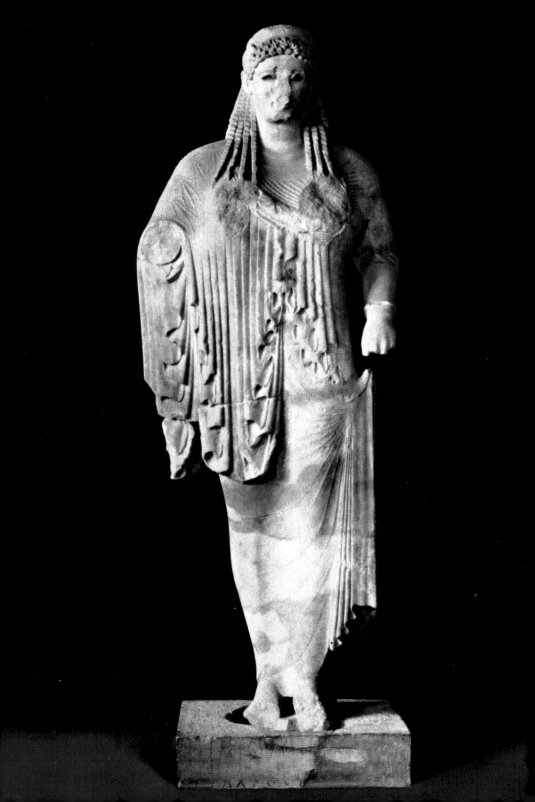

east appears the first campaign of the Greeks against Troy and its king Laomedon; in the western pediment, the figures enact the later, but more famous, campaign of the Greek heroes who set out under the leadership of King Agamemnon to fight against the Troy of King Priam. The similarity of theme permits a special kind of comparison between the two pediments. In the western pediment, the composition, the conception of the individual figures, and their formation indicate that this was a creation of late Archaic art of the last decade of the 6th century. The eastern pediment, on the other hand, has a more fluid composition. The individual figures are better integrated into the triangular space, and their forms have a severity that places them at the end of the transition to the Classical period— between 490 and 480 B.C. The helmeted head of Athena, who was represented taking active part in the battle in the center of the eastern pediment, has all the characteristics of what has been aptly called the Severe Style (62). Much of the eloquence and expressiveness of the surface modeling of late Archaic heads has vanished. A new seriousness and simplicity have replaced Archaic vigor and gaiety.

In the year 480 B.C., the Persians ravaged Athens and its Acropolis. The temples were desecrated, the statues overthrown. The Kritios Boy, a statue of a youth from the Acropolis, must have been made before this date, for it was among the statues shattered by the Persians (60, 61). However, it cannot have been made long before that fateful year, for it is so completely free from the formulas that shaped Archaic kouroi that it may be said to represent the true beginning of the Classical age. Its connection with the sculptor Kritios has little historical or epigraphical foundation, but the head is similar to a portrait by Kritios and Nesiotes of Harmodios, the younger of the two famous tyrannicides who slew the dictator Hipparchos. The group was sculpted in 477 B.C. to replace older bronze statues that had been taken by the Persians. (A marble copy of the tyrannicides Harmodios and Aristogeiton is in the National Museum at Naples.) Stylistic similarities make the attribution of the statue of the boy from the Acropolis to one of the two artists highly plausible; Kritios, being from Attica, is the more likely choice. The full height of the statue was about 1 meter; since the right leg and left foot are missing, its present height is only 86 cm. Nevertheless, it appears to be much taller, more powerful, and stately. As with Archaic kouroi, this nude figure of a youth is represented standing still, with one leg extended slightly, but this statue differs from those Archaic figures of young men as decisively as does the Aegina Athena from the late Archaic korai of the Acropolis (62, 63, 64).

The contrast between the advanced and the supporting leg becomes clear especially in side view. This difference results in a slight but nonetheless noticeable tilt in the pelvis. This tilt runs almost as far as the shoulders, which are horizontal. The slight turn of the head toward the right, a departure from Archaic frontality, heretofore strictly observed, was

another bold device to give the statue the illusion of life and movement. The arms of the figure are still linked with the body by small marble joints, and both feet were firmly planted on the ground. But the arms do not fall symmetrically on either side of the body, as with Archaic kouroi. The left upper arm is clearly held back a little, and must have bent slightly at the elbow; the right arm drops vertically and therefore extended further down the leg. The head was probably encircled by a metal ring, now lost, around which strands of hair were curled. While the peaceful perfect symmetry of the head of the Athena from the eastern pediment of the Temple of Aphaia (62) shows the Severe Style still governed by an initial restraint, the face of the Kritios Boy reveals a surer hand at work. The narrow, firm mouth is individual and the eyes, set deep under the protruding forehead, have a cool expression, which is reinforced by the lordly turn of the head. Here, again, the lively appearance of Archaic statuary has been replaced by a freer, more confident attitude. Perhaps, too, a new seriousness, a new feeling of responsibility to one's own existence, to one's own time, evoked by the challenge of the Persian War, is reflected in this statue of a young ephebe, which was dedicated on the Athenian Acropolis in the period between the battles of Marathon (490 B.C.) and Salamis (480 B.C.).

The war with hostile Persia released the creative forces of the Greeks to an unprecedented degree. They had defeated an enormously powerful enemy and maintained their independence against great odds. Seen against this background, the achievements of the Classical age reflect a new confidence and break with the past.

One decade later, work was started on the Temple of Zeus at Olympia, whose pediments were decorated with two great sculptural compositions (see *130*). The building was carried out between 470 and 456 B.C. The theme of the eastern pediment was the preparation for the race between King Oinomaos and the hero Pelops; the western pediment treats the battle between the men of Lapith and the centaurs, which disrupted the wedding feast of

56 KORE, from the Acropolis, Athens. c. 510 B.C. Whitish island marble. Height of the statuette as it survives 55.5 cm. Acropolis Museum, Athens, No. 675. The face with its slanted eyes, the delicate, craftsmanlike rendering of the garments, and the jewels suggest that this rare statuette is an Ionian work. Both the material and the style have suggested the island of Chios as the place of origin. In any case, the dainty figure with its refined, even sharp forms is an unusually fine example of the late Archaic art of the Ionian East. Numerous traces of color remain on the sleeved chiton and the cloak. The borders of the chiton were decorated in especially lavish color. The cloak is sprinkled with spiral and triangular patterns. The diadem has seven holes for the attachment of metal ornaments with dowels.

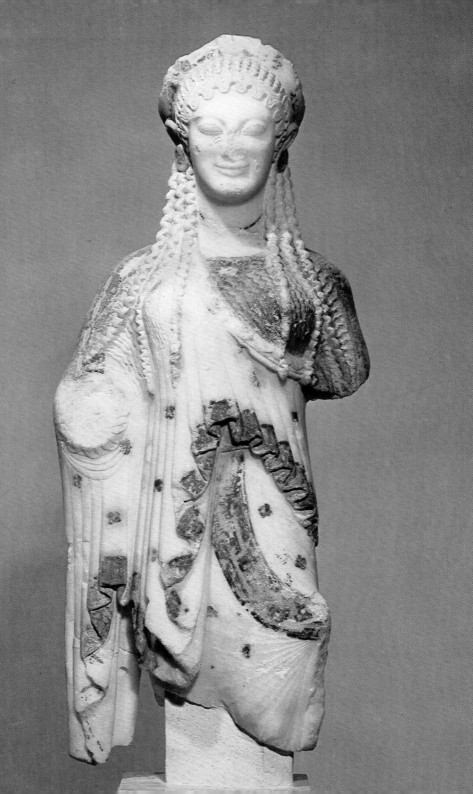

57 KRCISOS KOUROS, found at Anavysos (Attica). 530–20 B.C. Parian marble. Height of figure 194 cm. National Museum, Athens, No. 3851. This statue is one of the best-preserved Archaic kouroi. The figure is full of life and energy, of tension and controlled vitality. Despite its forceful appearance and powerful physical presence, the sculptural formation shows a fine differentiation of forms and a sensitive delineation of contours. An important artist, some of whose other works may survive, created this splendid full Archaic figure of a youth during the prosperous years in which Athens was ruled by Pisistratos. The details of the modeling, especially those of the body, should be compared with representations of athletes in early red-figure vase painting of c. 530–20 B.C.

58 HEAD OF A SPHINX, from Kalydon (Aetolia). c. 600–480 B.C. Terra-cotta. Height of the head 21.5 cm. National Museum, Athens. Fragment of decoration at the corner of a pediment in the form of a crouching sphinx. The huge eyes of this almost life-size Archaic head are framed by broad, sharply delineated brows. The eyes have a large black disc in the center, in which is engraved a white circle, which outlines the pupil. These magical eyes dominate the whole face. The face, too, has a pronounced geometrical structure, emphasized by the projecting oblong ears, and the triangular band of hair above the brow, which makes the sphinx a fitting architectural ornament. Because of its spirit and shape, as well as the manner in which it is painted, this beautiful akroterion should be attributed to one of the famous workshops of Corinth.

59 HEAD OF A SPHINX. c. 570 B.C. Marble from Hymettos. Height 60 cm. Kerameikos Museum, Athens. The eyes, with the gently curved, incised brows, are smoothly fitted into the rounded face, which is also modeled in gentle transitions. The hairstyle shows pleasure in ornament. This Archaic Attic sphinx crowned a high funerary monument with a broad square capital. Both the crouching sphinx, and the capital, which is decorated with a large lotus ornament, show numerous traces of coloring.

60, 61 KRITIOS BOY. Before 480 B.C. Parian marble. Height of the figure as extant 86 cm. Acropolis Museum, Athens, No. 698. The body was found in 1865 southeast of the Parthenon, and the head further to the east in 1888, in the rubble left after the Persian destruction of the buildings on the Acropolis. The head undoubtedly belongs to the body. The statue, especially the head, appears to have been conceived and fashioned as though it were of bronze. The stance of the figure in particular is revolutionary. The supporting leg is firmly locked; like a column, it is clearly differentiated from the loosely flexed advancing leg. This statue in the Severe Style of the immediate pre-Classical period, imbued with discipline and seriousness, reveals the spirit of the epoch between the battles of Marathon and Salamis.

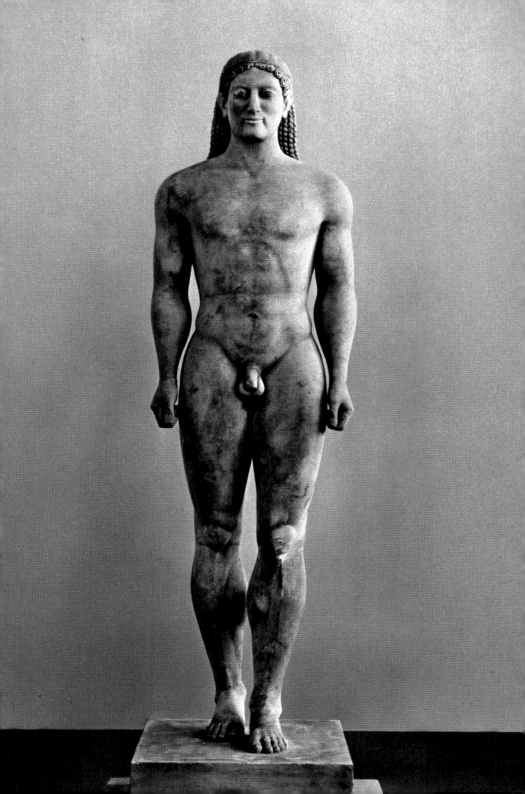

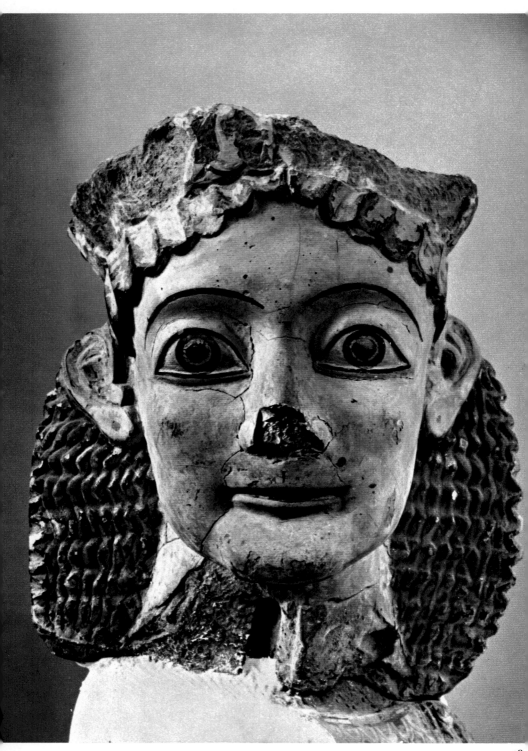

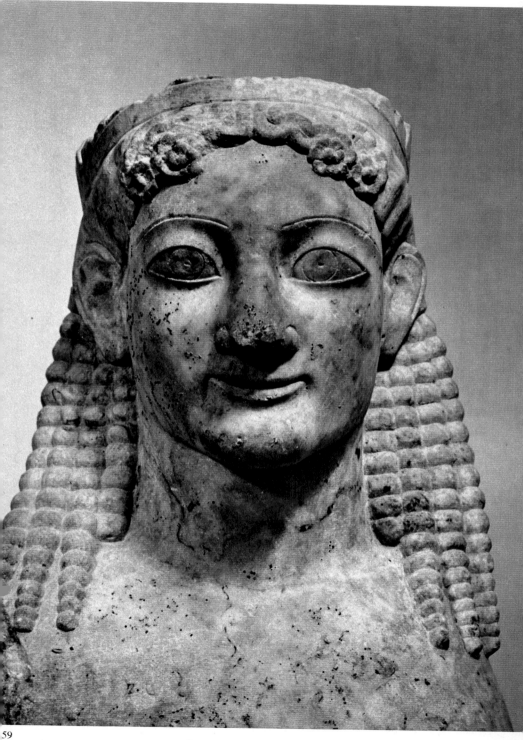

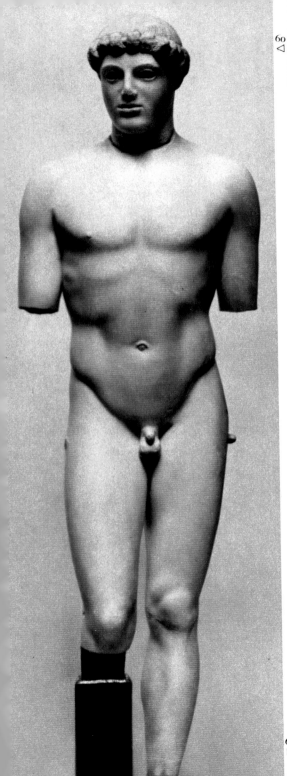

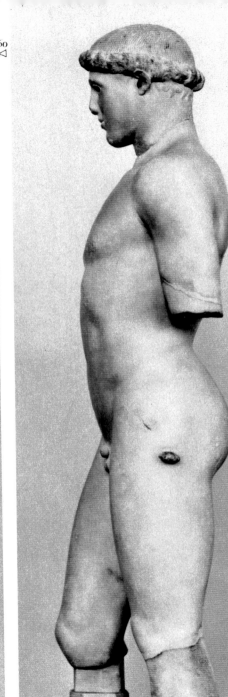

King Pirithoos. The figures of this pediment are among the latest temple sculptures at Olympia, made between 460 and 456 B.C. The center of the scene of warlike confusion is dominated by the tall nude figure of Apollo; his head and arm are turned to the right in a commanding gesture (65). The head of this majestic figure and even its patina are excellently preserved. Despite its larger, more powerful features and heavy contours, this face of the god may be compared to that of the Kritios Boy in its expression of profound seriousness. The fury of the battle is conveyed by the other figures, among them a Lapith woman who has fallen to her knees and attempts to free herself from a centaur who is moving to the left (69).

The power of these sculptures from Olympia is conveyed by the vigorous bodies of the combatants, and by the heavy, flowing grace of their movements and their draperies. The name and place of origin of the creator of the sculptures and the style are completely unknown.

The sculpted reliefs from a temple at Selinus, in Sicily, which is known as Temple E—or, with some justification, as the Temple of Hera—were made at about the same time, that is, in the early Classical period, around 460 B.C. Of the twelve metopes that once decorated the walls of the entrances to the interior chamber, or *cella*, in groups of six, five are relatively well preserved. Of the other metopes, some heads have come down to us. The reliefs were cut from a local limestone, which, although covered with a layer of stucco, like the whole temple, have seriously deteriorated because of rain and salt from the sea. The nude parts of the female figures, however—heads, hands, and feet—were made of precious, probably imported Parian marble. As at the Temple of Zeus at Olympia, these reliefs were not attached to the frieze above the columns (see *107*), but rather to the cella. Two were placed above the pair of columns between which one entered the porch (*pronaos*) of the cella, and from there the cella itself. On one of these metopes, which were set in such a prominent place, the loving encounter between the two highest gods on Mount Ida is shown (*70, 71*). Zeus is seated on a rock in a relaxed, almost reclining position. His left arm, slightly bent, supports the slender, almost lean torso, which rises upward in a lovely curve. His right arm in a sweeping gesture extends beyond the center of the relief and, in a firm clasp, he holds the wrist of the goddess Hera, who majestically regards him. This and the other metopes of the Temple of Hera in Selinus were created in an important workshop in southern Italy.

An original, over life-size bronze statue, the famous Charioteer from Delphi (*66, 67*), dates between 475 and 470 B.C., shortly before work on the Olympia sculptures began. Excavated in Delphi in 1896, together with the remains of a chariot, chariot shaft, yoke, and fragments of horses' legs and tails, it was the main figure of a large monument consisting of charioteer, chariot, four horses, and a boy leading a horse. The statue is one of the

rare original bronze figures surviving from the Classical period, for most of the bronze statues made and dedicated in large numbers, particularly in the 5th century, were subsequently melted down, especially during the period of transition from late antiquity to early Christendom. The Charioteer is a specially beautiful example of the transitional Severe Style. The tall slim body with the long garment of the charioteer has a columnlike poise and stability. The figure is impressively crowned by the small rounded head (66). This is an original example of the concise, crisp, and richly varied idiom of the art of bronze casting, with which the Kritios Boy is stylistically linked (60, 61). The rendering of the hair above the fillet is especially fine. These small locks of hair, ending in little sickle-shaped points, must have been modeled first in clay and then cast in bronze. The ringlets framing the head, especially above the ears, are almost sculpted in the round; this also is a characteristic of Classical bronze sculpture. The eyes, made of well-preserved stones of different kinds, lend an unusual vitality to the countenance. Their powerful glance enlivens the features of the bronze face.

The Delphic Charioteer was found in a sanctuary north of the Temple of Apollo and the Sacred Way and south of the theater and the upper terrace. Whereas the principal figure is very well preserved, the other elements of the group were almost completely destroyed. Presumably the monument was struck by a falling rock in antiquity and was buried there, together with a stone from the base on which the group stood. This stone bears a votive inscription, in which the name of the Sicilian prince Polyzalos is mentioned. From other sources we know that this young ruler's chariot was victorious in a race of 478 or 474 B.C., or perhaps in both those years; his team was driven to victory by a charioteer of his choice. Since the style of the figure of the charioteer makes a date of 470 or shortly before highly probable, it is likely that the group was erected immediately after the victory of 474 B.C.

So far we have discussed only original works from the first half of the 5th century, all examples of the Severe Style: the head of Athena from the eastern pediment of the Temple of Aphaia at Aegina (62), the Kritios Boy (60, 61), the Apollo (65) and kneeling Lapith woman from the western pediment at Olympia (69), the metope from Selinus (70, 71), and the Charioteer from Delphi (66, 67). A statue of a woman dressed in a peplos of the high Severe Style, however, is known only from a Roman copy (68). But in spite of its transposition from bronze to stone, and despite the cold Roman technique, the Kandia Figure offers a clear conception of the typical female statue of the years around 470 B.C. Every stylistic connection with sculptures of the preceding generation, and particularly with late Archaic art of the turn of the century, seems to have vanished. Gone are the richness, the delicacy, the warmth of the kore from the Acropolis (56)—replaced by this sterner conception of womanhood. Clothed in the traditional peplos, the Kandia Figure represents a new

heroic epoch. The original from which the Romans made their copies was cast in an Argive workshop during the same years as the earlier marble sculptures at Olympia.

Myron was among the most famous bronze sculptors of the Severe Style, and indeed of the whole Classical age. His Discus-Thrower is known through many Roman copies in bronze and stone. A bronze statue from the collection of antiquities in Munich (98, 99) fails to show the details faithfully, and the head was much altered in an attempt to make a portrait. Nevertheless, this statuette, because of its excellent state of preservation, gives an impression of the brilliant effect that the lost larger original must once have had. This bold and original work by the great Myron was made around the middle of the 5th century, just before the high Classical age and the career of Phidias. Myron's Discus-Thrower may not have been more famous in antiquity than other works by his hand or from his workshop; he also sculpted a famous group of Athena and the satyr Marsyas, and a perhaps even better-known representation of a cow.

• The history of sculpture in the Severe Style in the various parts of the Peloponnese and in Attica is chiefly known through single statues, mainly Roman copies like the Kandia Figure and Discus-Thrower. Some of these works can be attributed to famous masters —such as Myron or Kalamis—on the ground of style or of literary tradition. But documentation for relief sculpture, which had flourished greatly in all Greek lands in Archaic times, is much less extensive. In the Peloponnese, this branch of sculpture, except for architectural reliefs, appears to have died out gradually during the first half of the 5th century. From Attica we know only a few votive reliefs, since carving funerary reliefs revived only in the second half of the century—after the Parthenon frieze was completed. However, in the Aegean islands, the art of relief underwent a brilliant revival during the period of the Severe Style. There is, perhaps from the island of Paros, the very moving gravestone of a girl, at one time owned by the Giustiniani family in Venice (77, 78). The acanthus leaves on the palmette finial are the earliest known in the history of ornamental Greek sculpture. Two significant examples of the second half of the 4th century in the Metropolitan Museum of Art in New York (79, 80) show how varied and rich was the development of the finial throughout the 4th century and the end of the Classical period. A precious fragment of a relief that recently came to the National Museum in Athens dates from the same period as the Giustiniani gravestone. It had previously been privately owned by a collector on the island of Melos and doubtless originated on that island. This relief from Melos (75) is round and the surface is convex, like a shield. On this surface is carved in shallow and very delicate relief a female head. The dignified and expressive profile is turned to the right. Thick hair hangs down onto a delicate neck. The ear is only partially executed since it was covered, as indicated by the hole for a rivet, by a lock of hair. The head fills more than half of the circle;

thus, one should not imagine on the other side another similar head, but perhaps a hand, which might have held a flower. The shape of the medallion is quite unique, leading one to suppose that the moon goddess Selene may be depicted and that the round curved background represents the disc of the moon.

The wonderful bronze statue of a god that was rescued from the sea at a depth of 40 meters off the north coast of the island of Euboea shows the full freedom of the high Classical age of the midcentury (76). The statue is perfectly preserved, and it demonstrates the scope and individuality of high Classical composition, as well as the ability of a great sculptor. The widely extended arms are in perfect equilibrium. The majestic head is not set on the body in exact profile, but, slightly turned, appears in three-quarter view. The eyes, fixed on a target, were at one time filled with colored stone. The mighty torso also stands slightly diagonally, so at the left it appears foreshortened, whereas at the right it opens broadly into the flank in beautiful curvature. The whole structure is clear and forceful; the hips and pelvis are beautifully differentiated from the upper body. The broad, elastic stance can be interpreted either as the result of a step just taken or as a well-balanced, alert pose

62 HEAD OF ATHENA, from the Temple of Aphaia at Aegina. 490–80 B.C. Height 31 cm. Glyptothek, Munich, No. A 65. The head comes from the east pediment of the temple. The beautiful oval face is perfectly regular; the shallow arches of the brows and the narrow, widely spaced eyes give it a peaceful but firm structure. The nose exactly fills the central third of the face. The mouth is less wide and the lips have lost the attractive "Archaic smile," but the result is a new and moving seriousness of expression.

63 HEAD OF A KORE, from the Acropolis. c. 500 B.C. Marble. Height 27.5 cm. Acropolis Museum, Athens, No. 696. The head is adorned with a polos (which has a meander ornament on its lower border, and, above, a palmette-and-lotus pattern). Every feature is clear and precise, the surface is firmly modeled, and the structure beautifully analyzed. A certain rigid, precise formality, expressed for instance in the layers of hair, indicates that the work belongs to the very end of the Archaic period.

64 HEAD OF A KORE, from the Acropolis. c. 500 B.C. Parian marble. Height 13 cm. Acropolis Museum, Athens, No. 643. This animated and almost spiritual head is worked in a refined and unusual style. The treatment of the marble, and the softly modeled planes are extremely subtle. The numerous holes in the crown, for pins and dowels, served for the attachment of a metal headdress, probably of flowers.

65 APOLLO, from the west pediment of the Temple of Zeus, Olympia. 460–56 B.C. Parian marble. Height of the head c. 42 cm. Olympia Museum. The theme of the pediment in which this figure stood was the kentauromachia, the battle between Lapiths and Centaurs. The central axis of the composition was marked by the slender, vertical figure of Apollo. His right arm, firmly extended, spread over the wild turmoil of battle with a commanding gesture. The head, in a magnificent attitude, and the clear, large features are a wonderful illustration of the perfected Severe Style. The figure is a mature (probably late) work by a master of the early Classical age.

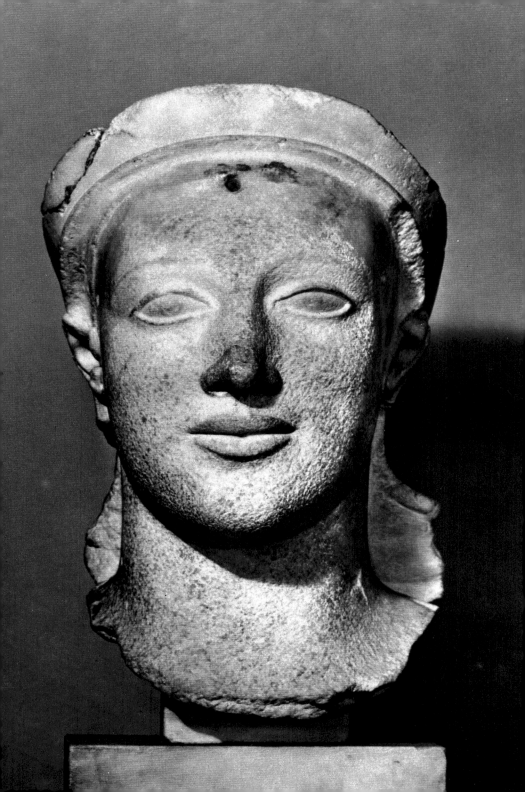

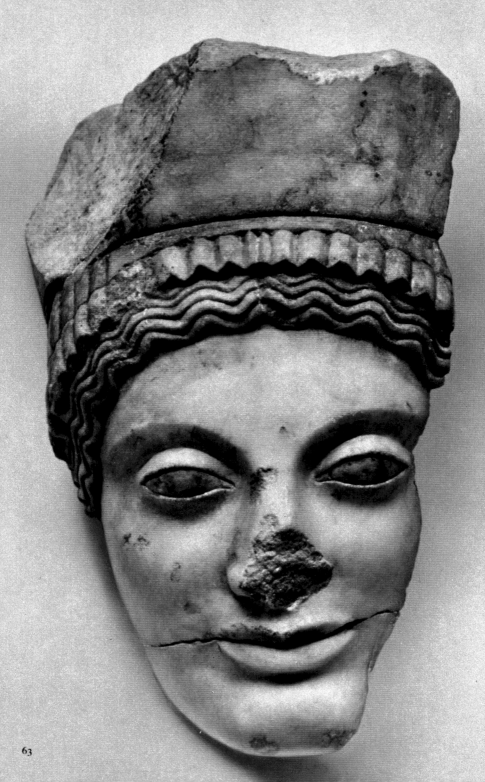

▷ 64

▷ 6§

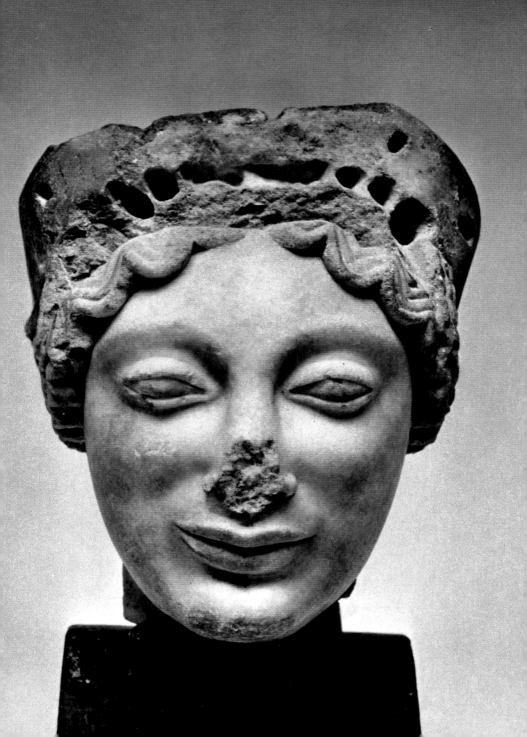

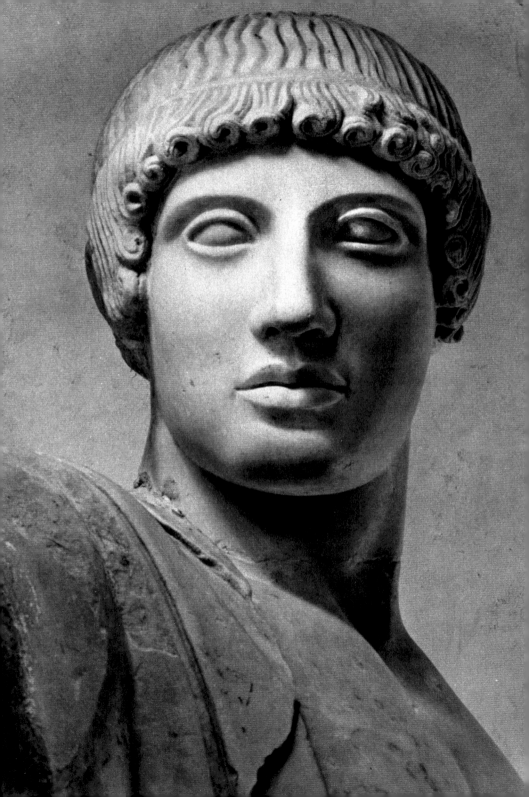

held. This figure of a god is one of the first great creations of the middle of the 5th century. It more probably represents Poseidon, god of the sea, with a trident, than Zeus with a thunderbolt combating the enemies of Olympus. It is not possible to name the Classical sculptor of this masterpiece or to define his origins. The statue has been attributed to several great bronze sculptors of this period—Onatas, Kalamis, and Myron, but without adequate proof.

The possibility of ascertaining the maker is somewhat more favorable in the case of a statue of Apollo of which several replicas—of the whole statue, as well as of the head alone— have survived. This type is known as the Kassel Apollo, after the best-preserved copy. A copy in the Palazzo Vecchio in Florence (72) gives the best impression of the head of the image; the bronze original, presumably by the famous sculptor Phidias, is lost. Even if the Roman copyist added some proof of his own virtuosity to his rendering, the greatness of the original and the restrained passion of Apollo's character speak no less eloquently in the intensity of the replica. The coolness of this replica may be attributed to the practices of Roman copyists rather than to the character of the god as expressed in Greek art.

Two works above all others spread the fame of Phidias in Greek lands and throughout the centuries of classical culture: the images of Zeus at Olympia and of Athena Parthenos on the Acropolis in Athens. Worked in gold and ivory, both were huge statues; the image of Zeus sat enthroned in the depth of the cella in his temple at Olympia, but the image of Athena, somewhat removed from the back wall of the cella of the Parthenon, stood freely in her setting, surrounded by a two-storied colonnade (see 134). Both statues must have been remarkable, if only for the sheer technical achievement they represented; indeed, the statue of Zeus was counted among the wonders of the world. The originals are lost; the gold used for the draperies made inevitable their destruction at the end of classical antiquity. According to a legend, both works were taken to Constantinople in order to adorn the new capital of the Byzantine Empire, in the 4th or 5th century A.D.

Numerous Roman copies survive of the Athena Parthenos, varying in size, quality, and style. One of the most careful and presumably faithful copies, though in size it is a tenth of the original, is a Roman statuette found in Athens near the modern Varvakion School, and is therefore known as the Varvakion Statuette (73, 74). Being so small, it records only a few of the elaborate decorations of the great cult image. However, on the upper part of the body, we recognize the collarlike aegis, which covers shoulders and chest. A row of carefully distributed snakes runs along the edge, and the whole surface is covered with a pattern of scales. Like a clasp, the head of a Gorgon joins the two halves of the aegis. Even in this Roman copy, the heavy, well-rounded countenance with its large features seems to retain something of the glow of the ivory in which the flesh of the original was worked. The Attic

ceremonial helmet worn by the goddess has a curved frontal part above the forehead, and, turned upward, on the left and right, above the ears, are the ornamental earguards, which, in the original, were decorated in gold relief. The upper curvature of the helmet supports three elaborate crests. The highest, in the center, rests on a reclining sphinx, and those on either side are each supported by a winged horse, a Pegasus.

We know that the Athena Parthenos was erected in the cella of the Parthenon in the year 438 B.C.; thus, we know that it was made between 448 and 438. It marks a climax of Classical art and of the career of Phidias. The even more famous cult image of Zeus at Olympia was made later, between 435 and 425 B.C. The huge complex of Parthenon sculptures was completed in 432 B.C. Although there cannot be any doubt that Phidias, to whom the great statesman of Athens Perikles entrusted the direction of the building and its sculptural decoration, exercised a very strong influence on the design of the sculptures, we cannot recognize or define his contribution.

With the completion of the Parthenon (448–432 B.C.) and its very rich sculptural decoration, a new period of Attic sculpture, and especially of relief sculpture (see *119*, *132*), was initiated. The sculptural decoration of the Parthenon may be divided into three large groups: the program of ninety-two metopes, which ran around the entablature of the building; the frieze, which circled the walls of the cella; and the two vast compositions that filled the pediments on the eastern and western faces of the building. To execute these three complicated independent groups of sculptures, careful artistic planning and thorough technical organization were required. When the building was begun in 448, work on the metopes probably commenced as well; they must have been ready by about 440 B.C., since in 438 the ceiling of the Parthenon was constructed, and the statue of Athena Parthenos was erected in the cella.

The four rows of metopes, fourteen on each of the short sides and thirty-two on each of the long sides, had four separate themes, one for each side. On the main face, at the east, was shown the Battle between Gods and Giants, and on the west face the Battle between Athenians and Amazons. In the long series of metopes on the north side the conquest and destruction of Troy was represented and, on the south side, the Battle between Lapiths and Centaurs. Of these metopes on the south side a relatively large number survives; almost all of them are in the British Museum in London. On each of the almost square slabs (height 1.34 meters, width 1.27 meters) one pair of combatants appears, a centaur, who has the body of a horse with a human head and torso, and a youthful, athletic Lapith. The artistic quality of the individual scenes varies. A conventional or clumsy design is usually combined with execution of the same description. This may indicate that the instruction given by the supervising master, who chose the themes for all the metopes, was only of a very general

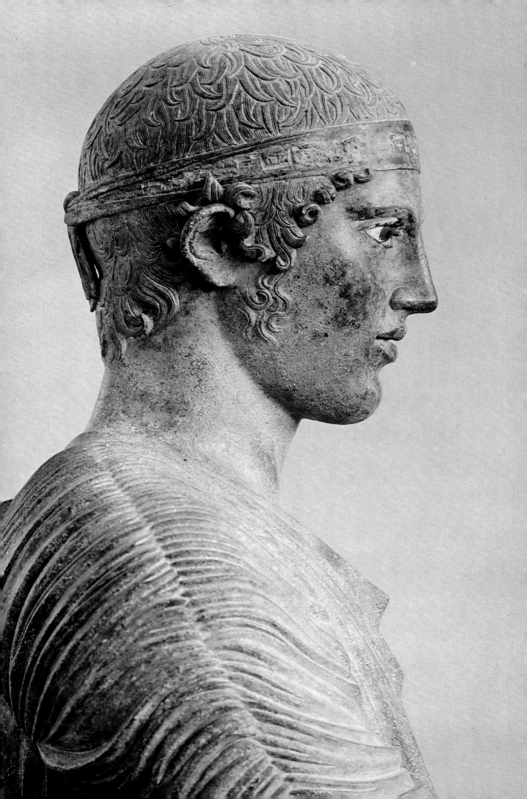

66, 67 CHARIOTEER, from Delphi. c. 470 B.C. Bronze. Height 180 cm. Delphi Museum. The statue of the charioteer is a little over life-size; it stood in a chariot, partially concealed by the front of the chariot. The horses of the team of four, judging by the remains, appear to have been life-size. The figure is identified as a charioteer by its garb, a chiton. This is worn with a belt, and crossed bands hold it back over the shoulders. The statue is slightly turned toward the right, so that the head appears in roughly three-quarter frontality. This original work of the period of transition to the Classical age is excellent testimony to the high development of the craft of bronze casting.

68 PEPLOS STATUE (Kandia Figure). Roman copy. The lost original was made c. 470 B.C. Parian marble. Height 180 cm. Museo Nazionale delle Terme, Rome. The figure is named after another replica, surviving complete with head, in the Kandia Museum in Crete. This excellently worked copy of the body has a cast of a copy of the head which is preserved in the Lateran. The long, compact, rectangular figure is handled with a restraint that bespeaks a skill very recently achieved. The only horizontal lines are formed by the hem of the garment and the folds of the upper part of the peplos at the waist. Only a few folds subdivide the upper part of the garment; the cubic form is not disturbed by any movement or action. The heavy oval of the lower part of the face is wonderfully balanced by the arrangement of the hair, which spreads thickly from the parting to the temples. The similarity between the type represented by this statue and female terra-cotta figures found in Argos makes it probable that the lost original was a famous bronze work from an Argive school of bronze casters and thus one of the most significant works of the Severe Style.

69 LAPITH WOMAN, from the west pediment of the Temple of Zeus, Olympia. 460–56 B.C. Olympia Museum. This figure comes from one of the struggling groups in the Battle of Centaurs and Lapiths. In this instance, the centaur, the front part of his body on its knees, steps into the lap of the woman with his left hind hoof; at the same time, he grasps her thick hair with his left hand, in order to pull her back and lift her onto

his back. The heavy, flowing mass of hair crowns the large, almost angular face of the woman, who, painfully twisting, sinks forward. The outlines of her body under the heavy garment are indicated particularly clearly in the legs, which are straining in opposite directions.

70, 71 METOPE, from the Temple of Hera (Temple E), Selinus. Hera and Zeus on Mount Ida. c. 460–50 B.C. 162 × 104 cm. Museo Nazionale, Palermo. The metopes of this temple are carved out of the local limestone tufa. This metope and one other were positioned in a prominent place above the pair of columns of the porch (*pronaos*) of the temple. The subject of this metope befits its position: the goddess Hera unveils herself in response to the desire of Zeus. Hera stands in a rigid, almost shy posture in front of the reclining figure of the god who desires her. Taking the hem of her veil with her right hand, she lifts it from her face and breast with a majestic gesture. The scene is impressively portrayed in a severe, still hesitant manner. A great theme is expressed in a halting, rather dry and formal language, in which details, such as the draperies, hair, and beard of the god, are somewhat stiff and formalized. Nevertheless, this is one of the most beautiful examples of South Italian and Sicilian art of the early Classical period; despite a certain clumsiness of style, the greatness of the design and its outlook speak powerfully. This metope in particular shows how the artists of the western Greeks, of the great colonial cities of southern Italy and Sicily, were able to apply the Greek heritage of the Archaic period to early Classical art and transform it in their own way.

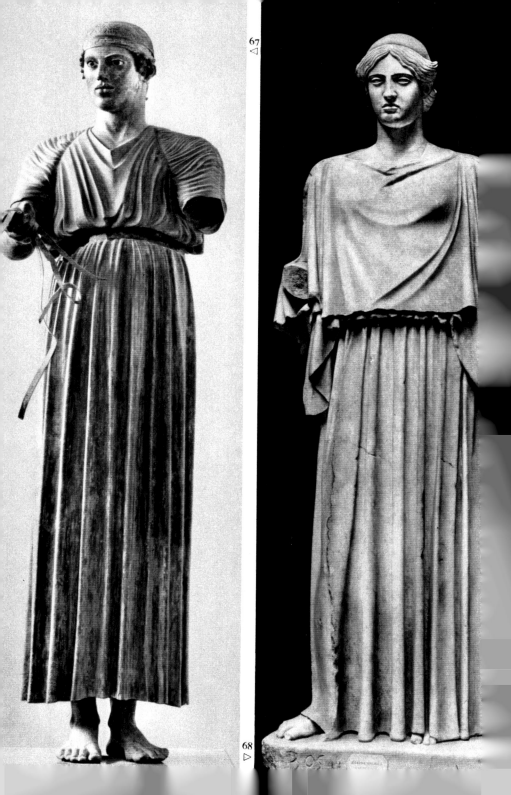

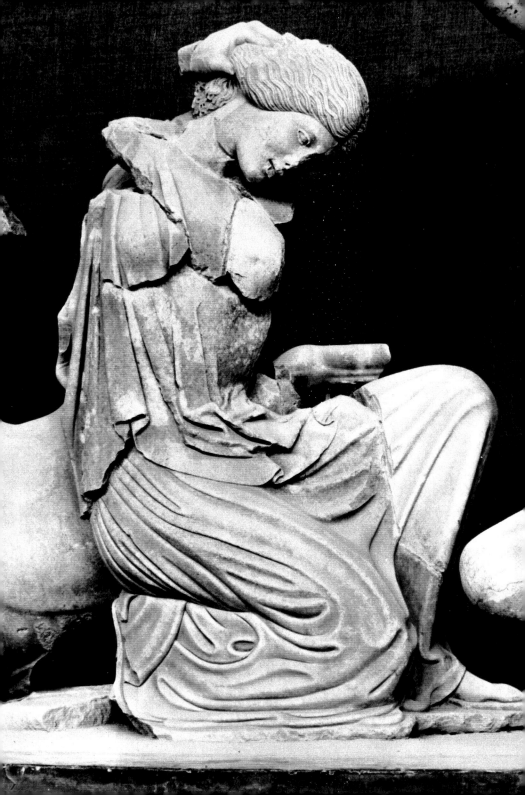

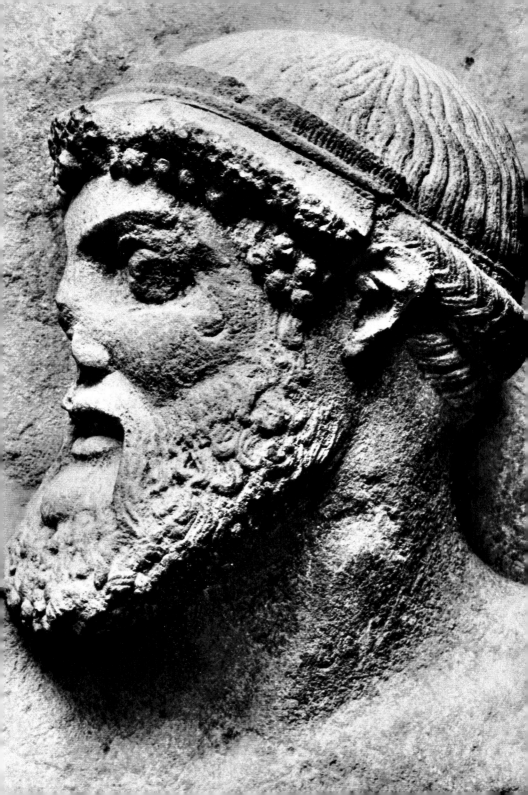

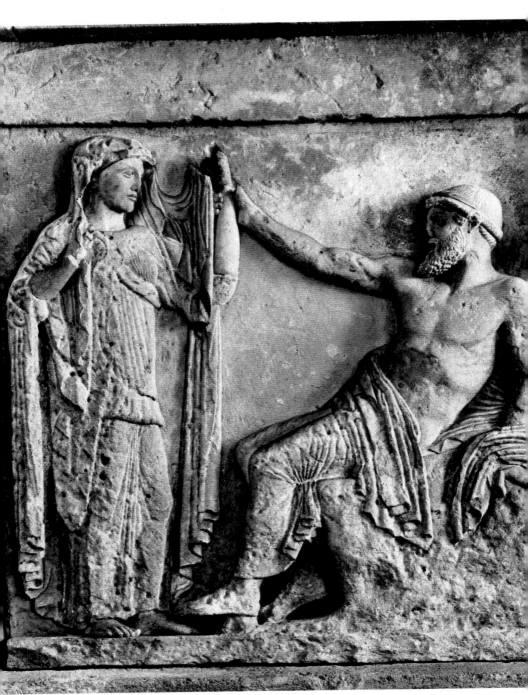

nature; each of the artists must have had a relatively free hand in the design of the individual metopes and the details of the execution. One of the most beautiful of the battle scenes shows the two opponents in a taut but generously conceived Classical composition (*81*). The Lapith seems to be formed on a larger scale than the cowering centaur. The youthful hero firmly braces his left foot and grasps the centaur by his hair. In his right hand he presumably held a lance with which he had pierced the back of the half-human, half-equine creature; he would accordingly be about to pull out the lance, an action which is rendered vivid by the equilibrium of the scene. With his right hand the centaur tries to touch the wound in his back. Skillfully intertwined, human and animal are locked in decisive combat.

The Parthenon frieze was 160 meters long and 1.06 meters high; the depth of the relief is never more than 5 cm. The frieze has a unified theme, the great Panathenaic procession that the Athenians held every four years. The cortege begins at the southwest side, where crowds of youthful riders gather; they are then shown in a beautifully balanced composition on the two long sides of the building, riding toward the eastern end. At their head, four-horse chariots with charioteers and hoplites advance in a burst of speed or in slow dignified motion. The rest of the long sides are filled with groups of citizens moving in procession, bearded dignified elders, musicians with flutes and *kitharas*, and men leading sacrificial animals. From both north and south sides, the procession turns onto the eastern face of the temple. Here is a centralized composition, in the middle of which is represented the handing over of Athena's Panathenaic garment to her priests. Six Olympian gods are seated at both the left and right and behind them appear groups of standing men, four on the right side and six on the left. These have been recognized as the heroes of the ten Athenian *phylai*, or tribes. They mediate between gods and mortals, even though, on the frieze, they are not brought into direct contact with the latter. Instead, at the head of the Panathenaic procession, young girls carrying sacrificial implements in their hands are received by magistrates. The division of the procession into two columns that meet on the eastern side of the frieze does not of course correspond to actual processions, which moved in one single column from the Propylaea (the gateway to the Acropolis) across the sacred hill to the east face of the Parthenon. The double disposition, however, had the artistic advantage of a centralized emphatic composition.

Among the gods at the right, between Apollo and Aphrodite, there is a lovely female figure whom we may identify as Artemis, for she is seated next to her brother Apollo (*82*). These gods at the eastern end of the frieze, because of their larger stature and inaction, demonstrate particularly well the skill with which the reliefs were made.

Of the two huge groups of figures in the eastern and western pediments of the Parthenon, very few remain. They are the figures which are seated or recline in the shallow ends of the

pediments and which were better protected because the raking cornice above the pediment was lower at the ends. In the eastern pediment is shown the birth of Athena from the head of Zeus. We have no clear conception of the scene of the birth itself, which was in the center of the pediment and has been destroyed. To either side, the news of the event spreads among the gods. Three mighty female figures from the right half of the pediment survive. Popularly identified as the Fates, they appear together in a magnificent group (*83*). One reclining figure rests the upper part of her body in the lap of a seated figure, who, in an almost violent movement, pulling in her legs and turning her knees in a sharp angle, seems to bend down over the reclining one. Further toward the center of the pediment, and separated from these two large figures (which are carved from one block of stone), is a third woman. The upper part of her body is erect, and she is shown in the act of moving her legs. The right leg is sharply bent, the left leg is pushed forward, and the foot rests firmly on the ground. This movement culminated in the head, which, like the right arm, was presumably turned to the center of the pediment. Thus, the effect of the action that has just taken place in the central scene can be followed in its development in these three figures. We may suppose that the woman nearest to the center has just heard the news of the great event; the next one bends forward to rouse her reclining companion, who, still half asleep, is hardly affected by the tidings. Identification of the figures is difficult even though they compose a compact group, united in form and content. The composition of these highly sculptural figures clearly follows the shape imposed by the pediment that contained them. The same is true of the reclining figure of a nude young man, who occupied the corresponding space at the left side of the pediment. Judging by the skin on which he rests (one paw of the beast emerges at the lower edge of the rocky support), he is to be identified as the god Dionysos (*84*). Lifting his head, and raising his right hand in a gesture of greeting, he looks toward the narrow end of the pediment, where his brother Helios is about to emerge from the waves of the sea in his chariot. Only the head, shoulders, and arms of the sun god appear above the surface of the water, together with the heads of his team of horses wildly thrust forward, with arching necks. The figure of Dionysos, however, is splendidly complete. He, too, appears to be rousing himself from his nightly slumbers. His back is turned to the dramatic birth in the center of the pediment; however, all-seeing Helios, rising from the sea in front of him, is perhaps about to notice it and announce it to his brother. Like the three female figures in the right half of the pediment, the figure of Dionysos is conceived in free, spacious movement, and effortlessly fits into the space available in the pediment.

Throughout the second half of the 5th century, the Classical face of the Acropolis took shape. The Erechtheion, the Temple of Nike, and the Propylaea were erected and decorated (see *117*). The last addition to the adornment of the Acropolis was probably the Nike para-

pet, which crowned the artificial southwest bastion of the Acropolis on which stood the Temple of Athena Nike (the goddess as giver of victory). The reliefs on the parapet, facing outward, are executed in a richly articulated and varied style; a number of the handmaidens of Athena Nike prepare a festival for her. One of the most beautiful of these figures is the Nike loosening her sandal (85). Since the style of the Nike parapet dates it to the late 5th century —about 410 B.C.— and since no reason for the erection of a monument of victory existed in Athens after the fall of Alkibiades in 408, the erection of this parapet should be dated to the years 410–08 B.C. Indeed, a connection can be found with the climax of Alkibiades's career in Athens, the period between his naval victory near Kyzikos in May 410 and his triumphal entry into Athens in 408 B.C.

The only sculptor of the high Classical age of the 5th century equal to Phidias the Athenian was Polykleitos of Argos. His art, however, is in complete contrast to that of Phidias. Phidias was a master of varied talents, a great organizer and planner, an inventive artist, full of imagination. Polykleitos restricted his sculpture to a few types, devised according to a fixed canon. Indeed, tradition has it that he established the rules of art he had worked out in a bronze statue entitled the "Canon" (Rule), his Doryphoros, the famous Spear-Bearer. A headless torso in Berlin gives a fine impression of this figure (94). The stance and pose —the turn of the head to the right and the position of the left arm—appear to have been admirably copied, and the statue still conveys something of the splendid balance and lifelike movement for which the original was famous. (Another copy of this statue in a more complete state of preservation is in the Museo Nazionale in Naples, and it reflects still more clearly the lovely proportions of this masterpiece of the Classical age.) The definitive quality of the Spear-Bearer, perhaps a figure of the hero Achilles, was recognized throughout antiquity, and a multitude of Roman copies and adaptations exist.

During the 4th century, Greek sculpture enjoyed a second flowering. Praxiteles of Athens and Lysippos of Sikyon were the two most important masters of the century, and like Phidias of Athens and Polykleitos of Argos they were artists of very different character. Praxiteles was active about 360–330 B.C.; Lysippos is assumed to have been creative for a very long period. In 370 he was already a recognized artist who received official commissions, and he was still active, toward the end of the century, about 310 B.C. This is clear from the style of his late works, as well as from a few surviving epigrams, which call him "Lysippos the old man." If we had a clearer conception of the works of his early period, we could deduce the development of sculpture during the whole century from his œuvre.

By Praxiteles we have an original—a rare piece of luck!—the Hermes in Olympia (95). Although it was cleaned and retouched in Roman times (there are traces of Roman tools on the stone), the fact that the statue itself is an original cannot be doubted. The scene

72 HEAD OF THE KASSEL APOLLO. Roman copy. The original, probably by Phidias, was made in the middle of the 5th century B.C. White, fine-grained marble. Height from pit of the throat to crown 38 cm. Palazzo Vecchio, Florence. The head probably belonged to the Medici. This Florentine copy of a famous Apollo, which is named after the best-preserved example of this statue, in Kassel, reproduces the Greek bronze original in a heightened, sophisticated Roman technique. The lost original—presumably by Phidias—surely rendered the forms of the head in a calmer, more restrained manner.

73, 74 VARVAKION STATUETTE. Detail. Roman copy of the Athena Parthenos by Phidias. White, probably Pentelic marble. Height with base 104 cm.; height without base 94 cm. National Museum, Athens, No. 129. The famous lost original of the Athena Parthenos by Phidias was made between 448 and 438 B.C., when Classical art had reached a climax. Despite its small format, this statuette is the most complete extant copy of the great gold-and-ivory image of Athena Parthenos. It was found in 1880 in Athens, near the present-day Varvakion School, carefully stored in a niche of a ruin of a Roman house, which explains its excellent state of preservation. Only a few parts are missing; some were repaired in antiquity, a few replaced in modern times. The imitation, which carefully renders many small details, has an almost scholarly character. The date of this Roman copy is uncertain; it was certainly made between the 1st half of the 2d and the 2d half of the 3d century A.D. Even though the parts of the original appear in a smaller and harder version, the Varvakion Statuette does give an impression of the solemn splendor of the lofty Classical Athenian cult image, covered in most elaborate ornament from the soles of the feet up to the three crests on the helmet.

75 CIRCULAR RELIEF, from Melos. Fragment. c.460 B.C. Parian marble. Maximum height of the fragment 32.5 cm.; maximum width 33.5 cm. National Museum, Athens, No. 3990. The background of the relief has a shallow convex curvature. The work has the shape of a round shield. The back of the tondo is flat and smooth. In the center is a hole for a peg, showing that originally the round relief was perhaps attached to a wall. The shape is unusual for a relief of the 5th century. Since in vase paintings the moon goddess Selene is sometimes shown in a similar medallion, one can probably interpret this beautiful delicate head as a portrait of this goddess, set within the disc of the moon.

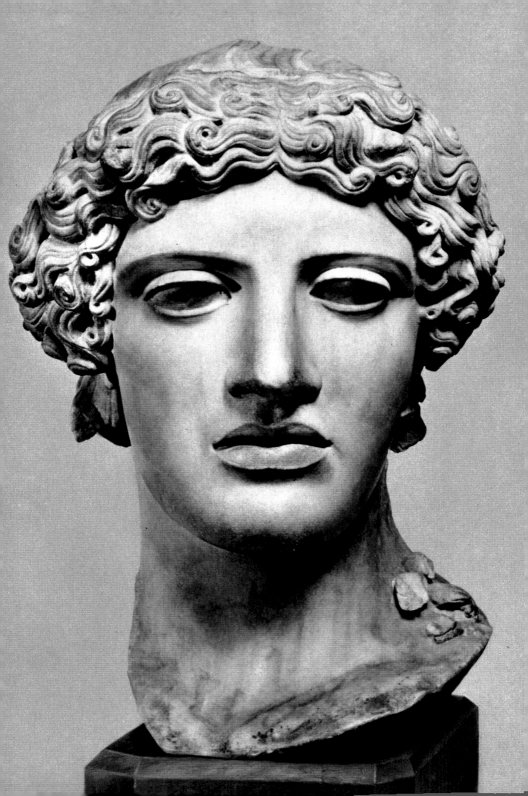

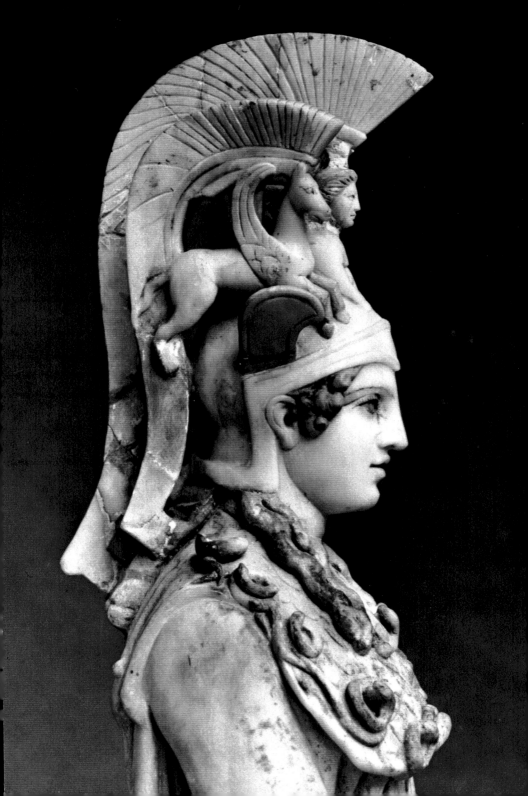

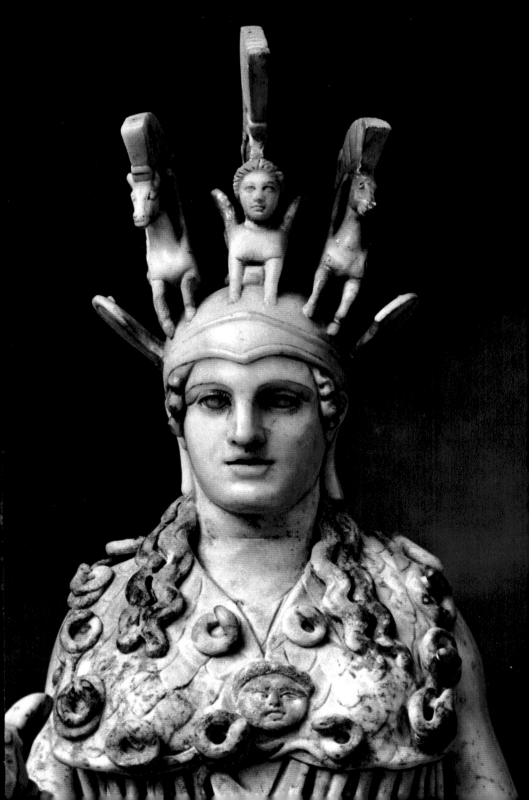

represented is Hermes, messenger of the gods, bringing the boy Dionysos to Greece. He is resting on his journey, his cloak thrown over a tree trunk, playing with the child. The group is from the mature period of the master, about 340 B.C.; its graceful, easily understood structure, its noble lassitude, and its delicate, intimate detail have the "noble simplicity and peaceful grandeur" the first great classical archeologist Johann Winckelmann attributed to Greek art as a whole.

Another creation of this master, the Sauroktonos (88), probably a work of his youth, shows Apollo killing a lizard. (One activity of this god of purification was the extermination of vermin.) The representation shows the youthful god, leaning on a tree trunk, lying in wait for a lizard, in order to kill it with a dart. Here, again, is a simple scene reflecting daily life. The tree trunk with the lizard crawling up it acts as a balance for the slender figure of the god and has a function as regards both the composition and its content. For this supporting tree trunk is as much conditioned by the motif as it is technically necessary. The tree trunk in the Hermes group has a similar duality of function, for it likewise is needed as a support, both for technical reasons and from the point of view of artistic content. These creations of Praxiteles neither endow the gods with the exalted significance of the high Classical age nor do they show them with the realism of the Hellenistic age—for instance, in the guise of a shepherd boy. The romanticism of the second Classical age is displayed in the playful inventiveness of these groups and in the soft idealism of manner of their execution.

According to legendary tradition, the great Lysippos is said to have created 2,000 works; yet, very few that are certainly his have come down to us, and these are all Roman copies. A statue of an athlete in the Vatican still represents for us the sum and essence of Lysippan art, as it did when it was found in Trastevere in Rome in 1849; it was immediately identified as the youth scraping oil from his body, the famous Apoxyomenos, by Lysippos (86, 87, 96). The simple everyday action of an athlete, who scrapes off the dust of the *palaestra*, explains the stance of this lively, exciting work of art. The raised right arm is held out into space toward the onlooker. The left arm, too, is raised and held out to the front of the figure, but at the elbow it is bent at a right angle, crossing the body of the athlete, in order to apply the scraper. The loose, flexible stance of the legs matches the elasticity of the arms. There is no sharp division between advanced and supporting leg. The feet are placed wide apart, the right foot and leg behind the left; the slender torso is easily balanced above the long supporting legs. The elegant body is crowned by a small head, which is raised and slightly turned to one side. The Apoxyomenos is a mature work of Lysippos; the famous wrestler Cheilon of Patrai died in 322 B.C., and, after his death, Lysippos made a statue in his honor. One may therefore regard the statue as the portrait of Cheilon. The face (86, 87), not at all

idealized, has a new sensitivity and nervousness, and its distant gaze conveys a momentary mood that points beyond the late Classical 4th century to the Hellenistic period, as it opens up new areas of artistic expression.

The Venus of Capua (*93*) is another Lysippan work. The goddess's cloak has slipped down from the upper part of her body, and is wound round her hips, covering the legs down to the feet. The left leg is slightly raised, and the foot rests on a small support; the right leg carries the whole burden of the body, as well as of the object that was once held in the arms. The nude torso, rising out of the mantle, is beautifully developed. Both arms are raised—as other Roman copies show, to support a shield in which the figure was mirrored; Aphrodite has picked up the shield of Ares in order to gaze at her reflection. The unusual position of the figure—for the motif of the shield supported on the knee and held with both hands makes the figure most effective when looked at from the side—and the wide extension of the arms, also well suited for a side view (the arms are probably correctly restored) remind one of other Lysippan creations, such as the Eros flexing his bow and the running figure of Kairos. However, the Venus of Capua is more likely to be a free Roman imitation of Lysippos than a faithful copy of a Lysippan original.

One of the few works of the late 4th century in which the art of Lysippos and the art of Praxiteles are perhaps reflected in conjunction is the Boy from Marathon Bay (*89*). In his left hand he carried a largish object. Perhaps it was a tray with implements for sacrifice, attached to the palm of the hand with a dowel, but the action cannot be surely interpreted. In spite of its accurate reflection of the style of the two great 4th-century masters, this romantic, almost overrefined statue moves further away from the Classical ideal than anything produced by Praxiteles or Lysippos. Working in a direction counter to this dreamy romanticism, the highly sophisticated, late Classical sculptor Skopas from Paros, who was active in the first half of the 4th century, is said to have developed a passionately expressive style, presaging the rejection of the high Classical canon by the artists of the Hellenistic period.

During the Hellenistic age, from the death of Alexander in 323 B.C. to the Battle of Actium in 31 B.C., the developments in sculpture can be traced more clearly than those in any other branch of Greek art; the course of this development can be divided, if not into decades, then at least into generations. The transition from the late Classical art of the 4th century to early Hellenistic art took place between about 320 and 280 B.C. In 281 B.C., the Athenians decided to erect a statue of the orator and statesman Demosthenes, and the commission was probably completed shortly after that year. The hard modeling of this famous statue and the emphasis on realistic portraiture documents the direction in which Hellenistic style was moving. After the middle of the century, the severity of this initial style

was replaced by a magnificent baroque realism, as exemplified by the famous the Dying Gaul and the group of the Gaul slaying himself and his wife. The great victory monument of which these figures formed a part was erected after the decisive victory over the Gauls won by Attalos I, king of Pergamon, immediately after his accession to the throne of the kingdom in Asia Minor in 241 B.C. The original bronze statues that composed this monument of victory, of which excellent copies in marble survive, were completed about 230 B.C. The monument was erected in the upper city of Pergamon.

The full flowering of the art of the Pergamene kingdom took place in the 2d century, during the reign of Eumenes II (197–159 B.C.) and Attalos II (159–138 B.C.). During that period, Hellenistic sculpture of high quality was executed in many parts of the Greek world, a world that now extended far into the East; but the art and architecture of Pergamon (see *147*), only one of several Hellenistic centers of culture, political power, and artistic achievement, is particularly well known, thanks to thorough excavations undertaken for many decades by German scholars.

The Great Altar of Pergamon remains the most brilliant and certainly the most sustained achievement of Hellenistic realism. Its fame was widespread in antiquity, so much so that the early Christians named it "Satan's seat." The Altar dominated the second of the three terraces of which the upper city was composed, being its sole large monument and having no direct connection with any temple or sanctuary (see *146*). It occupied the center of the terrace and was surrounded by other buildings and monuments.

Following eastern Greek custom, the Altar consisted of a mighty podium, 34 meters long and 37 meters deep, set on a substructure of four steps and a base. On the west side, opposite the Propylon at the entrance to the second terrace, a flight of steps, 20 meters wide, led up to the podium, where pillars enclosed a court. In this court stood the actual sacrificial altar. The massive podium was nearly 5.5 meters high. Along its sides was sculpted in relief the famous frieze of Pergamon, representing the Battle of Gods and Giants (*102, 103, 105, 106*). This frieze was nearly 200 meters long and consisted of over 100 single slabs, which were completed in a workshop before being set into the podium. A system of masons' marks, which can still be understood today, ensured that the slabs were placed in their correct sequence. At least twelve sculptors executed the different parts of the frieze, working in a studio, probably following a model that laid down the outline of the whole design as well as particulars of the various parts of the composition. The climax of the battle is on the eastern side, which faces the entrance to the terrace; Zeus and Athena are embattled among their adversaries (*105, 106*). Each of the gods, moving diagonally, dominates his particular area of combat, and, together, their diverging positions form a larger expanding group. The power of the design testifies to the skill of the artist who conceived it and

76 STATUE OF A GOD (Poseidon). Mid-5th century B.C. Bronze. Height 209 cm.; maximum extent of arms 210 cm. National Museum, Athens, No. 15161. The magnificent bearded man, legs wide apart, yet in perfect equilibrium, extends his right arm back to throw a weapon, and, pointing toward his target, stretches out his left. The missile was probably a trident, and the person represented, the god Poseidon. The figure unites superb poise with energetic movement. The well-balanced composition and the detailed, yet clear structure of the body suggest that the statue should be dated in the middle of the 5th century, the transitional period from early to high Classical art. The fuller modeling of the torso and the powerful sculptural structure of this bronze figure by an eminent master differentiate it from Attic works of the same period.

77, 78 GRAVESTONE OF A GIRL. c. 460 B.C. Parian marble. Height 143 cm. Staatliche Museen, Berlin. The girl is taking incense from a small box or pyxis—the lid lies on the ground—probably in order to scatter it on an altar, which is not represented. The figure is rendered in the broad bold relief of the Severe Style. Below the curved edge of the lapped-over material (*apoptygma*) at the waist of the garment a long triangular section of drapery was carved out in modern times. The upper part of the thigh is thus now shown in relief. The slender stele, which tapers toward the top, is crowned by a magnificent palmette finial. The lower part of the finial, between the volutes, displays two acanthus leaves; these are a decorative feature, disguising the juncture of the ends of the two volutes and the palmette with the molding.

79 FINIAL OF A GRAVESTONE. 2d half of the 4th century B.C. Pentelic marble. Height 105 cm. Metropolitan Museum of Art, New York. From two rows of acanthus leaves rise two fluted shafts which are slightly twisted round their axes and rolled into volutes; these support the palmettes. A heart-shaped palmette is set in front of a larger palmette, whose narrow leaves spread out individually like a feather fan. At the top of this larger palmette is a sculptured bud. All the parts of this elaborate ornamental motif are sculpted with mastery.

80 FINIAL OF A GRAVESTONE. 2d half of the 4th century B.C. Height 88 cm. Metropolitan Museum of Art, New York. The decoration of this finial is smoother, simpler, and more fluid in its structure and execution than the finial above (79).

81 LAPITH FIGHTING A CENTAUR. Metope from the south side of the Parthenon. c. 440 B.C. Pentelic marble. 120 × 127 cm. British Museum, London. The athletic body of the young Lapith who bends back toward the centaur on the right is splendidly displayed in front of the rich Classical drapery of the cloak, whose original coloring emphasized its shining marble whiteness. The pose of the centaur is more restricted; in fact, it is pressed in by the right edge of the metope. The taut, extended position of the young man's limbs, the tense poise of the torso, and the careful modeling may be regarded as an echo of the art of Myron.

124

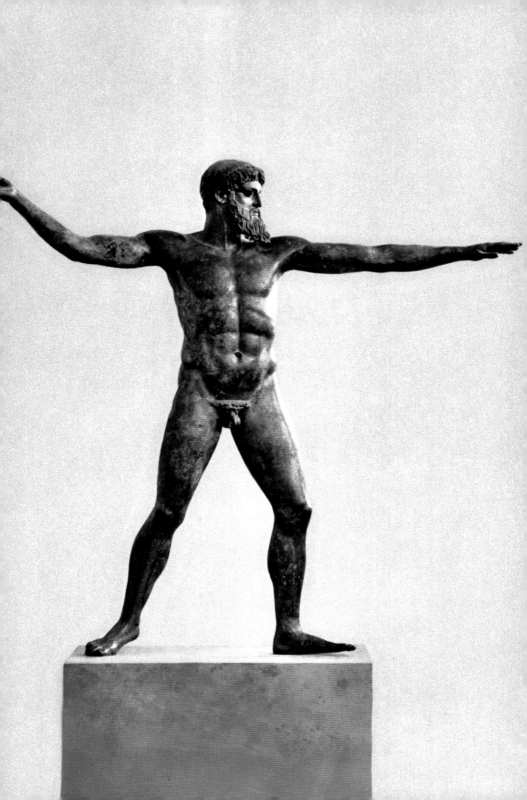



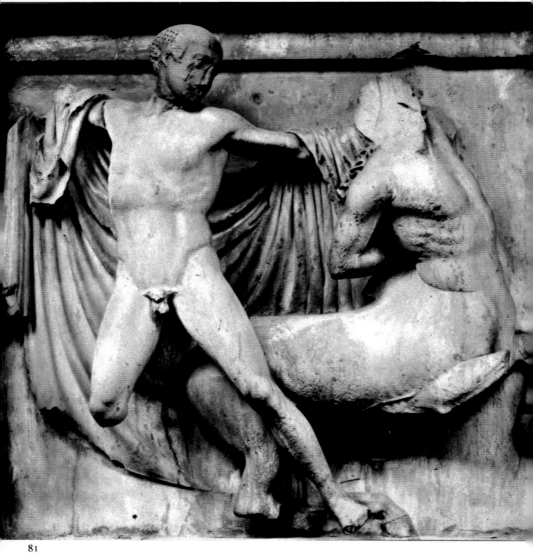

to the passionate interest of the workers who executed the various parts of the frieze. The figure of Aphrodite, who opens the battle at the far end of the north side, is calmer, yet filled with restrained fury (*102*). (The head of this soft, full figure has only recently been restored to it.) With her left foot, the goddess steps on the face of a fallen giant. Over her left arm is slung a shield, and her empty sheath hangs from a wide soft band. Accordingly, she must have carried a naked sword in her right hand, poised to strike the final blow against her youthful adversary. Another wonderful figure of the north side represents Nyx, the goddess of the night (*103*), one of the best-preserved figures of the whole frieze. The majestic goddess is depicted in grandeur and in the energy of action. In her right hand, stretched out far behind her, she holds a vessel decorated with a snake in high relief. Perhaps one may assume it to be the symbol of the great constellation Hydra which, in the midst of battle, the goddess of the night has plucked from the sky. With her left hand, she attempts to tear away her youthful opponent's shield. Although many parts are fragmented and missing, the great frieze of Pergamon is not only the most comprehensive but also the most impressive surviving testimony to the power of Hellenistic sculpture. The altar and the frieze were erected under Eumenes II, between about 180 and 160 B.C.

The famous Nike of Samothrace, now in the Louvre (*104*), is closely related to the figures of the great Pergamene frieze. The dating of this statue was long uncertain, but now a date in the high Hellenistic age has been generally accepted, for, when compared with the wonderful figure of Nyx on the Pergamon frieze (*103*), the Nike of Samothrace becomes its obvious contemporary. Only a small difference in time can have separated them. Some important historical event must have occasioned the dedication of the mighty monument that supported the statue of Nike, goddess of victory, which was found on the island of Samothrace in 1863. The figure stood on the prow of a ship worked out of a different kind of marble, to be found only on the island of Rhodes. Thus, it may be supposed that the Nike is not only a work of the famous Rhodian school of Hellenistic sculptors, but was also dedicated by the island and city of Rhodes. An occasion for the monument is to be found in the years 191–90 B.C., when Rhodes joined the Romans and fought victoriously against Antiochus III the Great of Syria. In the year 191, Antiochus suffered a crushing defeat in a naval battle near Side in Pamphylia, and in 190 in another naval battle near Myonnesos near Ephesos. The Rhodian admiral Eudamos made an important contribution to these naval victories, and it is quite possibly on his ship that the goddess, her garments blown back by the wind, alights at the moment of victory. The Nike of Samothrace illustrates the force and controlled emotion of high Hellenistic sculpture; in this new disciplined but highly theatrical style the old theme of the goddess of victory in flight achieves perhaps its most perfect expression.

By comparison with the Nike, whose stormy movements penetrate the space surrounding her, and with other creations of the first half of the 2d century, a precious bronze statuette of Poseidon (*97*), now in Munich, seems riveted within a compact visual area. Although the arms of the god are broadly and freely extended, although the stance is open and the head is inclined and turned to one side, the restriction of the statuette to a precisely defined frontal view is evident, and the head, with loose strands of hair, also indicates—in its hyper-refinement—the taste of the late Hellenistic age. Therefore, the Poseidon should be dated about half a century later than the Nike of Samothrace. A lovely terra-cotta statuette of Aphrodite, wearing a diadem in her hair (*92*), demands immediate comparison with the Aphrodite of Melos (or Venus de Milo), one of the most famous of all works of classical art (*91*). The counterposed parts of the terra-cotta statuette—legs against the arms, the head against the upper part of the body—still have the animation and spatial richness of high Hellenistic art of about 150 B.C. The pose of the famous Aphrodite of Melos, however, despite all the counterbalancing elements of its structure, is calmer, and cooler in the treatment of detail. A first breath of classicizing stillness pervades the figure and the highly regular features of the face. Since the modeling of the figure is flatter and offers broader, smoother surfaces, the Aphrodite of Melos should be dated in the second half, perhaps even at the end, of the 2d century B.C.

If we now compare a bronze statuette in Munich of a girl bathing (*100, 101*), which some scholars, following an old tradition, still date at the end of the Classical 5th century, to these two Aphrodites, the date of the bronze becomes obvious, though it has been much disputed. The complex, studied pose suggests a relatively late date, and the echoes of high Classical art can be explained as classicizing tendencies. Perhaps the statuette was made during the period of transition from the late Hellenistic age to the classicizing pre-Roman period; if so, a date around 100 B.C. seems justified.

The art of portraiture developed with especial richness and variety in Hellenistic times. Famous works—portraits of Plato and Aristotle, of Sophocles and Euripides—were produced during the high Classical age of the 5th century and throughout the 4th. Then, in Hellenistic times, the foundations of this art became broader, the styles more inventive and subtle, because the interest in individual characteristics became more profound. Among the many Hellenistic works that have come down to us, as originals and in the form of copies, there are some bronzes that bear eloquent witness to the impact and competence of Hellenistic portraiture. One of the most beautiful examples of this branch of art is a bronze head of a philosopher (*90*), the remains of a bronze statue, which was found in the sea near Anti-kythera. If the taut plasticity of the early Hellenistic age, the 3d century B.C., is no longer predominant, there is still no trace of the dissolution of forms that marks late Hellenistic

portraiture of the late 2d and early 1st centuries B.C. This handsome and vital representation of a philosopher should therefore be placed in the middle of the 2d century B.C.

82 ARTEMIS, from the east frieze of the Parthenon. c. 440 B.C. Pentelic marble. Height of the frieze 106 cm.; depth of relief 5 cm. Acropolis Museum, Athens. The cloak of the seated goddess Artemis is loosely gathered round her thighs. The generous chiton has slightly slipped down from her shoulder; with a graceful gesture of her right hand, Artemis holds its edge. Her face appears in perfect profile, and the clear lines were originally emphasized by a colored background. Head and body are rendered in the firm, high Classical relief that we admire on all parts of the Parthenon frieze.

83 THREE FEMALE FIGURES ("The Fates"), from the east pediment of the Parthenon. c. 435 B.C. Pentelic marble. Height 100 cm. British Museum, London. These three female figures, which survive only in part, are closely interrelated in composition and identity. If the reclining one is to be identified as Aphrodite, the woman who holds her in her lap could be her mother Dione or her companion Peitho; the woman sitting upright and slightly apart, might, in the latter case, be Dione, and, in the former, Hestia (goddess of the hearth). Although each of the three figures makes a beautiful individual sculpture, the three are brought into a unity in a composition of great refinement. Their positions constitute an ingenious but natural solution to the problem of filling the pediment, which, of course, narrows toward the ends. A great master of the mature Classical period created the models for all three figures; even the actual execution shows few variations in treatment.

84 DIONYSOS, from the east pediment of the Parthenon. c. 437–32 B.C. Pentelic marble. Height 121 cm. British Museum, London. This high Classical figure of Dionysos, reclining at ease on the skin of a beast of prey, is the only figure in the two pediments of the Parthenon to survive with its head in place.

85 NIKE LOOSENING HER SANDAL, from the parapet of the Temple of Athena Nike. c. 410–08 B.C. Pentelic marble. Height 104 cm. Acropolis Museum, Athens. The reliefs of this parapet show the attendants of Athena Nike preparing a festival of victory. This Nike is especially beautiful. She quickly loosens her sandal in order to enter the shrine of the goddess barefoot. The figure is poised in beautiful equilibrium over the slightly flexed left leg; the rich garments, cloak, and long chiton completely cover and yet reveal the body and the limbs with the utmost sensitivity; the bold long folds add new variety and refinement to classical drapery. The style that Phidias brought to life in the Parthenon frieze here achieves a final, gracious transfiguration. The high Classical frieze on the parapet is worked in relatively high relief, since it ran along the outside and could be seen only from a distance, when one walked around the Temple of Athena Nike.

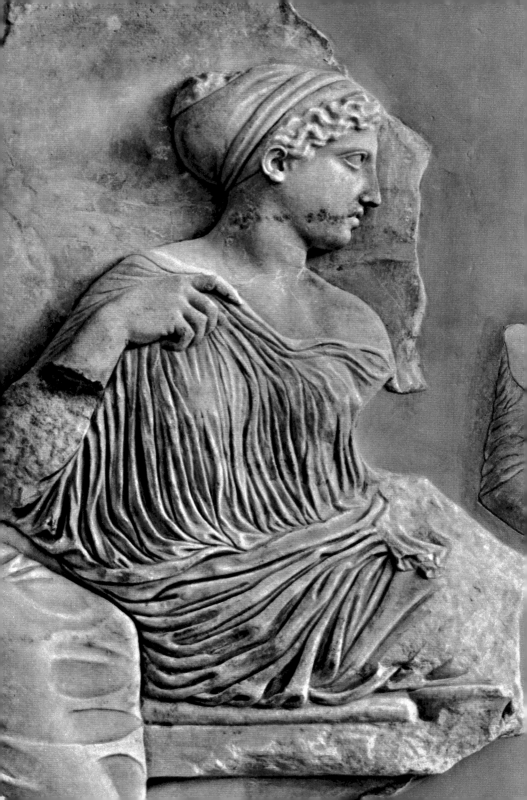

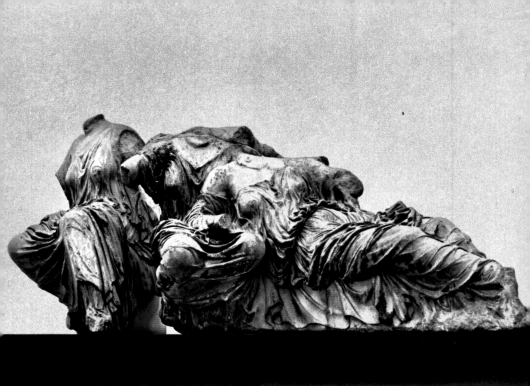

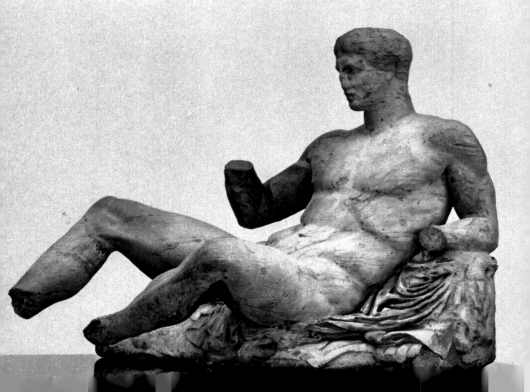

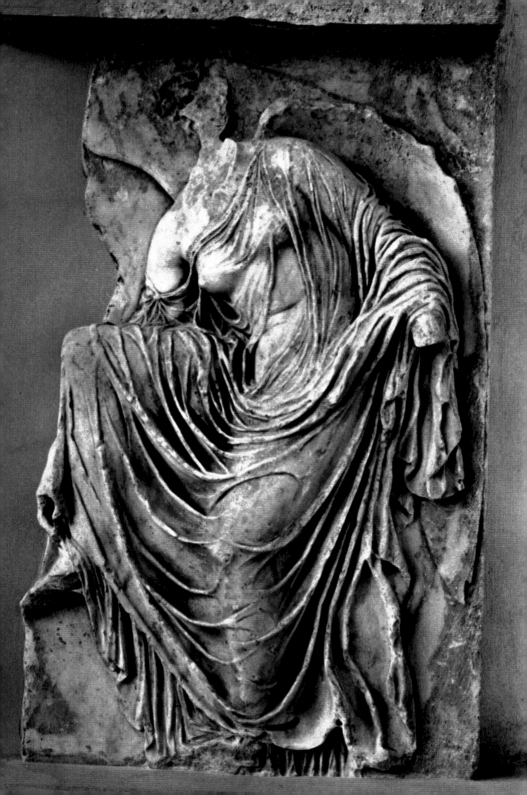

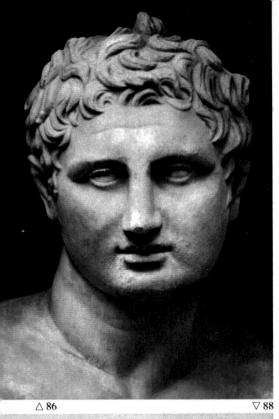

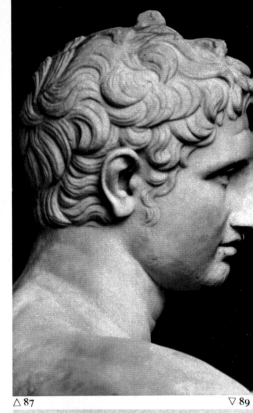

△ 86 ▽ 88 △ 87 ▽ 89

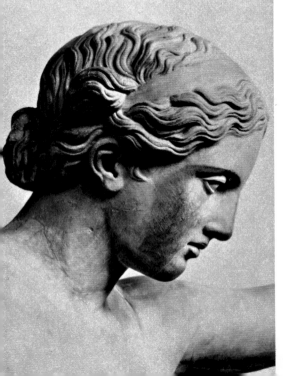

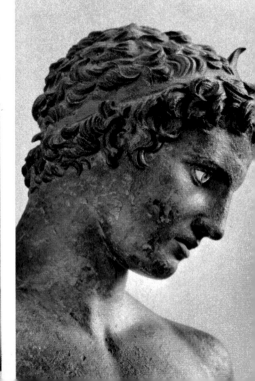

86, 87 APOXYOMENOS (Athlete Scraping Himself). Detail. Roman marble copy after an original by Lysippos of c. 320 B.C. Vatican, Rome. This head has a thoughtful, sensitive expression. The rendering of the hair is nervous, and the whole statue gives an excellent impression of the highly original, very personal art of the late Classical master. (See also *96*.)

88 APOLLO SAUROKTONOS (The Lizard-Slayer). Detail. Roman replica of a bronze original by Praxiteles of c. 350 B.C. Fine-grained, yellowish marble. Height of the figure 167 cm. Vatican, Rome. The statue was found on the Palatine in 1777. Large parts of the right half of the face and skull, as well as the nose and the left ear, are restored. Pliny mentions a bronze by Praxiteles, showing the youthful Apollo, lying in wait for a lizard, with a dart in his hand. The head of the god, with its fine profile and the elaborate, delicately arranged hair, has an almost girlish look. This graceful creation of Praxiteles, which was very famous in antiquity, and which exemplifies the lyrical style of the latter half of the second Classical age, survives in many copies.

89 BOY FROM MARATHON BAY. Detail. Late 4th century B.C. Height 130 cm. National Museum, Athens, No. 15118. This bronze original was found in 1925 in a shallow part of the sea near Marathon. The harmonious curve of the body is balanced by the gentle inclination of the head, which is turned toward an object that the figure held in its extended left hand. The bronze is in an excellent state of preservation. Even the inset eyes which so vividly project a thoughtful, sensitive glance, are intact. Head and face of this late Classical bronze statue show an intermingling of the style of Lysippos and of the late work, in particular, of Praxiteles. The eye is made of white stone in which is set a yellowish glass, ringed in black, representing the cornea. The pupils are missing. The head, with its loose, rich curls, in encircled in a narrow band, which ends in an upturned, leaflike twist above the brow.

90 HEAD OF A PHILOSOPHER, found in the sea near Antikythera. Mid-2d century B.C. Bronze. Height 29 cm. National Museum, Athens, No. 134000. This head, part of a shipwrecked cargo, was recovered at the beginning of the 20th century, with a right arm, feet in sandals, calf, parts of a cloak, and a left hand holding a staff. We are thus probably dealing with the representation of a wandering philosopher, presumably a famous Cynic. The whole statue—as is indicated by the vivid head—must have exhibited a poignant realism.

91 APHRODITE OF MELOS (Venus de Milo). Late 2d century B.C. Probably Parian marble. Height 204 cm. Louvre, Paris. The statue was found on the island of Melos in 1820 and was taken to the Louvre in 1821. The late-Hellenistic figure is composed of two blocks of marble; the joint runs just above the garment tied round the hips. The pose clearly reflects models of the 4th century, but the figure has a coolness and stiffness that characterize works done in imitation of Classical sculpture.

92 STATUETTE OF APHRODITE. c.150 B.C. Terracotta. Height 38.5 cm. Staatliche Museen, Berlin, Antikenabteilung. This figure, a composition characterized by strongly contrasting movements, probably represents the goddess of love occupied with her toilet. The fullness of the body and limbs, the generous, well-differentiated drapery, and the undulating composition indicate that this is a work of the high Hellenistic age, of the mid-2d century.

93 VENUS OF CAPUA. Roman replica of a Lysippan statue of c.350 B.C. made in the reign of the Emperor Hadrian. Height, 210 cm. Whitish-gray marble. Museo Nazionale, Naples. The figure was found c.1750 in the amphitheater of Capua. Restorations: arms, nose, parts of the cloak. The free, sweeping rhythm of this bold creation is characteristic of Lysippos. This rhythm embraces the whole statue, from the feet—the left foot is set forward in an almost hesitant manner—to the gracefully positioned legs and the slender torso with the open arms. The idiosyncratic, somewhat precarious position of the figure, the interrupted rhythm of its contours, and the proportions, which taper toward the head, seem to point to a youthful work, created by the great late Classical master.

138

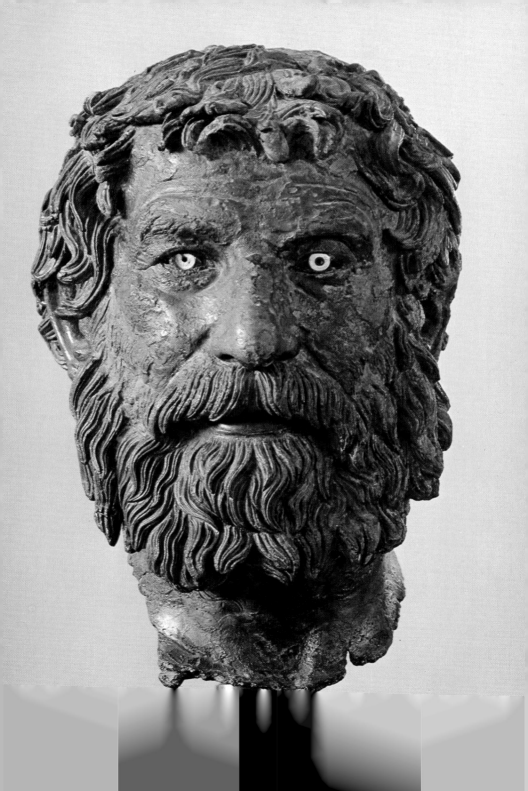

94 TORSO OF THE DORYPHOROS (Spear-Bearer). Roman copy of a statue by Polykleitos. Found on the Palatine, Rome. The lost original was made c. 440 B.C. Pentelic marble. Height 131 cm. Staatliche Museen, Berlin. Only surviving as a torso, this Classical copy is perhaps the best rendering of the high Classical Spear-Bearer by Polykleitos. The details of the bronze original seem expertly rendered in this marble work. The advanced and supporting legs are sharply differentiated, and, as a result, the pelvis is tilted. This tilt is balanced by a movement of the shoulders in the opposite direction, so that the right shoulder is lower than the left. The firmly positioned supporting leg is balanced by the right arm, which hangs down freely, and the lightly flexed advanced leg is balanced by the left arm, which was at an angle. The position is natural, beautifully balanced, and compositionally interesting. The head, as is shown in other copies, was turned toward the right shoulder in a slight but noticeable movement; the left hand held a spear. The fragment of an excellent replica of the head of the Doryphoros, which was also found on the Palatine and is preserved in the Museo delle Terme in Rome, perhaps belongs to this torso.

95 HERMES. c. 340 B.C. Parian marble. Height 215 cm. Olympia Museum. This late Classical original was excavated in 1877 from the cella of the ancient Temple of Hera in Olympia. Restorations: right and left calves, left foot, lower part of the tree trunk. The statue is supported by the right leg of Hermes and by the tree trunk with a garment spread over it. The flexed left arm is supported by the trunk and holds the boy Dionysos; the right arm was lifted up, and the hand held a bunch of grapes toward the boy—as is shown by a Pompeian wall painting. The playful motif corresponds to the idyllic peace and remoteness indicated by the setting. The back of Hermes and the tree trunk show traces of reworking, which, judging by the tools that were used, must have been done in Roman times. Also, the front of the torso, which looks polished, was cleaned, probably in modern times. There can, however, be no doubt that this statue is the original work by Praxiteles, which Pausanias described in the 2d century A.D.

96 APOXYOMENOS (Athlete Scraping Himself), found in Trastevere, Rome. Roman copy after an original of c. 320 B.C. Fine-grained, whitish-yellow marble. Height 205 cm. Vatican, Rome. The state of preservation is surprisingly good. Restorations: part of the nose, the left ear, the support linking the left hand and the breast, parts of the scraper and the right thumb, and the edges of the plinth. This is a good copy of a work of the mature period of Lysippos. The proportions of the long lithe legs, with the rounded trunk, are typical of Lysippos, together with the momentary stance. The nervous, high-strung expression of the face, linked with the strangely uncertain glance of the eyes, give the impression of a portrait; certainly, the face is individualized. In this romantic, late Classical work, the statue of the victor, which for two centuries had been such a frequent subject for sculpture, appears to have discarded its anonymity. (See also *86, 87*).

97 POSEIDON. c. 150–40 B.C. Bronze. Height 30.5 cm. Antikensammlung (formerly Collection Loeb), Munich. The statuette is preserved complete, except for the feet and the trident, which have been restored. An important sculptor in bronze of the late Hellenistic period has succeeded in conveying the nature of this god's own element, the sea; the sea is evoked by the undulating rhythm of the figure, the wide unfolding gesture of the arms, the furrowed face, and the windswept strands of hair and wreath of reeds. The figure is not only a symbol or representation of the sea, but its actual embodiment.

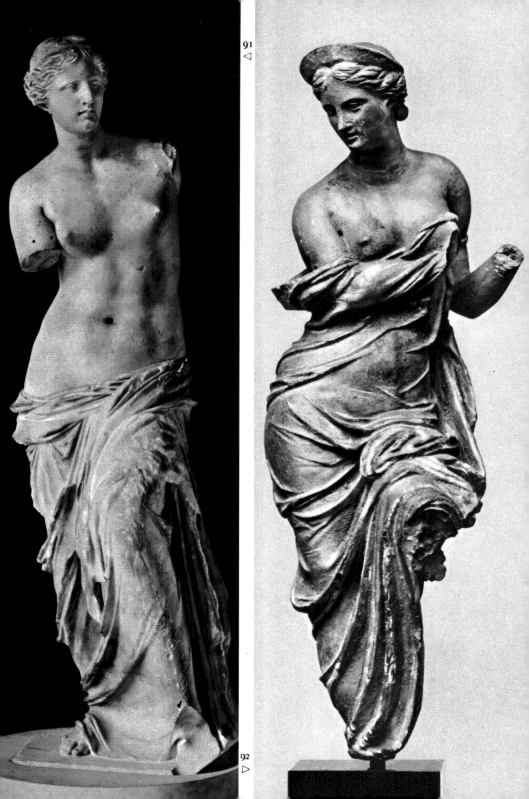

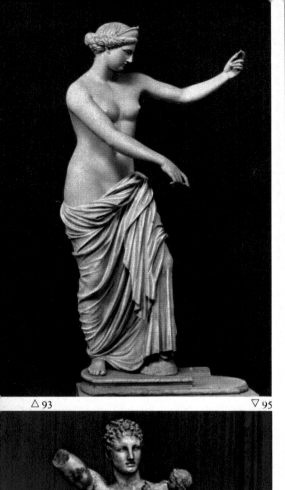

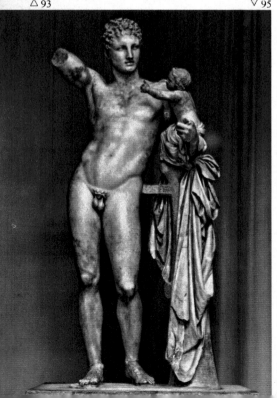

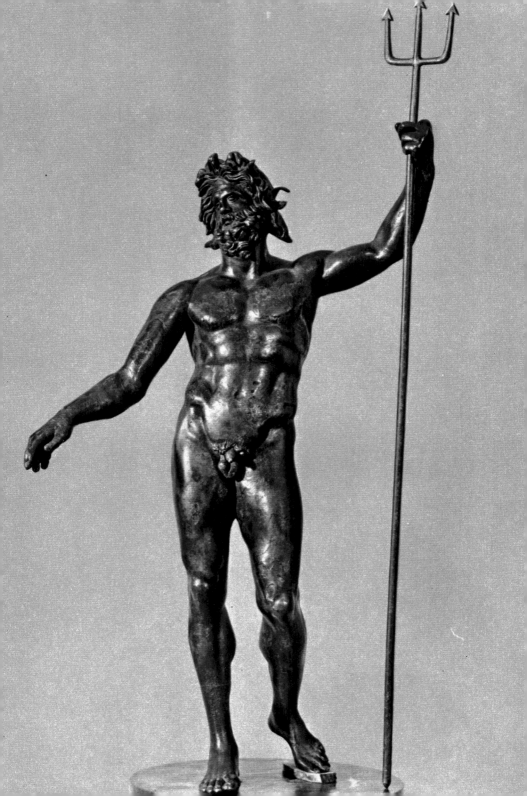

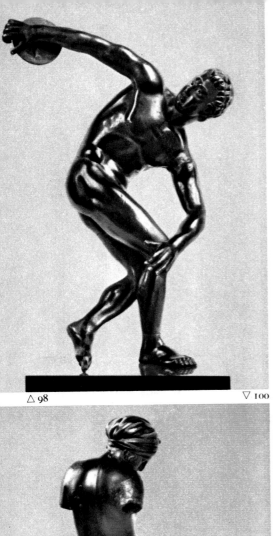

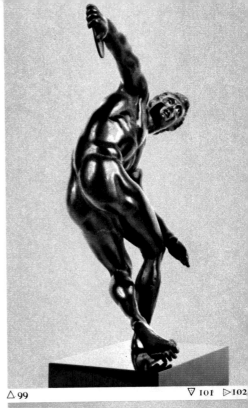

△ 98 ▽ 100 △ 99 ▽ 101 ▷102

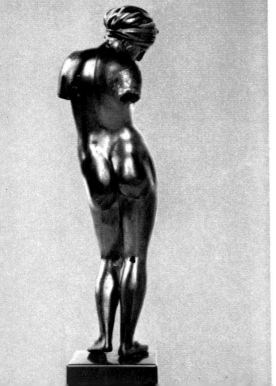

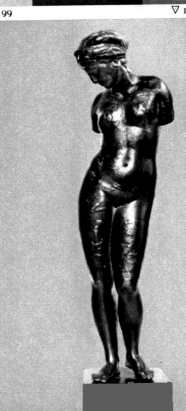

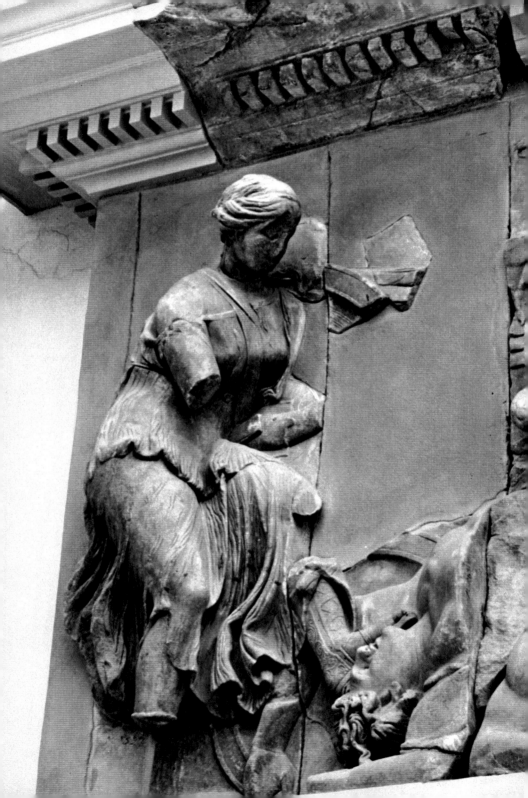

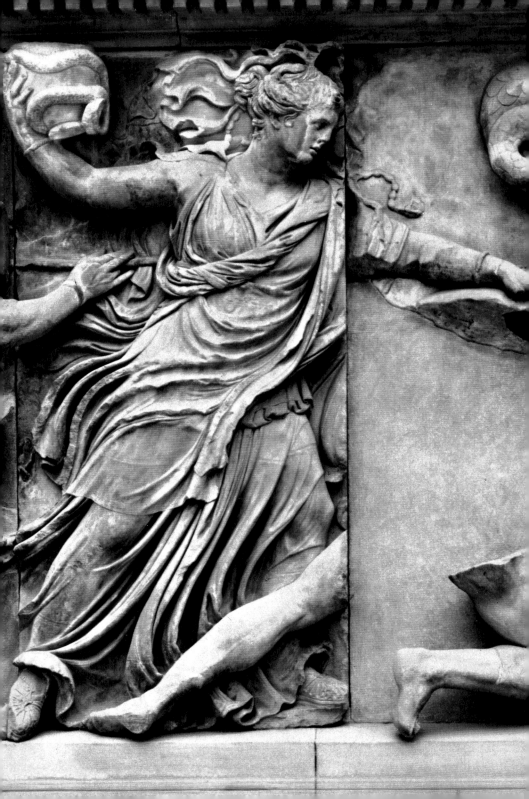

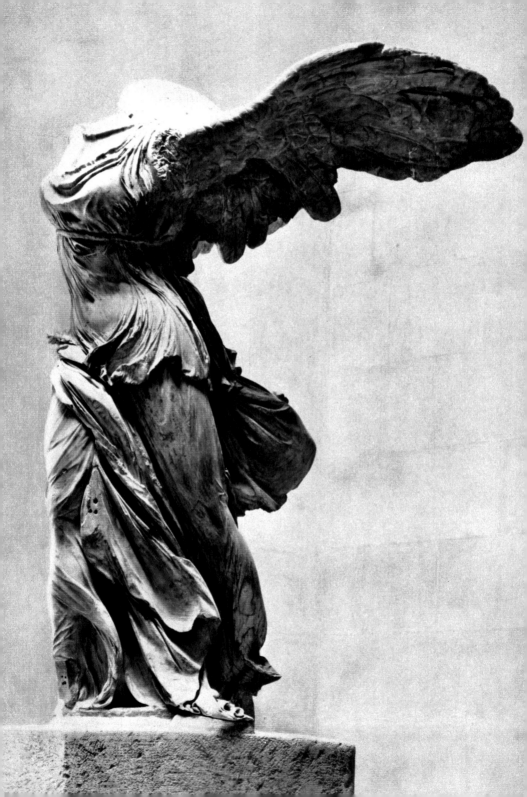

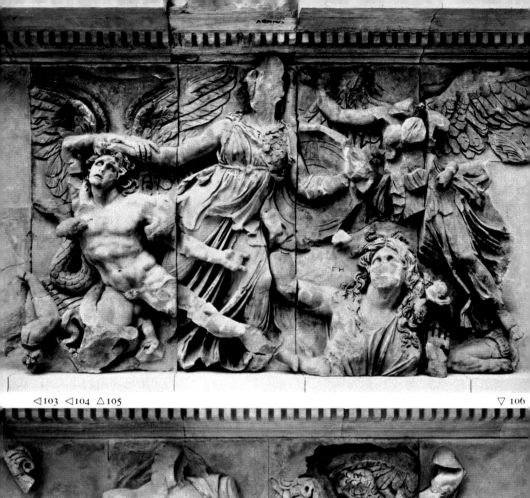

◁103 ◁104 △105 ▽ 106

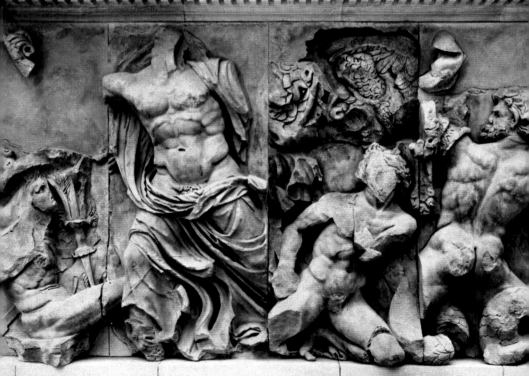

98, 99 DISKOBOLOS (Discus-Thrower). Roman replica of the famous statue by Myron. The original was made shortly before the middle of the 5th century B.C. Bronze. Height to the shoulder 28 cm. Antikensammlung, Munich. Restored right foot and discus. Judging by the style of the head, the replica was made c. A.D. 200. Unlike Myron's original, which was undoubtedly modeled with calm, restful surfaces, the copy exhibits a sculptural exaggeration of features and muscles. Nevertheless, this statuette gives an impression of the unusual pose and vigor of the lost bronze statue. Like the original, the copy is made of bronze, and the rendering as a whole is good. An athlete throwing a discus rotates at least once, turning on his right foot; it is admirable to see how the artist contained this whirling movement in a single composition. The idea created by studying only the side view—that we see merely a wide backward swing of the right hand holding the discus—is quite incomplete; for a full understanding of this three-dimensional work of art a comparison of its different aspects is necessary.

100, 101 GIRL BATHING. c.100 B.C. Bronze. Height 25 cm. Antikensammlung, Munich. The statuette was supposedly found in Beroea, the modern Veroia, in central Macedonia. The arms, now missing, were cast and attached separately. This late Hellenistic statue, which is distinguished by a certain Classical polish, is a very fine hollow cast (the thickness of the metal averages 1 mm.). On the back, there are small carefully inserted patches, which in antiquity were customarily hammered into a work in order to fill up small faults in the cast. The very dark, black-green patina is Classical. The eyes and a narrow strip at either end of the ribbons of the headdress are inlaid in silver. The pupils were made of colored glass or stone.

102, 103, 105, 106 SCENES FROM THE FRIEZE OF THE GREAT ALTAR, PERGAMON. c.180–60 B.C. Marble from Asia Minor. Height of the frieze 230 cm.; depth of relief 50 cm. Staatliche Museen, Berlin. Aphrodite (*102*), Nyx, goddess of the night (*103*), Athena (*105*), and Zeus (*106*) are shown fighting against giants. The frieze, composed of 118 slabs lining the podium of the altar, 190 meters long, was of colossal dimensions. The huge, over-life-size figures, sculpted almost in the round, re-enact the Battle of Gods and Giants with baroque expressiveness. The figures are highly dramatic, animated, and vigorous, and reflect all the characteristics typical of the high Hellenistic age. The wild energy and emotion, however, are successfully muted and contained by the horizontal lines of the altar— the heavy, molded base below the frieze and the elaborate protruding cornice above it. The Great Altar was erected by Eumenes II of Pergamon (197–159 B.C.) in commemoration of the victories of his father Attalos I (241–197 B.C.).

104 NIKE OF SAMOTHRACE. c. 180 B.C. Parian marble. Height 245 cm. Louvre, Paris. Excavated in 1863 in the Sanctuary of the Great Gods on the island of Samothrace. The left wing and the right breast are restored. Further excavations in 1950 produced the right hand of the figure as well as part of the right ring finger and thumb; the hand held a narrow wreath of victory. The lost head was slightly turned toward the right shoulder. The mighty statue stood—like a living figurehead—on the prow of a stone ship above the sanctuary of Samothrace, on the other side of a gully. A niche had been cut into the mountainside for both ship and figure. Presumably the observer saw the figure obliquely from its left side, and in this main view, the full richness of the composition is seen at its most effective. The head was turned north, toward the sea. With every fold of its fluttering garments the high Hellenistic figure expresses the passion, elation, and evanescence of victory.

ARCHITECTURE

As in most early cultures, the first monumental architecture in Greece was religious in nature. Even in Classical times the cult of the dead required no architectural monuments but funerary mounds and gravestones; the temple was the first and, for a long time, the only form in which the Greeks realized architectural ideas that transcended mere utility or necessity. The earliest temples of which remains survive date from the Geometric period. Generally, they were long and narrow structures with central interior supports, and a porch supported by columns in front (*pronaos*); later the enclosed structure, or cella, was often surrounded by a colonnade, and further elaborated by an additional porch at the back (*opisthodomos*).

A temple with a surrounding (peripteral) colonnade was built on the island of Samos in the 8th century. This Temple of Hera was 100 Samian feet—that is, 33 meters—long, but only 6.5 meters wide. In the interior, the long sides were subdivided by a series of supports that carried crossbeams on which stood the supports of the central beam of the roof. The result was an unusual narrow, corridorlike room, in which it is difficult to imagine a cult image, or a religious ceremony taking place. Methods of construction of the early temples remained modest and traditional. A shallow foundation of rubble supported the walls of the cella, built of sun-dried bricks and strengthened with beams. The inner supports as well as the columns of the colonnade were of wood and rested on stone slabs. The rafters and the low-pitched roof were also of wood; frequently the edges of the roof were faced with terra-cotta slabs, and the roof was covered with clay tiles. This type of building has been recorded in excavations in the Greek islands, the Peloponnese, and central Greece. It is important to note that even in these simple buildings all the important problems of Greek architecture were posed. What would become the Doric temple of mainland Greece and the Ionic temple of eastern Greece and the islands found their earliest and principal definition in these precursors of monumental stone architecture. At that time were developed the first syntax and grammar, so to speak, of Greek architecture.

The development of the Doric order or repertory of forms (*107, 111*) and the Ionic order (*108, 109*) occupied many generations of architects and builders. Many experiments were made and experiences gathered, before these orders found, if not a final, then at least a definitive expression in the stone buildings of the 6th century. In both cases—especially when the temple involved had a peripteral colonnade—a threefold subdivision of the structure became the rule: steps, columns, and entablature. This seemingly so obvious, and, to us, so familiar a sequence is expressed particularly strictly and logically in the Doric temple (*118–23, 130–32, 135*). The entablature repeats the forms and proportions of the structure

as a whole (*107*). One may regard the inferior band, the architrave, as corresponding to the steps of the temple, the foundation of its construction; above it, the frieze, with the vertical rhythms of the grooved triglyphs and the metopes that fill the intervals between them, can be viewed as a skillful repetition of the columns and intercolumniations of the temple below; finally, a projecting cornice (*geison*) forms the final horizontal conclusion of the building as a whole and of the entablature in particular. The sloping edge of the roof enclosing the triangular pediment, a gutter (*sima*), and the *akroteria*—those sculptural decorations on the corners of the pediment—form the ultimate conclusion of the two principal façades of the building. On the flanks, the structure is repeated in the same sequence, but above the raking geison, which follows the slope of the roof, is set a sima with waterspouts or individual antefixes. As blunt yet impressive as the other elements of the order, the Doric column rises directly from the temple pavement to the plain capital composed of *echinus*, a rounded upward curving molding, and *abacus*, a square block (*118*). This rather severe style spread mainly in southern Greece and the Greek colonies in southern Italy.

Eastern Greece—Asia Minor and the Greek islands—was the home of the more varied Ionic style. But rather in contrast to the luxurious Ionic style of temple architecture as developed in Asia Minor is the precise, meticulous, and terse variation of the Ionic built in Attica. It found its perfected expression in the Athenian Erechtheion and the Temple of Nike on the Acropolis. Its basic forms also consist of step course, Ionic columns, and entablature (*108*, *125*). The Ionic architrave, however, is divided into three narrow horizontal bands that echo the steps below even more forcefully. The bands are crowned by a richly ornamented molding. The frieze consists of a continuous band, rather than the Doric triglyphs and metopes; the narrow geison is also decorated with ornaments. The Ionic column (*109*) does not rise directly from the pavement, but is cushioned at the base by a system of concave and convex moldings, known as *trochilus* and *torus* (*125*, *126*, *127*, *129*), and is decorated at the neck by ornaments carved in relief (*112*, *125*, *133*). It is further distinguished from the Doric column by a capital that substitutes graceful volutes for an echinus (*112*). The Ionic style is also characterized by a predilection for swelling, Oriental, decorative structures.

Two architectural ornaments from the Treasury of the Siphnians at Delphi (*136*, *137*) give an idea of the beauty of Archaic architectural decorations of Ionic origin. In about 530 B.C., the wealthy island of Siphnos erected a treasury in the sanctuary of Apollo at Delphi which was covered with sculptural and ornamental adornments. A relief frieze of precious Parian marble surrounded the building on all four sides. Two delicate Archaic figures of girls appear at the front, between the pilasters, supporting the entablature of the porch. In the pediment above, the contest between Herakles and Apollo for the Delphic

tripod was represented in high relief. Apart from these sculptures, there were also elaborate moldings and other decorations on all sides of the building from the base of the wall up to the cornice. On one of the blocks there is a palmette-and-lotus frieze with egg-and-dart ornament above and a delicate strip of bead-and-reel below (*136*); another shows larger bands of bead-and-reel and palmette-and-lotus and, above, a band of leaf-and-dart (*137*). These architectural decorations are both delicate and lush, and their forms are rendered in bold relief. A comparison between these Archaic decorations and later examples is revealing. An excellently preserved ornamented cornice survives, which formed part of the ornamental frieze that crowned the ashlar walls of the Ionic Erechtheion on the Acropolis of Athens (*138*). Within the long building period of the structure it should be dated around 420 B.C. Another comparable architectural fragment (*139*) comes from the Temple of Asklepios in Epidauros, which was erected in the first half of the 4th century. All of these architectural fragments, which belong to three different buildings and centuries, have a palmette-and-lotus frieze as the main ingredient of their decoration. A band of egg-and-dart, and the Lesbian cyma, an ornament of leaves with a ridge in the center separated from one another by a thin dart, also appear (*137, 138*). The block from the cornice of the Treasury of the Siphnians shows a broad and full version of the lotus flowers, and the palmettes between them are more succinctly handled (*137*); the frieze (*136*) has firm and slender lotus flowers, while the palmettes and their volutes are broad and bold. The block from the cornice of the Erechtheion (*138*) deals with the same vocabulary of forms in the concise and severe language of the high Classical age. This palmette-and-lotus frieze appears as if cast in metal and set on top of its background. The band of egg-and-dart above has a compact sequence of ornaments sculpted with the utmost precision. The Lesbian cyma at the top is rendered in bold style, with clear contrasts of light and shade. On the block from the cornice of the 4th-century Temple of Asklepios in Epidauros, the severe terminology of Classical forms has been loosened (*139*). The frieze of palmette-and-lotus is less distinguished; the background area has become more important, and next to the palmettes are set undulating, animated plant decorations. The forms of the band of egg-and-dart above are more disjointed. These examples give an impression of the development of architectural decorations from the bold full forms of the 6th century to the more compact Classical forms of the 5th century, to the disrupted, differentiated, and isolated forms of the 4th century B.C.

Among the oldest stone temples in Greece are the Temple of Hera at Olympia (*118*), begun in the late 7th century B.C., and the Temple of Apollo at Corinth (*114, 122, 123*), of the mid-6th century. Both are in the Peloponnese and thus were built in the Doric style. While the temple dedicated to Hera was originally surrounded by wooden columns, which were gradually in the course of the centuries replaced by stone ones, the Temple of Apollo

at Corinth is one of the earliest known examples of a temple which from the outset was planned and executed in stone. Its ground plan still has a relatively elongated form, with six columns on the façades and fifteen on the sides (*114*). It is questionable whether this elongation is to be understood as a traditional feature, derived from Geometric times, or whether practical considerations gave rise to it, since the actual sanctuary consists of two rooms—an eastern one with eight columns, almost twice as large as the western one with four columns. Of the thirty-eight exterior columns, seven are still standing (the structure was, of course, vulnerable to earthquakes, which are frequent on the Isthmus). These massive columns from the southwest corner, each shaft worked out of a single block of stone, each still supporting the remains of a massive architrave, are today the most magnificent extant example of Archaic Doric architecture in Greece (*122, 123*).

The Heraion at Olympia, built about 600 B.C. or earlier, is older than the temple at Corinth. It, too, is elongated (six columns across the short sides, sixteen across the long) and has porches at front and back, but the cella is composed of one long room with two rows of columns supporting the roof. Some of its columns and capitals have very archaic forms (*118*), but others date from the Classical period and later.

Two temples of the high Classical age, the 5th century, are still standing, which even in antiquity were regarded as perfect examples of Greek architecture: the Temple of Zeus at Olympia, whose architect was Libon of Elis, and the Parthenon on the Acropolis of Athens, designed by Iktinos and Kallikrates with presumably the active participation of the sculptor Phidias, to whom Perikles had entrusted the direction of the whole enormous building program. They were built during that great and happy period, the fifty years between the Battle of Salamis (480 B.C.) and the beginning of the Peloponnesian War (431 B.C.). The Temple of Zeus was begun about 470, and was completed in 456 B.C. The Parthenon, according to inscriptions that survive in fragments only, was erected between 448 and 432 B.C. These two temples may be regarded as the most famous on the Greek mainland. Both contained cult images by Phidias; both were built in the Doric style; both were richly decorated with sculptures. There are, however, important differences between the two buildings, as becomes clear by a glance at the ground plans. The Temple of Zeus (*115*) is an example of strict Doric design; the Parthenon (*116*) has a distinct, novel character of its own—it is a unique, highly individualistic creation.

The Temple of Zeus at Olympia displays the more usual Doric set of six columns across the front (*130*). The cella is firmly contained by the framework of the columns. As is also true of the earlier Temple of Apollo at Corinth, the walls of the cella are aligned with the second column of the façades, and the porches are aligned with the center of the second intercolumniation at either end of the long sides. Thus, the width of the passages at front

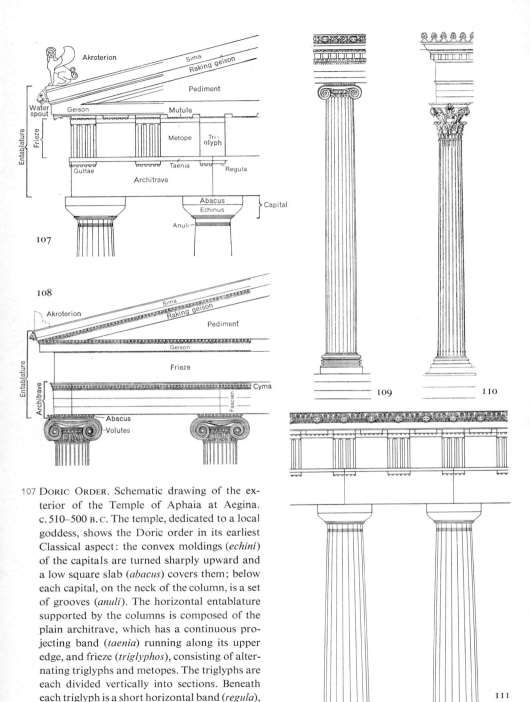

107 Labels: Akroterion · Sima · Raking geison · Pediment · Water spout · Geison · Mutule · Frieze · Metope · Tri- glyph · Entablature · Guttae · Taenia · Regula · Architrave · Abacus · Echinus · Capital · Anuli

108 Labels: Akroterion · Sima · Raking geison · Pediment · Geison · Frieze · Cyma · Entablature · Architrave · Fascien · Abacus · Volutes

109 · **110** · **111**

107 DORIC ORDER. Schematic drawing of the ex-
terior of the Temple of Aphaia at Aegina.
c. 510–500 B.C. The temple, dedicated to a local
goddess, shows the Doric order in its earliest
Classical aspect: the convex moldings (*echini*)
of the capitals are turned sharply upward and
a low square slab (*abacus*) covers them; below
each capital, on the neck of the column, is a set
of grooves (*anuli*). The horizontal entablature
supported by the columns is composed of the
plain architrave, which has a continuous pro-
jecting band (*taenia*) running along its upper
edge, and frieze (*triglyphos*), consisting of alter-
nating triglyphs and metopes. The triglyphs are
each divided vertically into sections. Beneath
each triglyph is a short horizontal band (*regula*),
with stone pegs (*guttae*). The projecting cornice

154

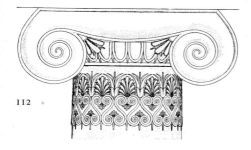

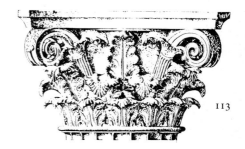

112 113

above the frieze (*geison*) has, on its lower side, above each metope and triglyph, a *mutule*, which is also decorated with stone pegs or guttae. The geison caps the entablature, and a raking geison frames the pediment, whose rear wall is called the *tympanum*. At the top of the construction is a gutter (*sima*), which conducts rainwater to waterspouts at each end. At either end of the pediment is set an akroterion, in this case the figure of a sphinx. Numerous elements in the Doric temple can be recognized as deriving from older wooden architecture.

108 IONIC ORDER, as developed in Attica. Schematic drawing of the northern porch of the Erechtheion, Acropolis, Athens. c. 421–06 B.C. When compared to the Doric order, the Ionic is seen to be more slender, delicate, flowing, and elegant. The Ionic architrave is divided into three horizontal bands (*fasciae*), each one projecting a little more than the one below. At the top of the architrave is a molding of double curvature, an Ionic *cyma*, ornamented with a band of bead-and-reel above a band of egg-and-dart ornament. Above this are a continuous frieze and a narrow cornice (geison), which also has a decorative molding at the top. (See also *117, 124–126, 133, 138*.)

109 IONIC ORDER, as developed in Asia Minor in the course of the 4th century. Schematic drawing of a column from the side of the Temple of Athena, Priene. c. 340 B.C. The base of the tall, slender Ionic column rests on a square plinth; the base itself is composed of concave moldings (*trochili*), on which rests a large convex molding (*torus*). The shaft has flutes—usually twenty-four—separated by narrow strips of unfluted surface, not ridges. The taper of the column toward the top (*entasis*) is subtle. The

two large spiral-shaped volutes that protrude over the sides of the column are typical of the Ionic capital, which was designed for a front view. On the narrow sides, the volutes form a bolster. At the neck, the column is decorated with egg-end-dart. The abacus above the volutes fills a narrow space between the column and the architrave. The frieze, above the architrave, is ornamented with an Ionic cyma (ornamented with a band of egg-and-dart and a band of bead-and-reel), dentils, and other decorative moldings. Above is the geison.

110 CORINTHIAN ORDER. Schematic drawing. The only important difference between the Ionic and the Corinthian order is the freely sculptured leaf-capital typical of the latter. The elaborate Corinthian column base, the fluted shaft of the column, and the divisions of the entablature are related to the Ionic order. Corinthian capitals came into use at the end of the 5th century. In Hellenistic and especially in Roman art, this luxuriant, diversified form was much favored. (See *113*.)

111 TEMPLE OF ZEUS, OLYMPIA. Side elevation. c. 470–56 B.C. The sturdy columns of the Doric order stand directly on the top step (*stylobate*) of the three-stepped base of the temple. The taper of the column from foot to neck amounts to roughly a quarter of the diameter of the base; the exaggerated degree of taper (entasis) of the column emphasizes the impression of power. The flat flutes of the shaft—generally twenty in number—are separated by sharp ridges (see the reconstruction of the east façade, *130*). The distance between the axes of two adjacent columns is called interaxial measure; the space between two adjacent columns is the intercolumniation. (See *115*.)

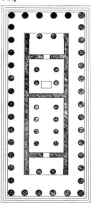

114

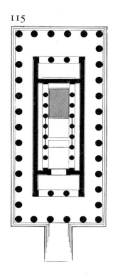

115

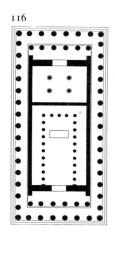

116

112 IONIC CAPITAL, from the Temple of Hera, Samos. c. 480 B.C. Reconstruction. There is an elaborate ornament at the top of the column, with bands of double whorls and alternating palmettes and lotus flowers. Beneath the bolster that terminates in volutes is an egg-and-dart ornament.

113 CORINTHIAN CAPITAL, from the Temple of Athena Alea, Tegea. Mid-4th century B.C. Reconstruction. The members of the Corinthian capital are arranged around a basketlike core or bell (*kalathos*). The elaborate composition consists of two rows of small acanthus leaves at the bottom, above which are larger acanthus leaves with spiraling tendrils forming volutes (*helices*). These curve outward at each corner. A curved, molded covering slab rests on top.

114 TEMPLE OF APOLLO, CORINTH. Ground plan. Scale 1:1200. Mid-6th century B.C. 6×15 columns. 21.6×53.8 meters. The floor (stylobate) of the temple is raised above the rock on which the temple is built by means of four steps. The front porch of the cella (pronaos) is oriented toward the east, the common practice. A double row of four columns each, inside the main room of the cella, divides it into a nave and two aisles; these Doric interior columns were arranged in two stories. A second room, half the size of the first, opens toward the west. Inside it were only four columns. A broad base

stood in front of the back wall that separated this room from the other. Probably this second room was also used for worship. (See also *122, 123*.)

115 TEMPLE OF ZEUS, OLYMPIA. Ground plan. Scale 1:1200. Built c. 470–56 B.C. 6×13 columns. 27.68×64.12 meters. The inside of the cella is divided by two rows of columns into a wide central nave and two narrow aisles in two stories. One third of the nave—from the fifth pair of columns to the back wall of the cella— is occupied by the large base on which was placed the seated gold-and-ivory image of Zeus by Phidias. (See the elevation of the east façade, *130*, and of the flank, *111*.)

116 PARTHENON. Acropolis, Athens. Ground plan. Scale 1:1500. Built 448–32 B.C. 8×17 columns. 34×72.5 meters. The great width of the façades (see *119*) is conditioned by the unusual width of the cella. In the cella, two stories of columns surrounded the cult image and its base in a rectangular formation. The cult statue of Athena Parthenos, sculpted by Phidias in gold and ivory, was set somewhat apart from the back wall, nearer the center of the cella (see *134*). In the west part of the cella, the actual Parthenon ("Maiden's Chamber"), stand four Ionic columns that supported a coffered ceiling. (See *117, 120, 132*.)

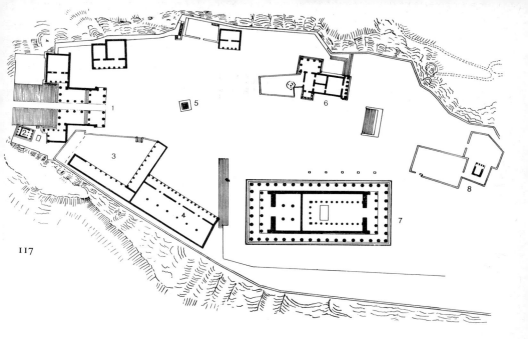

117 PLAN OF THE ACROPOLIS OF ATHENS in the Classical period. Reconstruction. The Acropolis of Athens is a flat hill, rising 60 to 70 meters above the plain of Attica (156 meters above sea level). 300 meters long and 150 meters wide, the plateau offers a somewhat modest area for fortifications, sanctuaries, and shrines. The hill slopes gradually toward the west, and access was possible only from this side. During the second half of the 5th century, the famous gateway of the Propylaea (see 131) was constructed here; it occupies the whole west side (1). South of the Propylaea, on a projecting rock, which already in Classical times had been built into a bastion, stands the small Ionic Temple of Nike (2), the construction of which was protracted throughout the last quarter of the 5th century. Further south lay the sacred precinct of Artemis of Brauron (3). Her cult center had been transplanted to the Acropolis of Athens from the village of Brauron on the east coast of Attica in the 6th century B.C. Next to this sanctuary was situated the Chalkotheke (4), a largish building, in which votive presents in precious metal dedicated to Athena were preserved. On the continuation of the axis of the Propylaea in an easterly direction stand the remains of the foundations and the top of a base (5), which presumably supported the bronze image, 9 meters high, of Athena Promachos. This colossal statue was made by Phidias. Sailors could supposedly see the top of its lance glittering from Cape Sunion. On the north side of the Acropolis, partly on a lower area of the citadel, was situated the complicated building called the Erechtheion (6). On its south side is the famous karyatid porch (124). The east side, from which one enters the temple cella, is decorated with a row of Ionic columns (133). At the western extremity of the north side rises the famous north doorway of the Erechtheion, which is built on a lower level (125). The significance of the layout and constituent parts of the Erechtheion are still unclear. The building appears to have been planned and begun by 421 B.C. It was completed only in 406 B.C. The Parthenon (7) is the largest building on the Acropolis. Both in size and significance it dominated the Classical Acropolis. It was built between 448 and 432 B.C. During this short period all the sculptural decorations of the building were also completed (see 81–84). Northeast of the Parthenon have been found the remains of a sacred precinct, which was probably dedicated to Zeus Polieus, the protector of cities (8).

and back is one and a half interaxial measures—i.e., the distance from center to center of adjacent columns—and the width of the passages down the long sides is equal to one interaxial measure. The walls of the cella terminate at the porches with pilasters, or *antae*, and two columns were placed *in antis* (between the antae) at the entrance to both pronaos and opisthodomos; this, too, was the usual Doric scheme.

The design of the façades and the long sides is also canonical. The east elevation shows how the four central columns stand in front of the body of the cella, the intercolumniations at the left and right corners being set in front of the two side passages. The buildings's proportions are determined by a basic measurement of 52.1 cm. The normal interaxial measure on all sides is 10×52.1 cm. wide, but the interaxial measures on the corners are contracted— presumably a visual correction. The width of the cella was three interaxial measures (i.e., 30×52.1), and its length, nine interaxial measures (i.e., 90×52.1), the proportions thus being 1:3. The height of the columns is twice the interaxial measure, that is, 20×52.1. Each triglyph and metope together are 5×52.1 wide, and they rest above the interaxial measure of 521 cm. The diameters of the side columns at base and neck are 4 cm. narrower than the equivalent diameters of the columns on the façades. In both cases, however, the tapering of the columns toward the top amounts to exactly 52.1 cm. These numbers and proportions should indicate with what mathematical precision the plan of the Temple of Zeus at Olympia was designed and executed.

The Parthenon, by contrast, is consistently but brilliantly exceptional. In the first place, it is much wider than the Temple of Zeus and most other Doric temples (*116*). The façade has eight columns, and there are seventeen down the sides. Given such a width, a cella with only two columns *in antis* would have been structurally unfeasible. The architect ingeniously placed six smaller Doric columns, raised on two steps, at either end of the cella, a unique solution for a Doric building. At the same time, the cella was expanded, so that the side passages on the flanks became relatively narrow, and the interior space and consequently the room available for the cult image became absolutely wider. Thus, the design of the temple appears to have arisen from the requirements of the cult image, the gold-and-ivory statue of Athena Parthenos. The architects apparently desired sufficient space to erect the image, freestanding, in the consecrated area, and to surround it with a wide circuit of columns (*134*). The structure as a whole was planned and executed with as much care as the Temple of Zeus and with infinitely more inspiration (*119, 120*). The platform curves gently away to the corners, giving a matchless effect of elasticity, and the columns lean inward, pulling the whole structure into taut, centralized balance. The wealth of such nuances culminates in the entablature, including the geison, which repeats the curvature of the steps. Every part is precisely measured and fitted. No building in the Greek world made such

great demands on the skill of its builders as the Parthenon, and none succeeded in imbuing the stone with such animation and delicacy.

The Parthenon is the undisputed sovereign of the Acropolis of Athens (*117, no. 7*). Situated on the highest eminence of the rock that looms above the city, and supported by enormous foundations, it rises above the other Classical buildings that were erected at the same time or shortly after. These other buildings are smaller and more delicate, and they differ very much from each other. The architects of the Erechtheion faced the barely soluble task of uniting several cults under one roof. Despite extensive research, the building remains almost unexplained as regards its function as a whole and the purpose of its three rooms, each on different levels. The ground plan is exceedingly unusual (*117, no. 6*). On the west, the building is delimited by a narrow corridor with colonnade, which provides access to two rooms dedicated to Erectheus and, running south to north, is only accessible from the famous north porch. The other end meets the back of the south, or karyatid, porch at a lower level, and was connected with it by a flight of stairs. The main room of the cella, richly decorated and dedicated to Athena Polias, is approached from the east. Here a narrow entrance is fronted with six Ionic columns (*133*). The form that the architect gave to the west side of the building is completely incomprehensible. One should probably understand it as an emergency solution to an alteration of an original plan, perhaps by a simplification of the design as a whole. Only this would explain the fact that the western wall of the beautiful porch on the north side (*125*) extends beyond the west façade of the building. This protruding part gives narrow access to the whole western part of the sanctuary, an open holy precinct, in which grew the sacred olive tree of Athens. This, too, would explain the fact that the karyatid porch, the jewel of the Erechtheion, was set at the end of the long south wall of the cella, without proper access even from the inside, and indeed, without recognizable purpose.

Despite all these difficulties in the planning and the execution of the Erechtheion, this temple is one of the few Classical buildings that gives an idea of the demands that could be met in the execution of a building and of its every ornament in this period, and of the skills that architects and craftsmen had to develop to fulfill them.

The karyatid porch (*124*) is the most beautiful surviving experiment involving the juxtaposition of architecture and the sculptured human figure created in antiquity. It was very famous even in ancient times, and was copied again and again; later, in the Renaissance and during various classical revivals, it was taken up again and repeated countless times. The height of the steps and balustrade, the height of the balustrade and of the female figures standing on it, are beautifully balanced. The entablature, which faithfully reflects the rules of the Ionic order, is lightly and effortlessly supported by the figures; their locks and

118 DORIC COLUMNS. Temple of Hera, Olympia. Early 6th century B.C. These columns, consisting of the original drums and capitals, were re-erected after the excavation of the sanctuary. The shallowness of the capitals is indicative of their antiquity; moreover, the flutes of the shafts are not very deep. The shallow rectangular cavities on the left column probably served for the attachment of plaques of clay or wood. Possibly these plaques were dedicated by girls who had won the foot race at the Olympic Games. The remaining columns of the Temple of Hera, although they are all of local limestone, poros, were carved in different periods, as is indicated by the varying forms of their capitals, the number of flutes, and the techniques employed in carving the drums. They were erected between the early Archaic and Roman periods. Apparently, the cella of the original 7th-century temple was surrounded by a ring of wooden columns, which, in the course of the centuries, were gradually replaced by stone ones.

119 PARTHENON. From the northwest. Acropolis, Athens. 448–32 B.C. The problems arising in the design of Doric temple corners were solved boldly in this high Classical Doric temple by reducing the space between the columns at the corners. Adjustments in perspective were achieved by giving convex curvature to horizontal lines of the building and inclining the vertical columns toward the cella or inner temple walls. (See also *116, 117, 120, 132, 134*.)

120 EAST FAÇADE OF THE PARTHENON. Acropolis, Athens. 448–32 B.C. (See also *117, 128, 129, 131*.)

121 EAST FAÇADE OF THE PROPYLAEA. Acropolis, Athens. 437–31 B.C. (See also *117, 128, 129, 131*.)

122 TEMPLE OF APOLLO, CORINTH. Southwest corner. Mid-5th century B.C. (See also *114, 123*.)

123 TEMPLE OF APOLLO, CORINTH. Southwest corner and southern side. Mid-6th century B.C. (See also *114, 122*.)

124 KARYATID PORCH OF THE ERECHTHEION. Acropolis, Athens. The building, unlike the Parthenon and Propylaea, was begun after the death of Pericles, in 421; however, its architect may have been Mnesikles, who designed the Propylaea. To judge by accounts surviving in inscriptions, building activity continued until 406 B.C. The placement of the human figure in an architectural context has here found a magnificent solution. The austere folds of the peplos lend a columnlike character to the maidens. Their arms were hanging down, slightly flexed. The hands over the supporting legs pulled the cloaks forward; the other hands carried libation bowls, probably of silver gilt. (See also *108, 117, 125, 126, 133, 138*.)

125 NORTH PORCH OF THE ERECHTHEION. Acropolis, Athens. c. 421–06 B.C. The columns of this entrance are worked in the Attic Ionic style in its finest Classical interpretation. The slender shafts of the columns rise high above graded and profiled bases, and are crowned by a decorated neck band, a delicate Ionic capital with a narrow abacus and volutes. (See also *108, 117, 124, 126, 133, 138*.)

126 IONIC COLUMNS. North Porch of the Erechtheion. Acropolis, Athens. 421–06 B.C. Bases and lower parts of the shafts. (See also *108, 117, 124, 125, 133, 138*.)

127 TEMPLE OF NIKE. South corner of the east face. Acropolis, Athens. c. 420 B.C. Top step of the three-stepped foundation, column base with wide concave molding between two roundels, and foot of an Ionic corner column.

128 DORIC COLUMN of the east face of the Propylaea. Acropolis, Athens. c. 435 B.C. The Doric column stands directly on its support, the stylobate, without a base. The relatively shallow flutes are separated from each other by sharp vertical edges. (See also *117, 129, 131*.)

129 IONIC COLUMN flanking the central passageway inside the west section of the Propylaea. c. 435 B.C. Base and lower part of the shaft. The building was probably completed in outline by c. 435 B.C.; work was discontinued at the latest in 431 B.C, the beginning of the Peloponnesian War; hence, parts of the original plan were not executed. The elaborately molded base rests on a disc-shaped support that is structurally a part of the stylobate. The base itself consists of a lower convex roundel, a concave central member (*trochilus*), and a narrow roundel at the top, the torus, with horizontal flutes. The flutes of an Ionic column shaft have rounded edges; unlike Doric flutes, they are separated by narrow bands of unfluted surface.(See also *117,128,131*).

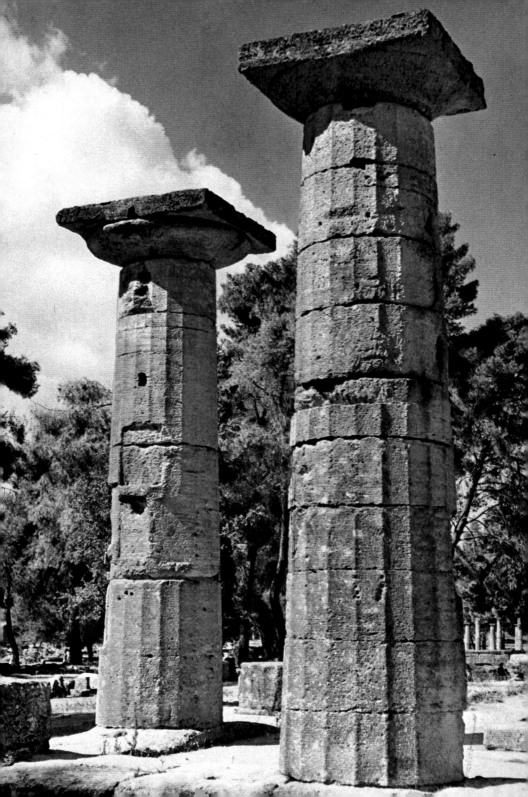

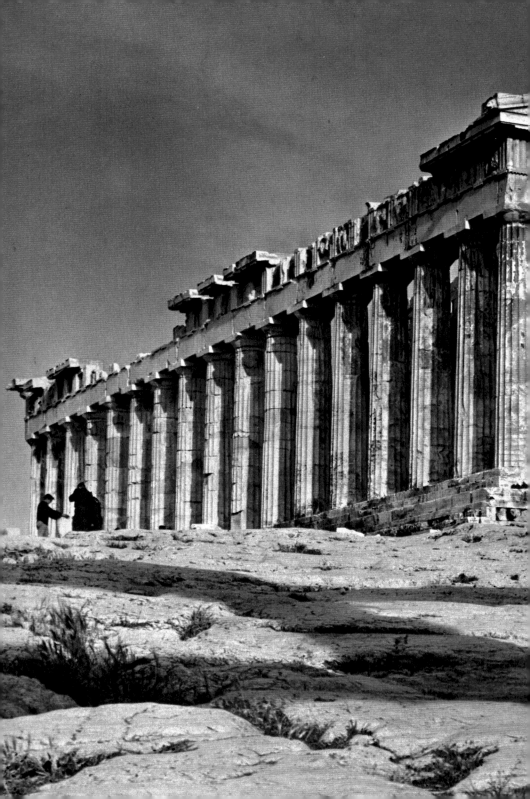

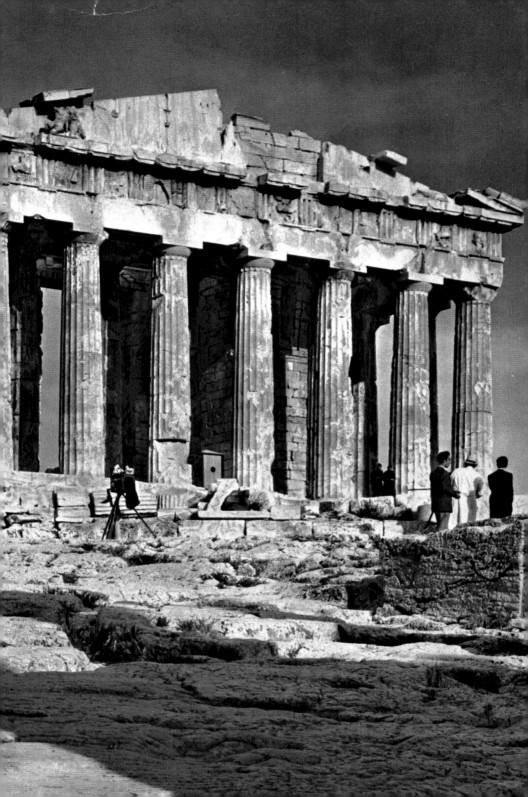

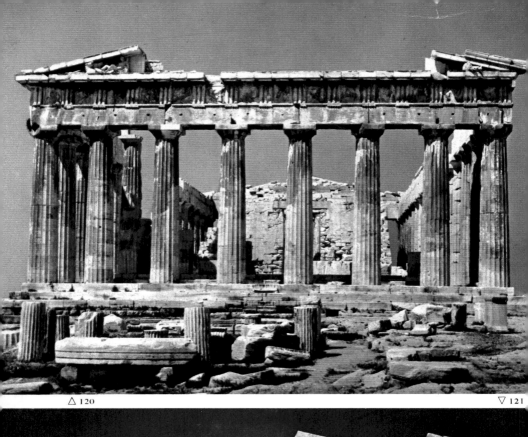

△ 120 ▽ 121

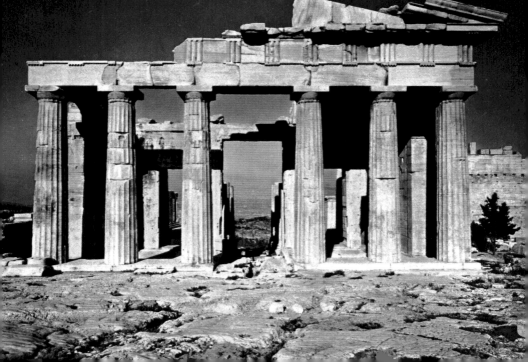

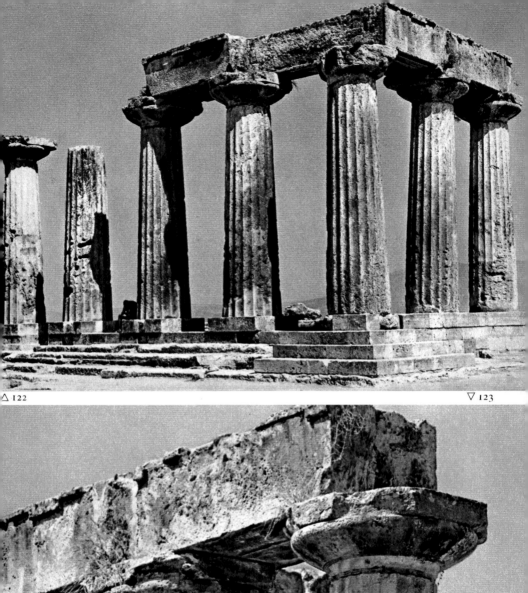

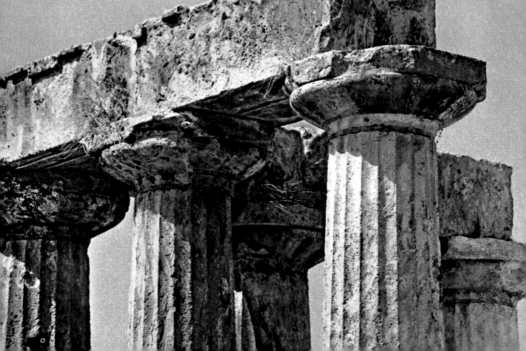

△ 122

▽ 123

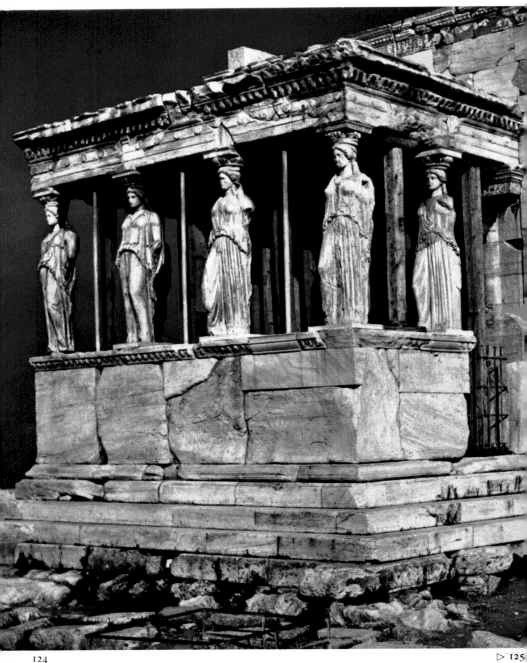

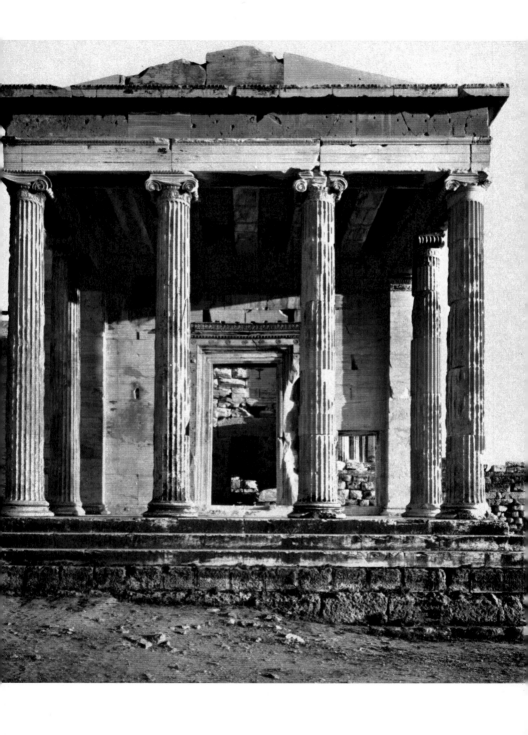

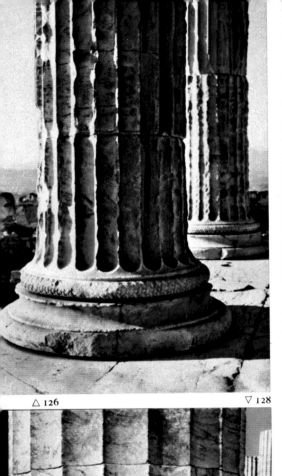

△ 126 ▽ 128 △ 127 ▽ 129

130

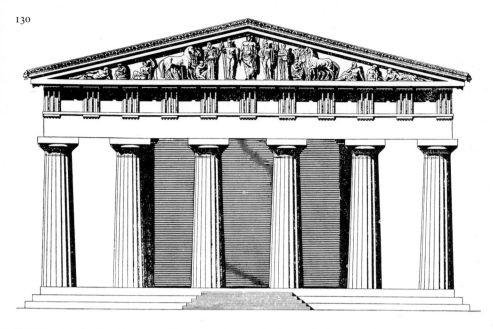

130 TEMPLE OF ZEUS, OLYMPIA. East façade.
c. 475–56 B.C. Reconstruction according to
W. Dörpfeld. Pedimental composition as sug-
gested by E. Curtius. The akroteria of the pedi-
ment are not shown, as their form is unknown.
(See also *111*, *115*.)

131 PROPYLAEA. West façade. Acropolis, Athens.
437–31 B.C. Reconstruction. This gateway to
the plateau of the Acropolis was designed by
the architect Mnesikles. The central part of the
west façade consists of six Doric columns,
8.82 meters high, through which one passed
into a deep hall. The central and largest pas-
sageway had a paved ramp with small steps for
sacrificial animal victims. Wings adjoin the cen-
tral building at right angles to north and south.
They are rectangular in ground plan, each with
three Doric columns between antae, supporting
an entablature. On the east side, on a higher
ground level, another hall with six Doric
columns (*121*) joins the central west hall. The
pediments of the Propylaea were not decorated
with sculptures. (See also *117*, *121*, *128*, *129*.)

32 PARTHENON. West façade. Acropolis, Athens.
448–32 B.C. Reconstruction. View from west-
northwest. The immediate surroundings are
included in the drawing, in particular, the steps

in front of the west façade, with numerous
votive gifts placed on them. (See also *116*, *117*,
119, *120*, *134*.)

133 EAST FAÇADE OF THE ERECHTHEION and west-
ern end of the north side of the Parthenon.
Acropolis, Athens. Second half of the 5th
century B.C. Reconstruction. The drawing pro-
vides a good comparison between the Doric
and Ionic orders. (See also *108*, *117*, *124–26*,
138.)

134 PARTHENON. Acropolis, Athens. a) Section
through the length of the cella: left, to the
west, the wall separating the room with the cult
image from the room called Parthenon ("Maid-
en's Chamber"). Within the cult room are a
colonnade in two tiers, twenty columns on the
long sides, and the cult image of Athena Par-
thenos. On the right, again shown in section,
are the wall with a door into the cella, the
porch (pronaos), and the east side of the
peripteral colonnade (*116*). b) Section through
the width of the temple; on left and right, the
colonnade (*peripteros* or *peristasis*), the side
passages (*ptera*), the walls and aisles of the
cella, the inner colonnade of the cella, and the
cult image of Athena Parthenos, seen frontally
from the east. (See also *117*, *119*, *120*.)

169

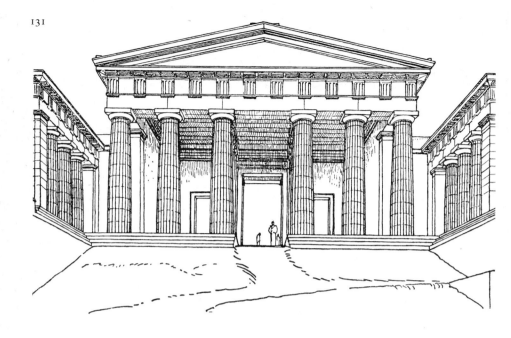

131

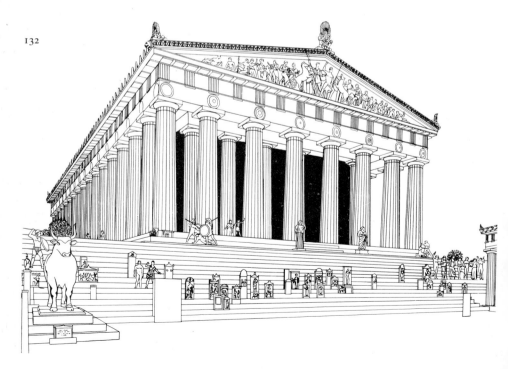

132

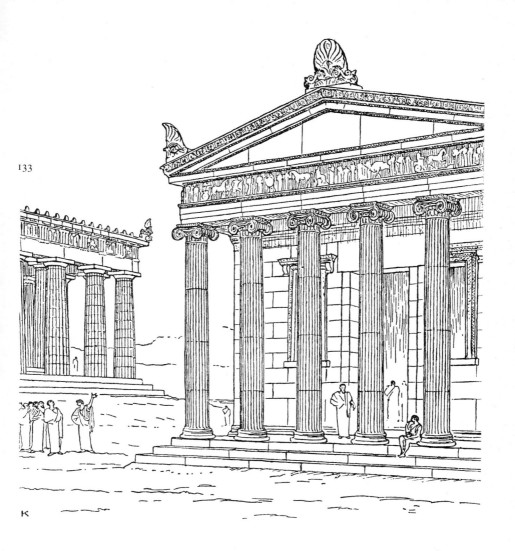

133

K

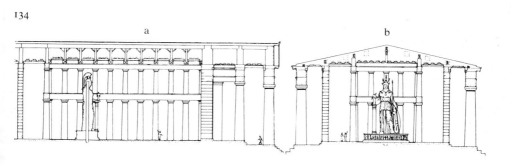

134

a b

curls are skillfully arranged in such a way that they imperceptibly blend into the round circles of stone that form the base. These figures of karyatids (girls supporting the roof) have taken the place of slender columns.

The real columns of the Erechtheion are examples of the most sophisticated and elegant Ionic architecture of the Classical period. Six are aligned along the east face (one, in the early nineteenth century, was taken to the British Museum in London by Lord Elgin). Six more delimit the rectangular area that lies in front of the entrance to the north-south corridor (*125*). With its richly ornamented frame, its lintel resting on consoles, and its beautiful proportions, this door became a much repeated model.

The columns of this north porch of the Erechtheion have bases with a specially elaborate and differentiated decoration (*126*). A concave molding joins the broader and seemingly compressed lower convex molding to the upper one with an elegant ornamental relief.

135 TEMPLE OF POSEIDON, SOUNION. South flank. Late 5th century B.C. Some of the columns have been re-erected and the ancient blocks of the architrave replaced. These columns, on the south side, however, are in their original positions.

136 SECTION OF FRIEZE, Treasury of the Siphnians, Delphi. c. 530 B.C. Fragment. Delphi Museum. On top, Ionic cyma, consisting of a bold band of egg-and-dart ornament (the darts are arrow-like) and a delicate band of bead-and-reel; then, a wide frieze of palmette-and-lotus, which is terminated by a band of bead-and-reel. These terse Archaic forms are at an early stage of their development. (See also *137*.)

137 SECTION OF DECORATED CORNICE, Treasury of the Siphnians, Delphi. c. 530 B.C. Fragment. Delphi Museum. A Lesbian cyma terminates the upper edge of the cornice. It consists of a band of leaf-and-dart, with hanging heart-shaped leaves; below is a bold band of bead-and-reel, one round bead alternating with two little vertical discs. The palmette-and-lotus frieze has particularly wide, luscious volutes beneath the palmettes, and swelling lotus petals. Below, this profuse assemblage of Archaic forms is terminated by another band of bead-and-reel. (See also *136*.)

138 SECTION OF DECORATED CORNICE, Erechtheion, Acropolis, Athens. c. 420 B.C. Fragment. Glyp-

tothek, Munich. The upper band is decorated with a Lesbian cyma with stylized, heart-shaped leaves. Below are an Ionic cyma framed by strips of bead-and-reel, and a delicately composed frieze of palmette-and-lotus. The slab has a Classical abundance of ornament, precisely and sensitively carved. (See also *108*, *117*, *124*, *125*, *126*, *133*.)

139 SECTION OF DECORATED CORNICE, Temple of Asklepios, Epidauros. First half of the 4th century B.C. Fragment. Epidauros Museum. The ornamental forms of this slab have a certain delicacy and disjointedness. The palmette-and-lotus frieze has acquired a playful late Classical richness of detail.

140 THEATER, EPIDAUROS. 3d–2d century B.C. View from the south into the Classical auditorium. The orchestra is in the center. On the right is the restored double gateway, giving access to the *parados* (wing through which the chorus entered the orchestra) and the ramp leading up to the *proskenion* (the platform on which the actors moved). An exact counterpart stood on the western side. These double gateways between the stage (*skene*) and the auditorium did not serve as access for the spectators, but for the solemn entrance of the chorus into the orchestra and the actors onto the stage. (See also *141*, *142*.)

172

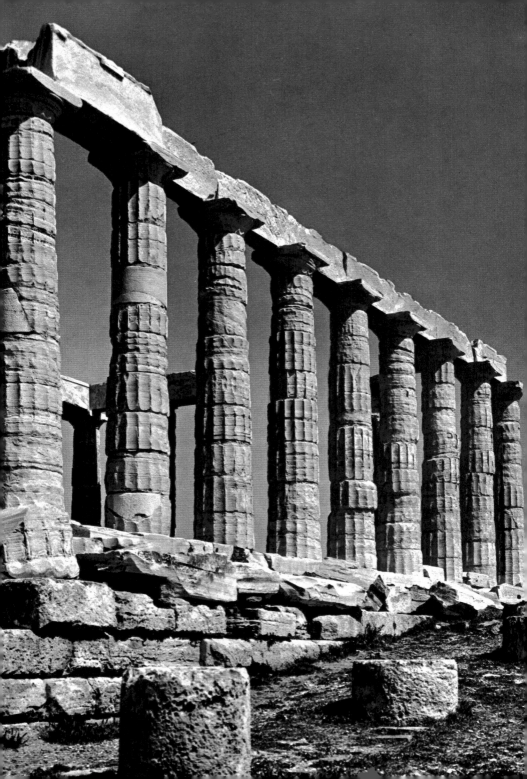

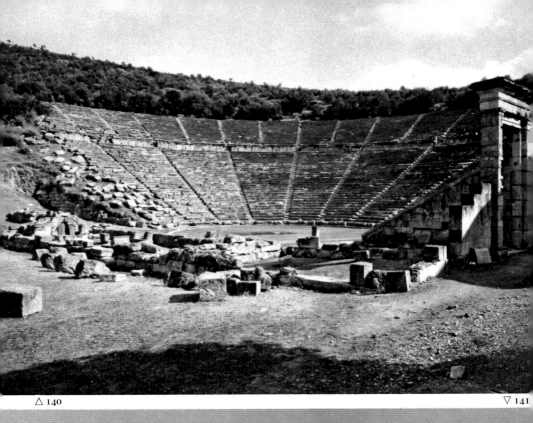

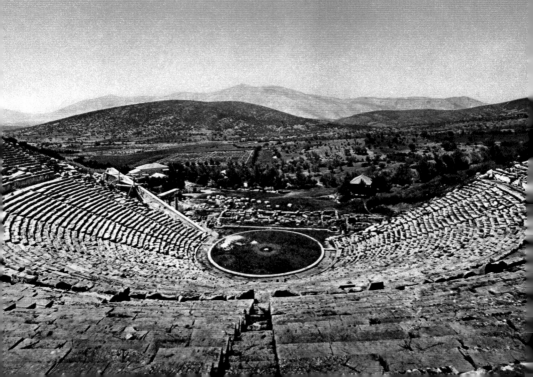

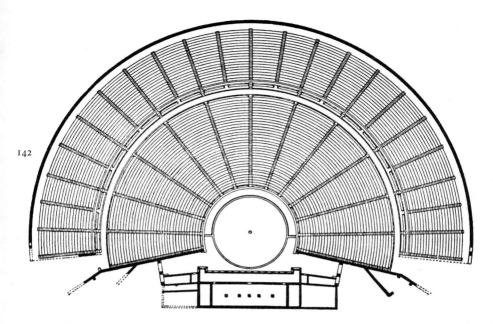

142

41 THEATER, EPIDAUROS. 3d–2d century B.C. View
from the top seats of the auditorium to the
orchestra and the sanctuary of Asklepios in the
valley below. (See also 140, 142.)

42 THEATER, EPIDAUROS. Ground plan in the 4th
century. Reconstruction. (See also 140, 141.)

43 THEATER, PRIENE. Reconstruction of the audi-
torium, orchestra, and stage (skene) in the 2d
century B.C. In the background, temples. On

the semicircular periphery of the orchestra
stood marble seats of honor, which were re-
served for high officials, priests, and guests.
The stage had two stories. When their shutters
were removed, the three large doors in the
upper storey gave access to an inner chamber.
Votive statues erected in the theater served as
sacred offerings and, at the same time, com-
memorated the donor.

143

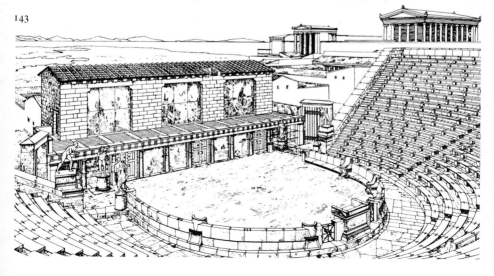

177

Above this, in a beautiful curve, rises the shaft of the column with deep narrow flutes. Only the bases of the columns from the east face of the Temple of Nike, south of the gateway to the Acropolis, are formed with more crispness (*127*). Here the convex molding at the bottom is shorter and narrower, the concave molding in the center is more erect, and the torus on top is subdivided by regular horizontal bands, which subtly echo the flutes of the shaft above.

A block from the cornice that ran along the top of the ashlar wall of the cella will serve as an example of the complexity of the other decorations of the Erechtheion (*138*). A wide band with a pattern of elongated palmettes alternating with lotus flowers is crowned by two further ornamental bands, one of egg-and-dart ornament, the other of leaf-and-dart; each of the three is separated by two bands of bead-and-reel ornament. The forceful, rounded formation of similar moldings in Archaic times (*136*) has been rendered with a new delicacy and precision.

It is not entirely clear whether the construction of the Erechtheion was begun at the same time as the gateway to the Acropolis, the Propylaea, in 437 or only in the year of the Peace of Nikias, 421 B.C. The karyatids and the ornaments of the building speak for the later date.

The Propylaea, the third main group of buildings on the Acropolis (*117, no. 1*), gave architectural form to the only natural point of access to the rock. According to the original plan, it was to form a uniform monumental boundary for the whole west side, from the Temple of Athena Nike at the south side, to the north slope. Only the central part of the building was actually completed; a north wing, which housed a picture gallery, is linked with the central section at right angles. The southern counterpart of this wing was only built in part, and was shortened by half of its planned extent in order not to crowd the Temple of Athena Nike. However, to one walking up to the Propylaea, the form of the building with its lateral wings was clear and well balanced, for the façade of the south wing, though smaller, corresponded to that of the north wing (*131*). Having been brought to the level of the plateau of the Acropolis in several stages, the visitor was graciously dismissed

144 FAÇADE OF THE LATER ARTEMISION, EPHESOS. Mid-4th century B.C. Reconstruction. The west façade of this huge Ionic temple has been reconstructed with three rows of columns on the front and four pairs of columns within the porch (pronaos) that leads to the large entrance door. This did not give access to a cella, but to a courtyard (*sektos*) surrounded by huge walls, at the back of which stood the sacred shrine, the aedicula, with the famous image of Artemis of Ephesos. In this reconstruction by Krischen, the shrine and image appear in the frame of the great door that leads to the inner courtyard. (See also *145*.)

145 ARTEMISION, EPHESOS. As rebuilt over Archaic remains in the second half of the 4th century B.C. Ground plan with restorations. Scale, 1:1250. (See also *144*.)

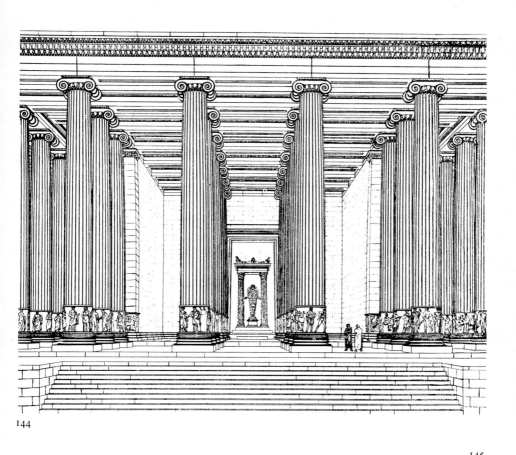

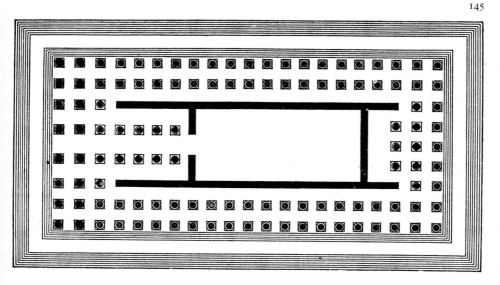

after traversing the east porch with its lovely row of columns, which have been partially restored (*121*). A wall cutting across the central part of the building from north to south is intersected by five passages that give access to the east porch; through the central and largest of these runs the road that follows the main axis of the Propylaea. This road was doubtless used by the Panathenaic procession on its way up to the Acropolis. In the western hall this central passage is flanked by three pairs of tall Ionic columns (*129*); the bases have an individual shape that differs from the shape of the column bases of the Erechtheion. The east and west façades of the central section of the Propylaea have six columns each; at each side, the central intercolumniation is wider, because of the road passing through it. The columns are sharply fluted, and, according to the rules of the Doric order, rest directly on the top step (*128*).

The building of the Propylaea was supervised by the architect Mnesikles; work began in the year 437 B.C. and probably stopped at the outset of the Peloponnesian War in 431 B.C. The more comprehensive structure that had originally been planned was never realized.

With these buildings, and the Ionic Temple of Nike (*117, no. 2, 127*), to which the Nike parapet was added between 410 and 407 B.C. (*85*), the brilliant half century of building activity in the Classical style on the Acropolis came to an end. It is surprising that so few alterations were made during the subsequent Hellenistic and Roman centuries. Although major Hellenistic and Roman buildings were erected all around the slopes of the Acropolis, the sacred citadal itself was not subjected to any changes or developments, except for a small, modest round Temple of Dea Roma—dedicated to Roma and Augustus—erected in Roman times in front of the east façade of the Parthenon.

The Temple of Poseidon on Cape Sounion, which today as in the past is famous for its magnificent position high above the sea, was erected later than the Parthenon. The temple, built of radiant white marble (perhaps from Naxos), had six columns across the front and thirteen down the long sides. These are surprisingly slender for the Doric style, and have capitals with a simple echinus on which rests a square abacus. On the south side, nine of the thirteen columns are still standing, as are parts of the entablature (*135*); some columns at the northeast corner have been re-erected. The inside of the east porch was decorated with a frieze of battle scenes from Attic mythology. The style of the frieze, as well as the form of the columns and their capitals suggest a date in the late 5th century.

In the course of the 4th century, and increasingly during the Hellenistic period, the Doric style became less important. Ionic temples continued to be built, especially in Ionian Asia Minor. During this period the Corinthian order was developed (*110*); the Corinthian capital (*113*), however, had been created at the end of the 5th century. In its essentials the Corinthian column is related to the Ionic. Two schematic drawings (*112, 113*) show the volutes

that are typical of the Ionic capital and the loosely composed acanthus leaves of the Corinthian capital.

The Artemision at Ephesos (*144, 145*) has always been one of the greatest and most famous temples of the Ionian coast of Asia Minor. Precursors of this huge temple, which was built around the middle of the 6th century and excelled all Greek temples in size and splendor, have been traced to the 8th century B.C. After its destruction by the sacrilegious Herostratos, who, according to legend, burned the temple to the ground the night of the birth of Alexander the Great (356 B.C.), reconstruction of the Temple of Artemis was decided upon and carried out with the cooperation of many Greek cities and states. The plan of this temple (*145*) corresponded exactly to that of its Archaic predecessor. Like the latter, it was octastyle, that is, a building with eight columns along its principal façades. To the side of the entrance, which in this case faced west, these eight columns stood three rows deep. Moreover, two rows of Ionic columns ran along the sides. Altogether, 117 columns enclosed the temple. The huge walls of the sanctuary, built of rectangular blocks, surrounded a courtyard in which stood a small temple and an aedicula that contained the sacred statue of Artemis of Ephesos. The columns of the entrance hall stood on high drums, which were decorated in relief (*144*). It was these carved columns in particular that made the temple one of the seven wonders of the world. It cannot be securely ascertained to what extent the building was completed in the 4th century and how much still remained to be done in the 3d.

Theaters of stone began to play an increasingly important role in the course of the 4the century. One of the greatest and most famous is the Theater of Dionysos in Athens. It was situated on the south slope of the Acropolis and witnessed performances of almost all the Attic tragedies. Its ground plan has been reconstructed, and from it one may deduce that it contained about 200 seats. The theater at Epidauros (*140–42*) is better preserved; in fact, it is the best-preserved theater in Greece and was used until late antiquity. Situated in a peaceful valley above the old port of Epidauros, it forms part of the famous sanctuary of Asklepios, which extends beneath it. Because the theater was built into a hill, the rows of seats were only covered by rubble and earth and could be excavated almost intact. They have now been cleared as far as the topmost, fifty-fifth row of limestone seats, which together provided room for over 12,000 spectators (*140, 141*). The lowest tier, surrounding the circular orchestra, consisted of seats of honor. Covered channels conducted rainwater round the stage and down the hill.

The theater was given its present form in the 3d century B.C. (the foundations of the original 4th-century structure by Polykleitos the Younger remain) and was expanded in the 2d century. The ground plan of the stage can be reconstructed (*142*). Two entrances, on the

east and west sides, linked the corners of the *skene*, or stage, with the huge supporting walls of the auditorium. These two towering gateways have been restored with ancient and modern stone blocks (*140*). On both sides, there is a wider and a narrower entrance (2.4

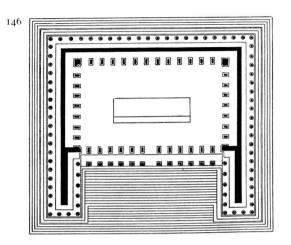

146

146 ALTAR OF ZEUS, PERGAMON. 180–60 B.C. Ground plan. An unroofed flight of steps led up to the altar, which stood in the center of an Ionic courtyard. (See also *147*.)

147 PLAN OF THE UPPER CITY, PERGAMON. Mid-3d to mid-2d century B.C. The citadel hill, extending from south to north, is subdivided into a series of terraces. On the lowest of these, at the south, lies the upper agora (1). Above the agora lies the terrace (2), on which stood the famous Altar of Zeus (3). Next follows the

terrace with the precinct of Athena and her temple (4), and the library of Pergamon (5). Adjacent to this, at the end of the semicircle formed by the citadel hill, lies the Temple of Trajan, the central structure in a square surrounded by halls (6). Arsenals (7) and fortifications were built on the northernmost spur of the hill. On the steep western slope was the theater (8), the lower ends of which met the long theater terrace, which was situated at the foot of the hill. (See also *146*).

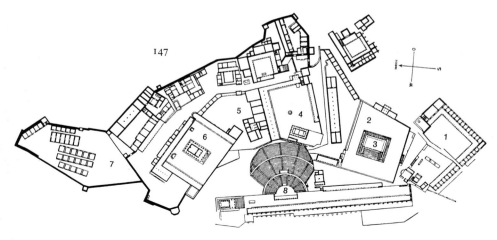

147

meters and 1.85 meters). The frames on the west side still show the holes that held the pivots on which the doors turned. The larger doors led into the *paradoi*—the wings through which the chorus entered the orchestra—and the smaller ones gave access to the ramps that ran up to the front of the stage—the top of the narrow *proskenion*, which at least after the 2d century B.C. served as the platform on which the actors moved. Behind it lay the upper storey of the skene, forming a background. (See the reconstruction drawing of the theater at Priene, *143*.)

The theater at Priene, an Ionian city in Caria in Asia Minor, is not as well preserved as that of Epidauros; however, careful excavations have brought to light enough of the architecture of the stage to allow a rough reconstruction. Figure *143* shows the stage in the Hellenistic period, about the 2d century B.C. Above and behind the proskenion is an upper storey where three doors could be opened if a scene were to take place there.

The largest complex of classical architecture that has become known to us through excavations is the upper city of Pergamon, in Asia Minor (*147*). Here were found numerous sculptures in the Pergamene Hellenistic style. Here, too, in the course of the most extensive excavations that have now been carried out for nearly a century, a Hellenistic capital of major importance has been uncovered systematically.

The first traces of classical buildings were found in the 1860's by the German engineer Carl Humann, who noticed large fragments of marble reliefs in a Byzantine wall. When some of these fragments were sent to Berlin, their significance as works of art and their connection with a large Hellenistic building were recognized. In 1878 the excavation of the terrace and foundations of the Great Altar of Pergamon began under the supervision of Humann and Alexander Conze. In the following years, thousands of fragments of the frieze relief, as well as complete and continuous slabs of it, came to light. An additional twenty years were required to order and join these fragments and slabs together. Their final arrangement in the great hall of the Pergamon Museum in Berlin took place in 1930. Meanwhile, the excavations on the site were continued and extended to the whole upper city of Pergamon. Apart from interruptions during World Wars I and II, they have continued until the present day. As a result, the plan of the upper city has been clarified, and many buildings and monuments have been reconstructed in detail.

The hill of the upper city of Pergamon, rising to a height of 308 meters, and extending from south to north in the form of a sickle, was systematically subdivided into individual terraces, which, like a series of steps, conducted the visitor to the northernmost eminence of the hill. The structures covered only the actual hill of the upper city, the citadel, below which further sanctuaries, gymnasia, and palaces extended toward the city of Pergamon in the valley.

The sequence of terraces on the Acropolis itself (*147*) begins at the southern foot with the upper *agora*, an open-air place of assembly (*147, no. 1*) which corresponds to a lower agora, situated further down in the valley. The upper agora is surrounded on three sides by colonnaded halls, some of which contained shops. To the west, above a supporting wall that slopes toward the Theater of Dionysos, was situated a temple dedicated to the same god. A main thoroughfare ran across the agora and continued past the east side of the terrace of the Altar of Zeus (*147, no. 2*). This terrace provided an ample base for the great Pergamene altar (*146, 147, no. 3*), for there were no other buildings on it. The back of the great podium of the altar (the longest side and of special importance) faced east, where the entrance from the main thoroughfare of the upper city was located. On this eastern side is the wonderful section of the altar frieze that shows the battle scene in which Zeus and Athena are the main protagonists (*105, 106*). From the terrace of the altar, the main thoroughfare loops around to the terrace dominated by a shrine of Athena. Situated at the edge of the platform and high above the theater stood the temple dedicated to the goddess (*147, no. 4*). Its façades with six Doric columns are balanced by long sides of only ten columns, an unusual truncated ground plan. The surviving column drums are not fluted. The frieze of the temple is subdivided in an elaborate manner, so that three metopes and triglyphs span only one interaxial measure. This Temple of Athena in Pergamon is probably one of the latest buildings in the Doric style; it can hardly have been built before the 3d century B.C.

The terrace of the Temple of Athena was bordered by two-storied halls on its north and east sides. Behind the wide north hall were several rooms, one of which, the main one, may be recognized as the library of Pergamon (*147, no. 5*). In its back wall there is a niche, and in front of this was found a freely adapted copy of the Athena Parthenos, the famous cult image by Phidias. In size it is a third of the original. This copy, the image of the patron goddess of arts and sciences, had presided over the library. Hollows in the floor and protrusions in the walls of this main room suggest that bookcases had been erected standing free of the walls, in order to protect them from damp and cold.

With the final terrace of the upper city, one reaches the region where, in a commanding position, the royal palace stood. Large sections of this Hellenistic palace were subsequently covered by huge substructures, and a last plateau was formed at this spot for a temple in honor of the deified Roman emperor Trajan, erected by his successor Hadrian (*147, no. 6*). Columned halls surrounded the square in which the temple stood. They gave to the temple on the highest terrace a monumental and symmetrical setting. This mighty edifice formed the grand culmination of the terraced structure of the upper city of Pergamon, although the last peak of the hill of the upper city was covered with buildings that undoubtedly served

as arsenals (*147, no. 7*). Clearly a guard for the kings of Pergamon, later probably a whole garrison, was stationed here.

The hill of the upper city of Pergamon extends northward in a wide curve; the western edge of the crescent forms a deep chasm, and the steep slope was brilliantly utilized as the setting for a theater (*147, no. 8*). The auditorium descends steeply from the supporting walls of the upper terraces of the city; its lower tiers, supported on a substructure, met a stage terrace, which runs at right angles to it. The terrace is shoved up against the continuing slope on the western side by large halls. At the end of this terrace, carved into the rock, was an Ionic temple, probably dedicated to Dionysos. With the aid of post holes that still remain in the stone pavement, the scaffolding for the skene was erected on the terrace. The auditorium that rises up the slope of the hill as far as the upper terraces is among the steepest built in antiquity.

The whole splendid structure of sanctuaries, palaces, open courts, theater, and library was created in the short period of one century. Building in the upper city began under King Attalos I (241–197 B C.) and was almost entirely completed under Eumenes II (197–59 B.C.). The latter was responsible for the construction of the Great Altar of Pergamon, and probably also the library, as well as the acquisition of the library's large collection of scrolls. Building on a grand scale ceased when the Pergamene kingdom merged with the Roman Empire (under Attalos III, in 133 B.C., the kingdom was bequeathed to the Romans).

The ground where Pergamon was built was untouched soil when Greek culture took root there at the beginning of the Hellenistic age, and the city and its art maintained something of the individuality and vision of Greece itself. It was, however, a city and an art of conquerors, and power is clearly expressed in the weighty, baroque sculpture of the Great Altar and of numerous single monuments, as well as in the grand scale of the plan of the upper city. Indeed, the subdivision of the hill into terraces expresses an imperious and self-assertive attitude to nature that was a new and typically Hellenistic characteristic, by no means confined to Pergamon itself—and one which was to be developed by the Romans in their architecture and city planning.

BIBLIOGRAPHY

GENERAL

Beazley, J. B., and Ashmore, B. *Greek Sculpture and Painting to the End of the Hellenistic Period.* New ed. Cambridge: Cambridge University Press, 1966.

Boardman, J., and others. *The Art and Architecture of Ancient Greece.* London: Thames & Hudson, 1967.

Carpenter, R. *The Esthetic Basis of Greek Art.* Bloomington, Ind.: Indiana University Press, 1959.

Curtius, L. *Die antike Kunst: Die klassische Kunst Griechenlands.* Potsdam: Athenaion, 1938.

Demargne, P. *The Birth of Greek Art.* New York: Golden Press, 1964.

Homann-Wedeking, E. *Archaic Greece.* London: Methuen, 1968. Also issued as *The Art of Archaic Greece.* New York: Crown, 1968.

Matz, F. *Geschichte der griechischen Kunst I: Die geometrische und früharchaische Form.* Frankfurt: Klostermann, 1949–50.

Richter, G. M. A. *Archaic Greek Art.* London and New York: Oxford University Press, 1949.

— *A Handbook of Greek Art.* 5th ed. London and New York: Phaidon, 1967.

Schefold, K. *Classical Greece.* London: Methuen, 1967. Also issued as *The Art of Classical Greece.* New York: Crown, 1967.

Webster, T. B. L. *Greek Art and Literature, 530–400 B.C.* London: Oxford University Press, 1939.

Zshietzschmann, W. *Die antike Kunst II: Die hellenistische und römische Kunst.* Potsdam: Athenaion, 1938.

VASE PAINTING

Alfieri, N., and Arias, P. *Spina, die neuentdeckte Etruskerstadt und die griechischen Vasen ihrer Gräber.* Munich: Hirmer, 1958.

Arias, P., and Hirmer, M. *History of Greek Vase Painting.* London: Thames & Hudson, 1963. Also issued as *History of 1000 Years of Greek Vase Painting.* New York: Abrams, 1963.

Beazley, J. D. *Attic Black-Figure Vase Painters.* Berkeley, Calif.: University of California Press, 1951.

— *Attic Red-Figure Vase Painters.* 3 vols. 2d ed. London: Oxford University Press, 1963.

— *Attic White Lekythoi.* London: Oxford University Press, 1938.

— *Potter and Painter in Ancient Athens.* London: Oxford University Press, 1946.

Buschor, E. *Griechische Vasen.* New ed. Munich: Piper, 1969. First edition also issued as *Greek Vase Painting.* London: Chatto & Windus, 1921; New York: Dutton, 1922.

Cook, R. M. *Greek Painted Pottery.* London: Methuen; Chicago: Quadrangle Books, 1960.

Lullies, R., and Hirmer, M. *Griechische Vasen der reifarchaischen Zeit.* Munich: Hirmer, 1953.

Pfuhl, E. *Malerei und Zeichnung der Griechen.* 3 vols. Munich: Bruckmann, 1923.

Richter, G. M. A. *Attic Red-Figure Vases: A Survey.* Rev. ed. New Haven: Yale University Press, 1958; London: Oxford University Press, 1959.

— and Milne, M. *Shapes and Names of Athenian Vases.* New York: Metropolitan Museum of Art, 1935.

Riezler, W. *Weißgrundige attische Lekythen.* 2 vols. Munich: Bruckmann, 1914.

Robertson, M. *Greek Painting.* Geneva: Skira, 1959.

Rumpf, A. *Malerei und Zeichnung der Griechen.* Munich: Beck, 1953. (Handbuch der Archaeologie, Vol. 4.)

SCULPTURE

Alscher, L. *Griechische Plastik.* 5 vols. Berlin: Deutscher Verlag der Wissenschaften, 1954–1963.

Becatti, G. *Problemi Fidiaci.* Milan: Electa, 1951.

Bieber, M.: *The Sculpture of the Hellenistic Age.* 2d ed. New York: Columbia University Press, 1961.

Blümel, C. *Greek Sculptors at Work.* London and New York: Phaidon, 1955.

Buschor, E. *Frühgriechische Jünglinge.* Munich: Piper, 1950.

— *Das hellenistische Bildnis.* Munich: Biederstein, 1949.

— *Phidias der Mensch.* Munich: Münchner Verlag, 1945.

— *Die Plastik der Griechen.* New ed. Munich: Rembrandt Verlag, 1958.

— *Vom Sinn der griechischen Standbilder.* Berlin: Gebrüder Mann, 1942.

Carpenter, R. *Greek Sculpture: A Critical Review.* Chicago: University of Chicago Press, 1960.

Charbonneaux, J. *Greek Sculpture.* London: Zwemmer, 1950.

Diepolder, H. *Die attischen Grabreliefs des 5. und 4. Jahrhunderts vor Christus.* Darmstadt: Wissenschaftliche Buchgesellschaft, 1965.

Fuchs, W. *Die Vorbilder der neuattischen Reliefs.* Berlin: De Gruyter, 1959.

Hausmann, U. *Griechische Weihereliefs.* Berlin: De Gruyter, 1960.

Homann-Wedeking, E. *Die Anfänge der griechischen Plastik.* Berlin: Gebrüder Mann, 1950.

Kähler, H. *Das griechische Metopenbild.* Munich: Münchner Verlag, 1949.

— *Der große Fries von Pergamon.* Berlin: Gebrüder Mann, 1950.

Kluge, K., and Lehmann-Hartleben, K. *Die antiken Großbronzen.* 3 vols. Berlin: De Gruyter, 1927.

Langlotz, E. *Frühgriechische Bildhauerschulen.* 2 vols. Nuremberg: Frommann, 1927.

Lapalus, E. *Le Fronton sculpté en Grèce des origines à la fin du IVe siècle.* Paris: Boccard, 1947.

Lippold, G. *Die griechische Plastik.* Munich: Beck, 1950. (Handbuch der Archaeologie, Vol. 3.)

Lullies, R. *Greek Sculpture.* Rev. ed. New York: Abrams, 1960.

Payne, H., and Young, G. M. *Archaic Marble Sculpture from the Acropolis.* 2d ed. London: Cresset; New York: Morrow, 1951.

Picard, C. *Manuel d'archéologie grecque: La sculpture.* 5 vols. Paris: Picard, 1935–66.

Richter, G. M. A. *The Portraits of the Greeks.* 3 vols. London and New York: Phaidon, 1965.

— *The Sculpture and Sculptors of the Greeks:* New ed. New Haven: Yale University Press, 1950; London: Oxford University Press, 1951.

Schuchhardt, W. H. *Die Epochen der griechischen Plastik.* Baden-Baden: Grimm, 1959.

ARCHITECTURE

Berve, H., and others. *Greek Temples, Theatres and Shrines.* London: Thames & Hudson; New York: Abrams, 1962.

Bieber, M. *The History of the Greek and Roman Theater.* 2d ed. Princeton, N.J.: Princeton University Press, 1961.

Dinsmoor, W. B. *The Architecture of Ancient Greece.* 3d ed. London: Batsford, 1950.

Gruben, G. *Die Tempel der Griechen.* Munich: Hirmer, 1966.

Lawrence, A. W. *Greek Architecture.* 2d rev. ed. Harmondsworth and Baltimore, Md.: Penguin, 1962.

Plommer, W. H. *Ancient and Classical Architecture.* London: Longmans Green; New York: McKay, 1956.

Robertson, D. S. *A Handbook of Greek and Roman Architecture.* 2d ed. Cambridge: Cambridge University Press, 1959.

Scranton, R. *Greek Architecture.* New York: Braziller, 1962.

Scully, V. *The Earth, the Temple, and the Gods: Greek Sacred Architecture.* Rev. ed. New York: Praeger, 1969.

INDEX

Descriptions of the illustrations are listed in boldface type

189

PHOTO CREDITS G. Gruben, Griechische Tempel und Heiligtümer, Munich 112–16, 130, 142–47 – Archiv Walter Hege, Karlsruhe 125 – Hirmer Verlag, Munich 1, 4, 6–9, 12–16, 18–23, 27–29, 31, 32, 34–36, 44, 53–57, 62, 66, 67, 69–71, 75, 76, 82, 83, 85, 89, 90, 97, 104, 134 – H. Kähler, Der griechische Tempel, Berlin 117 – K. Martin, Kunst des Abendlandes I, Karlsruhe 109, 110 – Metropolitan Museum of Art, New York 42, 43, 79, 80 – Museo Nazionale di Spina, Ferrara 30, 33 – Nationalmuseum, Copenhagen 17 – M. Schede, Die Burg von Athen, Berlin 131, 133 – H. v. Schoenebeck-W. Kraiker, Hellas, Burg v. M. 107, 108, 111 – Staatliche Museen, Berlin 24, 38, 77, 78, 92, 103 – All other photos: Archäologisches Institut der Universität Freiburg i. Br.